# HOPE IN SHADOWS

# HOPE

ARSENAL PULP PRESS · PIVOT LEGAL SOCIETY

# IN SHADOWS

*Stories and Photographs of Vancouver's Downtown Eastside*

BRAD CRAN AND GILLIAN JEROME

With a foreword by Libby Davies

ARSENAL PULP PRESS
341 Water Street, Suite 200
Vancouver, BC
Canada  V6B 1B8
*arsenalpulp.com*

PIVOT LEGAL SOCIETY
678 East Hastings Street
Vancouver, BC
Canada  V6A 1R1
*pivotlegal.org*

The publisher gratefully acknowledges the support of the Canada Council for the Arts and the British Columbia Arts Council for its publishing program, and the Government of Canada through the Book Publishing Industry Development Program and the Government of British Columbia through the Book Publishing Tax Credit Program for its publishing activities. The authors acknowledge the support of Arts Now, part of 2010 Legacies Now.

Book design by Shyla Seller
Front cover photograph by Wilda; back cover photograph by Skyla

Printed and bound in Canada by Transcontinental Printing.

Library and Archives Canada Cataloguing in Publication:

Cran, Brad, 1972-
    Hope in shadows : stories and photographs of Vancouver's Downtown Eastside / Brad Cran and Gillian Jerome; with a foreword by Libby Davies.

Co-published by: Pivot Legal Society.
ISBN 978-1-55152-238-8

    1. Downtown-Eastside (Vancouver, B.C.). 2. Downtown-Eastside (Vancouver, B.C.)—Biography. 3. Downtown-Eastside (Vancouver, B.C.)—Pictorial works. 4. Downtown-Eastside (Vancouver, B.C.)—Social conditions. I. Jerome, Gillian, 1974- II. Pivot Legal Society III. Title.

HN110.V3C73 2008          971.1'33          C2008-901767-6

*Dedicated to the people of the Downtown Eastside.*

# CONTENTS

# FOREWORD

How many times have you opened a newspaper, turned on the TV, or listened to the radio, and there it is again: more headlines, more human tragedy, more sensational grit and grime from Vancouver's Downtown Eastside. I do it all the time, and sometimes feel overwhelmed by how negatively the community can be portrayed. Sometimes I think there's empathy and realism in the stories. I appreciate that because it shows what is really happening in a community that I have known for three decades, once lived in, and now represent as a Member of Parliament.

Vancouver's Downtown Eastside gets more attention than pretty well any other neighbourhood in Canada. People are alternately shocked, saddened, disgusted, and awestruck at the various news stories about it, yet the media coverage doesn't even begin to portray what the meaning of the Downtown Eastside really is.

Thirty-five years ago it was called Skid Road and wasn't seen as a neighbourhood at all; not by the powers-that-be and often not even by the people who lived there. Residents were considered bums, down and out, alcoholics, and "clients" of one government agency or another.

It took a revolutionary effort in the early 1970s to transform Skid Road into a community called the Downtown Eastside. This happened because visionary people like Bruce Eriksen started organizing and fighting for people's rights to decent housing, community space, protection under the law, and simple human dignity. The fight began with the Downtown Eastside Residents Association (DERA) in 1973 and the community has struggled to survive ever

since, sometimes against overwhelming odds. People who live in this fragile yet highly resilient community have endured much and have given much. From their experience comes the truest sense of community that you will ever encounter.

Back in the '70s—when I was a young organizer with DERA—the area's population was mostly older. It included injured workers and old-timers who came to know the hotels and rooming houses as home. There was no homelessness then, as we see today. There was no visible drug use on the street. People were poor and the single-room hotels were terrible places (as many are today), run mostly by absentee landlords who earned the bulk of their revenue from the numerous beer parlours. But the depth of poverty was not like what we see today. We got Oppenheimer Park fixed up, we battled the city to save the old historic Carnegie Library (now a community centre), and we fought tooth and nail for the Standards of Maintenance bylaw to be enforced against slum landlords. In addition, new, higher quality social housing got built; finally, the neighbourhood seemed to be improving.

But in the 1990s, massive cutbacks in federal housing programs, the erosion of social programs, and welfare cuts took an enormous toll. Poverty deepened, and drug use and homelessness became visible and prevalent. (The impact it has had on individual lives is apparent in the stories told in this book.) On top of this, smart-assed developers realized that the Downtown Eastside was a gold mine, a would-be blank slate for extending the wealthy downtown business district; probably more than anything, this has been the enduring struggle and story of this community for more than three decades. Elsewhere in North America, most other low-income inner city neighbourhoods have been obliterated: demolished, gentrified, and sanitized, and some left empty

and uninhabitable. Not so here. The only reason is because the people of the Downtown Eastside fought back. They asserted their right to live, to exist, to have hope, and to have a future. Their story is one of resistance—one that deepens the value of what community and survival really means to the lives of its residents and the place as a whole.

There have been many attempts over the years to wipe out the Downtown Eastside. Even today, encroaching and rapid redevelopment threatens the very soul of this historic area. It is a never-ending battle. Any other community might have given up the struggle and accepted these powerful forces as inevitable. But not here, and maybe never.

There is the physical survival of the neighbourhood from the forces of development, block by block. But there's also the political survival to contend with too. I've witnessed various attempts over the years, under the guise of public policy, to break up the community in order to save it from itself. The view here is that poor people should not live together in a community because it creates a "ghetto," allowing anti-social and deviant behaviours to take over. In order to deal with crime and the visibility of poverty on the street, it is seen as necessary to disperse people, all done in the name of "revitalizing" the area and ridding it of these social ills. This view gains credence as the visibility of poverty increases. There's a general wringing of hands, and the pressure mounts to clean things up (read: people). I wonder in what other place today would we tolerate people being moved about like goods to be sold. Historically, such policies have been seen as oppressive and colonial. What established community—with history, deep roots, and social connections—would willingly submit to dismantling itself?

And so the struggle continues for a small community, not only to survive, but to thrive. The unique and powerful stories in *Hope in Shadows* are really about people trying to find a way to ensure that basic resources are available to them. They are stories of making the Downtown Eastside a healthy community for those who call it home. It's not high-minded stuff, really. It's as basic as understanding that years of lost purchasing power and economic despair have robbed people of their basic rights. It's as basic as understanding that a law enforcement regime against drug users, sex workers, and people struggling to survive only creates further harm and marginalization.

At Bruce Eriksen Place at Main and Hastings—a good example of sound social housing—there's a mural that Bruce repainted in 1996 shortly before he died. He originally created it as we were battling to save the Carnegie Library from demolition in 1976. It's a painting of old blind Bill panhandling outside the Woodward's department store (gone and now the site of a forty-storey condo development). Bill was a regular in the community, and included in the mural are the words of French writer Anatole France: "The law in its majestic equality forbids the rich as well as the poor to sleep under bridges, to beg in the streets, and to steal bread."

By no means does everyone in the Downtown Eastside have to beg, sleep under a bridge, or steal. Not everyone is a drug user or sex worker, despite what some media reports portray. It is a community of diversity, as the stories in this book show us. It is a community of people from many backgrounds and experiences who share the place as home in sometimes dire circumstances. It is a place of poems, plays, art, activism, solidarity, hope, and still, the resistance to be of its own mind and future.

THE LAW IN ITS
MAJESTIC EQUALITY
FORBIDS THE RICH
AS WELL AS THE POOR
TO SLEEP UNDER BRIDGES
TO BEG IN THE STREETS
AND TO STEAL BREAD

Mural by Bruce Eriksen, at Bruce Eriksen Place (380 Main Street).

When I first worked as a community organizer with DERA, I had no foresight that a group like VANDU (Vancouver Area Network of Drug Users) would be created and become a new voice for transformation. I never knew the Downtown Eastside would experience the ravages of an HIV epidemic, or that it would lead the way across the country to stop the madness of the war on drugs. But all of these things did happen, and are now part of our collective experience and expression. I always knew that the Downtown Eastside is a remarkable place. It is like the heartbeat of our city and what happens here happens to all of us.

—Libby Davies
Member of Parliament, Vancouver East

*Libby has been the Member of Parliament for Vancouver East since 1997.*

# PREFACE

In October of 2007, contributing photographer Rosalynn Humberstone led a friend of hers through the Pendulum Gallery in Vancouver to where her photo was displayed as part of the most recent *Hope in Shadows* photography exhibition. She was overcome with pride as she pointed to her photo and said, "Look, they put it in a frame."

The *Hope in Shadows* project, from which this book was born, is an important source of empowerment for the people of the Downtown Eastside. The project is comprised of an annual photography contest and the publication of a calendar which features the winning photographs, as well as a series of seemingly small but important gestures, such as the display of participant's photographs (like Rosalynn's) in some of Vancouver's most prestigious galleries with the same care and dignity that is afforded to professional photographers.

Pivot Legal Society started the project both as a potential fundraiser and as a response to the disparaging images that are commonly taken of the Downtown Eastside by the media and artists who often misrepresent the true picture of the community. In the first year, the project was simply called *Downtown Eastside Portraits*; it was not until the second year that the project was dubbed *Hope in Shadows*, after Timothy Kirk's optimistic photograph of Calvin Smoker in the shade of a tree, which took the top prize in 2004 and was published on the front cover of the 2005 calendar.

The idea for this book came a short time after we saw that calendar with Calvin on the cover in our local grocery store and later approached Pivot about

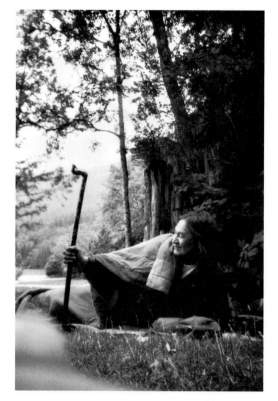

"Hope in Shadows," a photo of Calvin Smoker by Timothy Kirk.

tailoring a selection of the photos into a photo-essay for *Geist* magazine, where we both sit as contributing editors. After a few meetings, it was clear that the scope of collaboration could go much deeper than a single photo-essay and we began talking about presenting a selection of the photos in book form with accompanying texts.

We had a clear idea of the potential of the project through the fine examples of oral histories in Daphne Marlatt's *Steveston* (with Robert Minden) and in particular *Opening Doors: Vancouver's East End* (with Carole Itter), which is comprised of stories of long-time residents of the Downtown Eastside's Strathcona neighbourhood. We had the stunning archive of *Hope in Shadow* photographs that captured the Downtown Eastside from the perspective of the people who live there, so the idea of oral histories—stories told in the voices and perspectives of the residents of the Downtown Eastside—seemed like a natural evolution for the project.

The photos in the archive were of a high calibre, so any photographer (or subject of a photograph) who was in the top forty photographs from any given year was on our list as a possible interview subject. Some of the people were contacted by phone or email, while others were found through drop-in centres or by tacking up notes at any number of community boards in the neighbourhood. The majority of interviews took place at the Pivot office although some were done in the community, such as at the Carnegie Centre or the Potluck Café.

We researched oral history techniques, which allowed us to anticipate ethical complications in conducting the interviews as well as to meet certain archival standards, but as the project moved forward, we became more and more comfortable with dropping the "oral histories" moniker and instead thought of the texts simply as stories.

By finding the stories behind the photographs, we hoped to extend the spirit of the photography contest by giving participants a forum of self expression that was rooted in their own perspective. Where the contest offered participants the dignity of professional presentation in calendars and exhibitions, for the book we worked with them through the interview and editing process to prepare their stories for the printing press.

It became clear to us as we progressed that our job was not an academic one and certainly not a journalistic one. At its easiest, our job was to turn on the microphone and make the contributors feel comfortable enough to discuss personal matters that were important to them. At its hardest, our job was to engage with participants in an empathetic way while preserving our position as unbiased recorders of their stories.

All subjects were briefed on the process and purpose of the interviews before they took place. They were also given the opportunity to review their work before publication to make changes and decide whether it was in their best interest to publish under a partial name or pseudonym. In the end, we interviewed fifty-seven people, which we narrowed down to the thirty-three you now see in this book.

The stories in *Hope in Shadows* are not always easy to read, nor were they always easy for us to obtain. Above all, we tried to keep this project rooted in respect: the respect we showed the people we interviewed, and the respect they showed us in turn by opening up their lives to us and speaking with grace, honesty, and humour.

As writers, we strove to keep ourselves out of the project as much as possible; we wanted to lend our skill and not our voices. This project was about making connections with people. We are proud of these connections and we hope that we have been successful in transferring the resulting words to these pages so that these stories, these sparks of life and threads of wisdom, can open another door into this proud and important community.

—Brad Cran and Gillian Jerome
March 11, 2008

# A HISTORY OF PIVOT LEGAL SOCIETY

Pivot Legal Society is a non-profit legal advocacy organization located in Vancouver's Downtown Eastside (DTES), the poorest neighbourhood in Canada. Our goal is to take a strategic approach to social change, using the law to address the issues faced by our society's weakest members. We believe that everyone, regardless of income, benefits from a healthy and inclusive community where values such as opportunity, respect, and equality are strongly rooted in the law.

## Pivot's Early Days

Pivot's beginnings were humble. In 2000, I was an articling student working in the DTES when I met Ann Livingston, who worked with the Vancouver Area Network of Drug Users (VANDU). Both Ann and I saw the desperate need for an organization to address the legal human rights issues faced by the women and men living in the DTES, and we hit it off right away.

We began by hosting monthly meetings with lawyers and DTES residents to discuss the issues affecting people in the neighbourhood. The goal of these unconventional meetings, among the suits and the poorest of the poor, was to answer two questions: First, how could lawyers use the law to improve the lives of the DTES residents? Second, if lawyers could help, what issues should be addressed?

Everyone learned a lot. The lawyers heard directly from residents of the DTES about their struggles and their vision for social change. The residents of the DTES received helpful legal advice from the lawyers. In those early

meetings, we learned that there was an overwhelming need for a legal response to the pressing human rights issues there.

We decided a new organization, with a clear plan to use the law as a tool to improve the lives of DTES residents, was the best way forward. We gathered a team of volunteers and set out a plan for how the new organization could function. Everyone involved was very excited and incredibly supportive. After a year of monthly meetings, Pivot Legal Society was officially incorporated as a non-profit society in early 2001.

In February 2002, Pivot made its first appearance in the Supreme Court of British Columbia. A coalition of merchant groups and property owners initiated a lawsuit against the Health Contact Centre, a street-level health centre for residents of the DTES. VANDU called on Pivot to be their lawyers. Without VANDU's participation, this lawsuit would have gone ahead without any input from the people who are served by the Health Contact Centre.

Pivot asked the BC Supreme Court to hear from VANDU in addition to the merchant groups, property owners, and the government lawyers. The judge agreed that drug users were directly affected by the lawsuit because of their need for the services provided by the Health Contact Centre, and let VANDU join the case. In April 2002, the merchants and property owners announced that the lawsuit would be too costly to pursue and they gave up. It was a victory for the residents of the DTES, who desperately needed health services, as well as for Pivot, which had won its first case.

During this entire time, we were working with the DTES community to refine our list of issues and our plans for Pivot. When in our second year,

Vancity Savings Credit Union, a Vancouver financial institution, gave us our first significant contribution, we were ready to go with five core issues that we would address: policing, sex work, housing, addiction, and child protection. Pivot was really going to happen.

*Policing*

During Pivot's early meetings, policing had been identified as the most important issue for community members. They were concerned with how the police acted towards them, and about how they felt that the police made their lives less safe, not more. Policing remains an important issue today.

We realized quickly that many people simply didn't know what police were allowed to do and what they weren't allowed to do. Many community members wanted to know whether something a police officer did was just part of his or her job, or signified an abuse of power.

The Rights Card that we created to solve this problem has become our longest lasting and one of our most successful campaigns. Based on the rights and protections found in the Canadian Charter of Rights and Freedoms, the Rights Card (about the size of a business card) provides plain language information on what to do when you are stopped by the police. The card has been produced in English and French and in a special version for young people, and tens of thousands have been distributed throughout the DTES and across Canada in partnership with other organizations.

In addition to educating residents about their legal rights when stopped by police, we wanted to improve the quality of policing in the DTES. We also

wanted a more respectful relationship between the police and residents.

As a result of many personal stories we had heard from people about incidents where they believed police had acted illegally, we started our first "affidavit campaign" where we took sworn statements from people who wanted to report their experiences of police misconduct. We compiled over fifty sworn statements from people who swore, under oath, that they had experienced police misconduct ranging from illegal stops and searches to physical assaults. Many accounts involved serious allegations of criminal activity involving police.

In 2002, we released a report called *To Serve and Protect*, which was based on the evidence contained in the sworn statements. We also filed the statements with the Office of the Police Complaint Commissioner (OPCC) and filed complaints against individual officers for misconduct on behalf of our clients.

When *To Serve and Protect* was released, the Vancouver Police Department (VPD) was very upset, going so far as to use the media to depict Pivot as a radical group of trouble-makers and stating that the report was "preposterous." Because of these comments and his concern that a VPD investigation of the complaints would not be seen to be fair, the Police Complaint Commissioner asked the RCMP to investigate the complaints, not the VPD.

As a result of their investigation, and despite stiff resistance from some VPD officers who refused to co-operate, the RCMP were able to find that fourteen of the complaints were valid. In the end, however, no officers were ever disciplined. Pivot and its clients felt that the entire process had been a sham, and subsequently filed another complaint stating that the police chief, along with ninety police officers, had not co-operated with the RCMP. For a time,

it seemed as though there was a stalemate. But everything changed with a new police chief.

In November of 2007, Jim Chu, Vancouver's new police chief, issued an official apology to Pivot's complainants. The apology also set out all of the positive changes in police policy set in motion by Pivot's campaigning, which included changes in how police are trained, conduct personal searches, make "breach of the peace" arrests, and record seized property. The police also relocated their complaints office outside of the police station to make it more independent and accessible to the public.

Despite these positive results, Pivot's policing campaign will continue. Pivot strongly believes that police should not investigate themselves in cases where somebody dies or is injured as a result of police action, or while in jail. Pivot is also working to ensure that policing makes residents in the DTES feel safer and helps them to access the services they need. Pivot will continue to work towards the necessary changes in the law to make both of these goals a reality.

*Sex Work*

Our second campaign area was the safety issues faced by sex workers in the DTES. This campaign was initiated by Katrina Pacey, who has been involved with Pivot since she was a first year law student in 2001. Katrina saw the need for Pivot to pay particular attention to women's issues in the DTES. She started hosting meetings for women from the community to see what they identified as their most pressing human rights issues. Two issues were consistently raised: the criminalization and violence that surrounds sex work

and the issue of child apprehension. Those meetings directed Pivot towards its next campaign areas.

Pivot established a Sex Work Law Reform Committee, which is composed of lawyers, sex workers, activists, academics, and other women volunteers. In 2004, Pivot released its first report on sex work and law reform entitled *Voices for Dignity: A Call to End the Harms Caused by Canada's Sex Trade Laws.* The report is based on the evidence and opinions contained in sworn statements from ninety-four sex workers who said that the current criminal laws relating to adult prostitution must be changed. Their statements explain how the laws create dangerous working conditions where sex workers are very vulnerable and experience extreme violence and exploitation.

At that time, the federal Liberal government had set up the Parliamentary Subcommittee on Solicitation Laws, a special panel to assess the current criminal laws on adult prostitution. Hearings were held across the country and Pivot was called on to testify many times. However, despite hearing very strong evidence regarding the harms caused by the current prostitution laws, the Subcommittee did nothing more than state that the current laws are unacceptable and provided no direction for law reform.

Pivot produced a second report in 2006 entitled *Beyond Decriminalization: Sex Work, Human Rights and a New Framework for Law Reform.* Assuming that sex work was decriminalized, *Beyond Decriminalization* examined existing laws in a range of areas, from zoning to employment standards to tax law, and whether the sex industry needs special laws in any of those areas or if the existing laws will meet the needs and interests of sex workers and communities.

We no longer feel we can depend on government to create the legal and social changes necessary to protect the human rights of sex workers. So in 2007, Katrina Pacey became the lawyer for the DTES Sex Workers United Against Violence Society to challenge the laws relating to adult prostitution. In the winter of 2009, Pivot will appear in front of the BC Supreme Court to argue that the current laws violate sex workers' rights to security, liberty, equality, expression, and association as protected by the Charter of Rights and Freedoms. We will ask that the Court strike down those laws. If our case is successful, sex workers will finally be able to create safer conditions in their industry.

*Housing*

Our housing campaign, co-ordinated by David Eby, is based on the idea that every person has the right to safe and appropriate housing, with hot and cold running water, no bedbugs or cockroaches, flushing toilets, working showers, and protection from arbitrary evictions. Although in a city as rich as Vancouver this goal seems reasonable, Pivot's housing campaign has had its work cut out for it.

Our first housing work was centred on the Woodward's squat in the fall of 2002. Protestors, many of them homeless, had entered the abandoned Woodward's building on West Hastings Street to squat there in protest of the fact that the government had not converted the building into social housing as promised. We provided legal support to the squatters, contributing to the larger community effort. In the end, "Woodsquat" resulted in the Woodward's development, scheduled to open in 2009, which will include 100 new units of social housing.

Following legal support at the Woodsquat, we completed an affidavit campaign around housing and homelessness, compiling unbelievable stories of the conditions in which people live throughout the DTES. Even worse than the conditions in the residential hotels that line Hastings Street was the fear that many residents were losing this housing as these buildings were closed, condemned, or converted to student housing or other uses – often illegally. Over 160 people swore statements about their living conditions, including a large group of homeless people. Their statements formed the base of our report entitled *Cracks in the Foundation*, released in 2006.

*Cracks in the Foundation* made a significant impact on the media, with most news stories trumpeting the prediction that homelessness would triple before the 2010 Olympics arrived in Vancouver. Unfortunately, with eighteen months to go before the Games as of this writing, Pivot's prediction is right on target. On the positive side, Pivot's continued advocacy on the issue has—combined with the efforts of many other community members and groups—resulted in the provincial government purchasing sixteen residential hotels to turn into social housing. The Province of British Columbia has also announced that they will be funding 1,200 new social housing units before 2010.

Throughout 2006 and 2007, Pivot's efforts focused on reversing illegal eviction attempts that occurred throughout the DTES. While they were not successful in every case, Pivot lawyers helped to reverse evictions at seven different DTES buildings by invoking tenant protection laws. Their actions saved many people from homelessness.

In 2007, Pivot hosted the Special Rapporteur of the United Nations' Human Rights Council for adequate housing during his visit to Vancouver and co-ordinated his meetings with advocacy groups from across British Columbia. The Special Rapporteur's final report is due out shortly, but his initial report condemned the high rates of homelessness in Vancouver and Canada.

*Addiction*

Our fourth campaign deals with illegal drug use and addiction. Pivot has been a strong advocate for harm reduction. Harm reduction means, in part, understanding that addiction is a health problem, not a criminal problem. It looks at ways of helping drug users minimize the risk of overdose, AIDS, hepatitis, and many other dangers that drug users face, while providing them options for addiction treatment. Well-known examples of harm reduction in Vancouver include needle exchanges and the supervised injection site, both of which have been proven to save lives and reduce the spread of AIDS and hepatitis.

Unfortunately, these life-saving strategies are not popular with everybody, including initially with the police in Vancouver. Our first efforts in this area were to defend a needle exchange program that VANDU was operating at the corner of Main and Hastings Streets. The program consisted of a single table with some injection supplies, such as clean syringes, as well as needle disposal to make sure that used needles were thrown away safely.

Despite the important public health benefits of this program, the Vancouver police seized the table and equipment, claiming that drugs were being sold by the staff who were operating the needle exchange. We challenged these

false allegations, threatening legal action, and the VPD were forced to return VANDU's property.

In April 2003, harm reduction activists opened their own supervised injection site at 327 Carrall Street. The site was unlicensed and operated through the efforts of a number of volunteers, including a nurse. Pivot provided legal support to the site for the duration of its operation and, in recognition of this work, received an Award for Action on HIV/AIDS and Human Rights from the Canadian HIV/AIDS Legal Network and Human Rights Watch. But the story did not end there.

The success and public support for the unlicensed site created pressure on the Federal government to open North America's first legal supervised injection site. Insite opened its doors in September 2003 and continues to operate to this day. However, the current federal government is threatening not to extend the legal exemption which allows the site to operate legally.

Pivot, on behalf of VANDU, filed a lawsuit on August 30, 2006 to force the government to keep Insite open. In this lawsuit, we will argue many different technical points of law that all amount to the same thing—Insite saves lives, and it should be kept open.

In a community were addiction is so rampant and the population is suffering such significant harm as a result of criminalization, Pivot will continue to work towards the social and legal changes necessary to treat addiction as a public health issue.

*Child Protection*

Pivot's fifth and newest campaign focuses on reforming British Columbia's child welfare system. The campaign's goal is to ensure children aren't being removed from their birth parents in cases where social supports could be used to keep families together, such as when poverty, addiction, or mental health issues are present. This campaign is headed by Lobat Sadrehashemi and Darcie Bennett, who began work on the issue in the fall of 2006, and aims to improve the government's response to vulnerable parents and their children.

In February 2008, Pivot released a report entitled *Broken Promises: Parents Speak about BC's Child Protection System*, based on interviews with parents, grandparents, service providers, social workers, and lawyers involved in the child protection system. The majority of the parents who took part in the study were single mothers living in poverty who had spent time in government care themselves as children. These families were also overwhelmingly Aboriginal. Aboriginal children are nearly ten times more likely to be in care than non-Aboriginal children. While the Ministry for Children and Family Development (the provincial government ministry responsible for child welfare services) has taken some steps towards preserving the cultural heritage and kinship network of Aboriginal children, in 2006, the number of Aboriginal children in care surpassed the number of non-Aboriginal children in care for the first time. Less than sixteen percent of these children are placed with an Aboriginal caregiver.

One goal of the child welfare campaign has been to counter some of the myths about why families become involved with the child protection system. Physical and sexual abuse are not the primary reasons that children are removed from their parents. In fact, physical harm by a parent was only given

as a reason for removal in ten percent of child protection cases in the Lower Mainland, and sexual abuse or exploitation by a parent was given as a reason for removal in less than one percent of cases. Apprehensions are generally the result of a parent's struggle with poverty, addiction, mental health issues, or family violence.

Pivot's report noted how BC's child protection law is reasonably progressive, with a focus on supporting families to allow them to care for children in the home, improving services for Aboriginal families, using apprehension only as a last resort, and if so, returning children as quickly as possible. However, in practice, these ideals are not being realized. The government's lack of commitment to providing publicly funded mental health, addiction, and other social services has severely undermined the Ministry of Children and Family Development's ability to take a preventative approach to child protection issues.

The child protection system fails to address the system-wide issues that affect children's well being, such as poverty, the legacy of colonialism, and the lack of social supports for single mothers. When children who have been in care grow up and leave care, they frequently end up in poverty or in jail, or lose their own children to the foster care system. As Pivot's child welfare campaign moves forward, the focus will be on those system-wide issues that must be addressed if BC's government is to claim that it is genuinely acting in the best interests of children.

*The Spirit Behind the Campaigns: Fundraising and Hope in Shadows*
Pivot Legal Society has grown exponentially in the past few years. While grants from institutions fund much of its campaigns, the society relies on donations from members of the public and thousands of volunteer hours from hundreds of people annually. Co-ordinated by business and development manager Peter Wrinch, it is the spirit of Pivot's supporters, both financial and in volunteer hours, that is the backbone of the society.

One of our most visible campaigns is the Hope in Shadows project. In 2003, we were looking for a way to raise funds which would also illustrate the strengths of community in the DTES.

In September of that year, we came up with the idea of a contest, where we would hand out disposable cameras to residents so that they could document their own lives. We would publish a selection of the images in a calendar, which residents themselves could sell for a profit. By November, after giving away and retrieving over 100 single-use cameras and developing the film and printing the photographs, forty winning images were chosen. The idea was a huge community success, resulting in a calendar which was sold to help pay for the costs of the project.

Now entering its sixth year, the DTES Hope in Shadows photography contest, exhibition, and calendar has generated more than 20,000 images of the community and has become one of Canada's most well-known photography contests. In 2007 more than 190 local residents, many of them who are featured in this book, earned in excess of $60,000 selling the Hope in Shadows calendar on the streets of Vancouver. The personal confidence gained by sell-

ers who are in many cases poor or homeless, or both, is invaluable as Hope in Shadows helps them to help themselves.

*The Book You Are Reading*

The success of Hope in Shadows is rooted in compassion. There are three approaches to dealing with suffering: you can ignore it, you can crush it, or you can be compassionate towards it. In our society, there has never been enough compassion towards those among us who have been marginalized and cast aside. The stories and photographs in this book are a step towards engendering that compassion. They create a safe vantage point for people to care about and understand the Downtown Eastside.

People are often wary of approaching the DTES and its citizens, both physically and emotionally. The DTES is where our society's greatest fears—of poverty, abuse, crime—are anchored, no matter where one lives; these fears, however, are often the result of misunderstanding. By reading this book and hearing the poignant voices of residents, you are helping to break down those fears and dispel the misguided notions of what this community really is. The stories are not always easy to listen to, but they offer a place where we can all meet, on common ground.

—John Richardson, Executive Director

*Written with input from Katrina Pacey, David Eby, Darcie Bennett, Lobat Sadrehashemi, and Paul Ryan of Pivot Legal Society.*

"Chanel" by Hendrik Beune, 2004.

# HENDRIK "HENNY" BEUNE

born in 1951, Utrecht, Netherlands

This girl lived in the Astoria with me for a while after I'd taken the picture. Just friends. I didn't know her really and I was looking for photographs. It was daybreak so there's some natural light and there was little traffic. She was sitting on the corner doing her make-up and I asked if I could take her picture and she says, "Okay, but you gotta wait 'til I finish doing my makeup."

So I said, "Fine." I said, "Do you want a cigarette?" So I rolled her a smoke which is what she's got in her fingers right there. She finished doing her makeup and said, "Okay, you can take your shot now." So I took that one.

She usually hangs around on Kingsway. Her mom lives on Vancouver Island. She went back there to try and find a better lifestyle, but she didn't get along with her mom's boyfriend. She stayed with me for a while. She needed a place to stay. Things like that happen often in the Downtown Eastside.

She asked me, "Can I stay with you for a while, I need a place to stay," and I said, "Well, I can't," thinking that my girlfriend would get jealous. My girlfriend's name was Alexis. I really liked her and we were sorta living together and I didn't wanna screw that up. The girl in the picture is Trish. I would think of her more of a "street sister" than "girlfriend." I let her stay with me for a couple of weeks before I met Alexis. When I asked Alexis if she could stay again, she said she wouldn't get jealous, it was alright.

I'd met Alexis on the very same corner where I took this picture, just after Christmas, and right away we knew we clicked, and she happened to have Dutch ancestry as well, like me. She wanted to come and see me, but the guy she was living with at the time made sure my telephone number disappeared.

I'd gone out between Christmas and New Year's and my roommate stood me up the year before on New Year's, you know, like went out the minute before midnight and I thought, that's not gonna happen again, so I'd given up on her coming home and us having a celebration.

I went out for a walk and on that same corner Alexis comes driving by in a taxicab and jumps out of the car and she explains the story with this other guy that she was staying with, that she wanted to get away from him. She really wanted to be with me, she said, right away, and she went home, picked up a few things, and basically moved in.

Then the guy she was staying with found out where she was and he came knocking on the door the next day and said, "I want my girl back," and Alexis went, "I'm nobody's girl, I'm my own. Go away."

Alexis and I clicked right away. She was a significant person in my life. She died last Christmas. Not even twenty-three, four weeks shy of her twenty-third birthday.

We went through quite a few things when she was dying. She told me about a week and a half before that she was gonna die. She told her grandpa a month and a half before, and basically she thought, Why me? I'm so young, why am I in so much pain?

If there was legal heroin to deal with people's pain, you wouldn't get these infections. If people were treated a little bit better even though they're drug users, if they weren't moved around so much, if they actually had a home where they could stay for a while to recuperate, these things wouldn't happen.

She died because no doctor could be found to come give her the antibiotics that she needed. That's what she died of, not getting a renewal on her antibiotics. Apparently a doctor needs to be prescribing it, and there was no way that she wanted to go into an ambulance to go to the hospital and wait in emergency. I've taken her to the emergency in a wheelchair and she's been refused medication for pain because she was a druggie.

The main reason that I open up my doors to people on the street is so that they would have a place to sort of come home. They'd have a refuge and a chance to stabilize. I've taken care of a lot of people, people with stab wounds, people that wanted to get off the drugs. My place was a safe injection site before the safe injection site was open. We had to do that out of our own apartments.

There's a lot of places called SROs, right, single room occupancy, or single occupancy residences as they're called. I don't think they're very well managed in general. I had a place I had to vacate because they weren't doing the maintenance. The fridge had an electrical short in it so if you touched the sink and the fridge at the same time you'd get a shock. They wouldn't fix that. The fan in the bathroom had stopped working so it was getting moldy. They did nothing.

You know, people out there are freezing. I used to make the rounds when I

was staying in the shelter. I'd hand out leftover food and clothing. I'd look after a few people and if everybody does that, looks after a few people, then the world's much better.

The safe injection site could've been open as a health care facility right at the beginning, but it started up as a research facility. All the reports are out; now it's gotta be continued as a health care facility. Of course Prime Minister Harper's gotta play out his cards, you know, like they make all these promises at the beginning, being Conservatives, "I'm gonna do this, I'm gonna do that." So they get all the votes. He has to say, "I'm against it," but then there'll be an overwhelming majority that will pressure him into the extension that they need. People will be dying if they shut down the safe injection site.

If you read the reports, it's been shown to be everything that it was promised to be, and we should've known that a long time ago. As far as I'm concerned it is an established essential health care facility that should not be shut down. The person who does shut it down is actually negligent and will be causing people's deaths.

I'm going to the Netherlands next week. My parents live there and I do research there. This time I'll look at the housing situation. Holland's done quite well. They had a major problem with a housing shortage since World War II and they've always been open to refugees, yet they don't seem to have many people on the streets.

One of the resolutions is that they don't allow any building to be vacant for more than three months. It's gotta be used. I know when I was on the street in the winter, you couldn't sleep anywhere because it's too moist. By the point

that you start falling asleep you shake, you wake up, and after a while you just get to the point where falling asleep becomes synonymous with being in shock. At night when I'm on the street and I'd be walking past these buildings and there'd be like one person, a security guard in there, and the whole building would be heated.

I also met a person who does the street paper in the Netherlands. He was amazed that there were so many people on the streets, especially Indians as we call them, you know, Indigenous, and I explained to him that we destroyed their culture and that's what happens.

I've been in the Downtown Eastside for about five years now. Before that I was twelve years on a farm, living in a log cabin until my marriage broke up, and then I was still there for three years. I have a degree in biology and zoology from the University of British Columbia. I love living in nature, but when you start talking to yourself, you gotta answer yourself back.

You know, Alexis still comes to see me. I mean just yesterday for instance I was working on my computer, you know how the screen goes black, then if you haven't used it for a while you have to touch it to make it turn on again? Well I just walked by it and all of a sudden the screen goes on. She does these things with electronics. She used to turn my TV on for a couple of minutes, just to let me know that she's there. I really loved her. She loved me too. She said she'd stay with me until she died and, you know, she did.

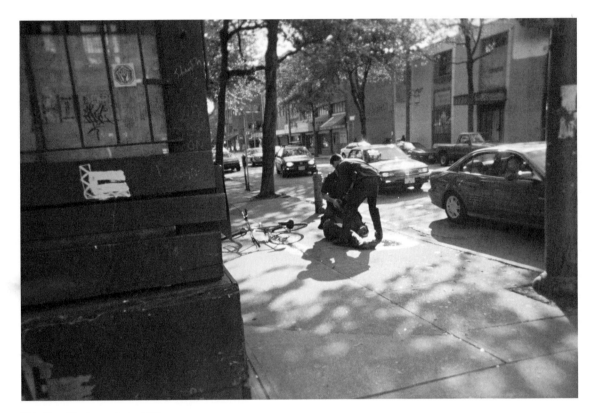

"Take Down" by Tommy Taylor, 2003.

# TOMMY TAYLOR

born 1958, Duncan, BC

I never actually met my mom. She left me and my sister at this lady's place that she used to work at. She cleaned her house. I was three and my sister was two. They were fascinated with the girl but didn't want the boy problems, so they put me in foster care. I floated around for about five years and then this family picked me up.

My dad was an alcoholic. I met my dad once at a fair in Duncan. He walked up to me and gave me a fifty-dollar bill when I was seven. He was a logger so he'd go up and make thousands of dollars and take a cab from the top of the Island all the way down, hit every bar on the way. My foster parents were Mormon, so the deal was he'd come see me if he was sober and he was never sober so he never came.

My foster parents took care of me. They picked me up because they'd only had a daughter and my foster dad liked to renovate houses and he needed a helper that didn't cost a lot of money. I was with them until I was fifteen and then I just got tired of the beatings.

It's all in the past. You can't hang onto that shit or you'll go crazy. I have a lot of people, brothers, you call 'em brothers, they're not really brothers but people that you regard as family, and they just keep going on about it, you know, the brutality and shit like that. You hear it every day with the church thing, but the church is settling up for them. It's not a lot of money, maybe ten grand or so, for the sexual abuse, but it'll help to bury it.

We had to go to church. I just played the role. Did what I was told. They were good people. I was just doing my thing to get it over with. See, I never really had much of a childhood because I'd go to school and then I had a paper route. So I'd do my paper route, I'd be done by five p.m., come home, have supper and we'd go to work 'til ten at night.

I was there right from five to fifteen. We built two trailer courts and we built about ten houses. I never got nothing for it.

I left them and lived in the bush. I had a tree fort built, stole wood and stuff. It was just in the hills in Duncan. I'd survive from the farms. I would live on potatoes and all the fresh milk you could drink. It was my freedom. Then the police came and got me and they took me back. I was forced by the Courts to go back.

See, it gets really technical. I'm half-breed, right, Salish and Scottish, but I look really white and I went to a 99.9 percent Indian school, so you just end up fighting all the Indians. My foster dad said, "You got two choices, you can keep fighting the school, or you can go to work." So I just said, "I'll go to work." I only went to grade five.

I was back with them, but it was different because I'd bought my own motor-cycle. I owned it. It was mine and I kinda tried to separate myself from those people.

The house was a mansion. We built it from the ground. We built it from a post office, just a little bigger than this room. They turned it into an antique shop when they sold it.

Go through Duncan about a mile, you drop down, there's a golf course, you drop down, there's a bridge, and then there's kind of like an Indian carving place with big wooden tree shacks. And then there's a big trailer court. We built it, me and my foster dad. The house is just out in front of it.

My foster mother was good to me, but she wouldn't stand up to him. A couple of years ago I went back there and saw her, after I'd found out that he'd passed away.

And then I lost my arm. Motorcycle accident. Guy fell asleep at the wheel in Lake Cowichan.

I went to Victoria. The only time I ever lived with my sister was in Victoria. I went to Garth Homer where they rehabilitate people to get them into a job situation. ICBC used it to rehabilitate people that had lost limbs and stuff like that, but it was mostly for underdeveloped people.

I met this guy Roy. He's in a wheelchair, and he moved up to Edmonton. I got $40,000 from my settlement, so I basically went up there to Edmonton to hang out with him. There was this girl across the street that lived there and it was tragic because he was in love with her and I came onto the scene and she was like, "Hey, come on over to my place," and I ended up moving in with her and bought a trailer with my forty grand. We were hanging out and then we separated. I was working at selling underground condominiums, you know, graves for Memorial Gardens.

Then the tornado came through our trailer court, that was in 1986, and two rows over there was like a strip taken out of the whole thing, so I just said to

hell with this shit. They don't get tornadoes in BC. So I came back to Vancouver and did some telephone work and started sellin' grass. Grass, hash, mushrooms, and oil.

I won't sell dope on the street. I'll get a house and sell it there. They suspected the guy in this photo of selling drugs so they took him down. They grabbed him right here and I was walking along and they wrestled him down to the ground. I'd just gotten this camera so I went beep. And then I walked over and told them they shouldn't be so rough on him and they were givin' me grief.

That's their technique, right. If you're not afraid of the police, why would you bother with them. Like if they were to be nice to you all the time you wouldn't be afraid of them. It's not worth me complaining.

There's no injecting in my life. Pot, you could be stoned forever on pot, and it's so cheap. People come to my house with no money and I give 'em dope. You would never go to a crack dealer and say, "Oh jeez, I have no money, but I'd like to get high." He's gonna give you nothing.

One of my escapes from the foster people was the hippies. I'd go and hang out with the hippies and stay with them for a couple days and smoke dope and listen to music. It was so nice and mellow, no rules, no beatings, no shit. And eventually I just fell right in and I've been like that ever since.

I'm diabetic. I'm gonna lose my legs. What happens is that sugar without the proper procedure in your body stays in your blood and it slows your blood

pressure down really bad, like you should be dead, so the things the farthest away die. All your skin, it just dies. So basically my legs are numb past my knees so there's nothing you can do about it. It's a done deal. I'm gonna be in a wheelchair. I've already lost a few toes. God's taking me one piece at a time.

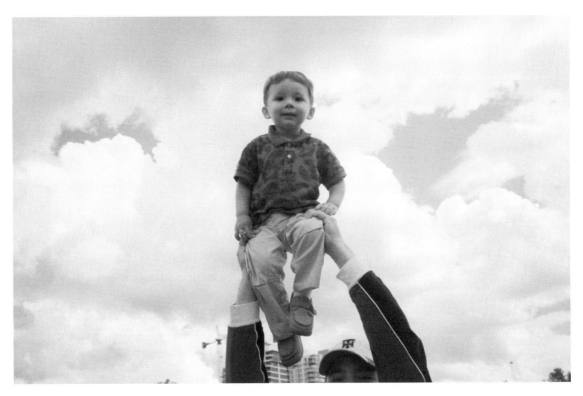

"Next Generation" by Dolores Dallas, 2007.

# DOLORES DALLAS

born 1950, Vancouver, BC

Here I am living in the Downtown Eastside on Cordova Street with my dog Sir Butter of the Hood who got left behind one Christmas when his family went to Ottawa. The little girl who owned him before me called him Butterscotch, and I said to him, "Well that makes you even gayer than you look."

He's got a lot of aristocratic moves. His little nose sticks up in the air. I said, "You sure are an aristocratic little mite, aren't you?" And I dubbed him that night with my kitchen knife. I said, "You moved down here and I moved down here so I dub you Sir Butter of the Hood." And that's his name now and people in the street actually ask me, "Where's Butter? Where's Sir Butter?"

I never thought I would ever live down here because I've had such a journey trying to keep away from here. I was living in Kitsilano and my son said, "Mom, you keep hanging onto Kitsilano, but there's nothing there for you. You've got to leave it behind." I finally listened to him and got this housing in the Downtown Eastside when my daughter Ember was dying in hospital. I wanted to help her.

I'm Cowichan from Duncan, BC, but my father was Italian. One of my first memories is the car ride that took me to one of my first foster homes. That was traumatic.

There was serious abuse in that home. I was there for five years, but I was too young to remember. The abuse was documented in my Children's Aid forms

where it says that a lady beat me with a brush and bit me. They knew because I asked my next family, "Are you gonna do that to me?" All I have left of that experience are weird body memories.

For ten years I was raised in Langley by a German family. They were rich and had ten foster kids plus a bunch of grandchildren. I never felt that that place was my family. I wasn't stupid. I could see them loving their grandchildren and the other foster kids.

My home was huge. It had five bedrooms up on the top floor, a main master bedroom, big living room, big dining room, huge kitchen, and a wine cellar. I think that's what got me kicked out: I broke into the wine cellar and got drunk and got everybody in the house drunk. We all ended up puking our guts out.

After the old couple died, their son took over the house. He was a religious fanatic. By that point there was no getting to know me. I felt alien there all the time.

If there's one good memory of foster care, it's this lady in Burnaby. She had a whole bunch of foster kids, about nine of them. A lot of them were First Nations and a lot of them were handicapped. She showed genuine affection to those kids and that just blew me away. That's when I knew how badly I'd been treated. But I still didn't trust her even though she showed me a lot of affection. I couldn't trust anyone. So I kept taking off.

Once when I was a little older I met a Native girl. At the time I didn't even know what it meant to be Native. Mostly I was raised by Germans. This

girl said, "Do you wanna come with me to my house?" So I said, "Where do you live?" She said, "The Northwest Territories." I said, "Where's that?" She said, "Well it'd take us about a week to hitchhike." I said, "Okay." So we went around to all our boyfriends and asked for money because we were taking a journey. We stuck out our thumbs and hitchhiked up to the Northwest Territories.

It wasn't fun to find myself pregnant, but it was the most liberating year of my life. I slept under the Northern Lights on the Mackenzie River, adopted a dog named Silver, and somebody gave me a sleeping bag. After I gave up on the guys up there, I just started sleeping along the river, going to sleep looking at the Northern Lights and then hiking into town to find something to eat.

I got a babysitting job at a doctor's house. They tried to talk me into going to residential school. They still had them up there. By the time the fall came I didn't know what I was going to do. I didn't have any family and it was going to be cold. I had this one good friend, Maggie Norwegian. She got adopted by this old couple and they were getting ready to go out in the bush about three hundred miles in. They hunt and trap and they wanted to take me along, but at the last minute I chickened out. Reality is one thing, but I'm not the sinew-chewing type.

They didn't like my uppity ways that I learned being raised in the German house. At the foster home I was taught to set out two knives, three spoons, two forks, napkin, wine glass, water glass, and coffee cup. At the Indian house they were eating out of a can of beans. The culture clash was so extreme for me. I couldn't believe people were eating out of cans.

So nobody knew when I was there that I was pregnant. I just told myself I had cancer and I could feel this lump in my stomach. But the mother of the girl that I hitchhiked up there with knew that I was pregnant. She caught me throwing up in the baseball field early in the morning and she said, "You're pregnant, aren't you?" and I said, "No." I was eighteen. I told them that I wanted to pay my own way back to Vancouver.

Sometimes I think about how my life might be different if I was raised by my parents. When I was twenty-one I went looking for my family. A social worker gave me a list of names and said, "This is all that we know of your family."

My mom went to Kuper Island Residential School. Two of my aunts went as well. I never got to know my mom because she died in jail when I was ten. That was about the age I started wondering, where's my mom? I'd see other kids going back home to their families. I asked about her, but I was told that she was dead.

My mother went to residential school. It's a cycle of loss that has been created by taking my mother away from her mother, by taking me away from my mother, and by taking my firstborn away from me. I was coerced into putting my first born up for adoption. I didn't want to, but back then I was powerless. There is a settlement being negotiated right now, but we are excluded because we were taken from our families and put in foster homes instead of the residential schools. In some ways being put in foster homes was worse than residential schools because you were alone. Taking kids away from their mothers is a cycle of genocide that is still going on and being perpetuated.

"Mae Cordasso" by Dolores Dallas, 2007.

My mom and dad got married, and then she lost her status for marrying a non-Indian. He was Italian. They lived in Vancouver and they both had alcohol problems. One of the frequent comments by the social worker was that they didn't have a permanent address. I read all of my files and that's the grounds on which they got to take us away. I had a brother who died shortly after birth, and I had three other sisters.

They were all taken away from my parents and put into foster care. Two of them were in Woodlands, a school for kids with special needs. My eldest sister had Down Syndrome. My other sister was epileptic and abused by her foster family, so they put her in a lockup ward at Woodlands too. That's how I met my sisters.

Going to Woodlands was scary because you could hear the doors lock after you when you went in. My eldest sister had a big head and this short body. She might've been about three feet tall and she was happy. She was running around like a little child and that was weird because she's a year older than me. So I'm looking at this little person running around saying, "Hi."

I asked the nurse at Woodlands if my sister who's epileptic could leave, and she said yes, she could, if an immediate family member signed her out. I'd

never met her before, but I said, "I'm her sister, can I sign her out?" That's all it took. Who knows how many years she was in there suffering.

Every First Nation person experiences it a little bit differently: my stories come from me and my truth, and in that there's a lot of pain. I moved to the Downtown Eastside when my daughter Ember was dying in the hospital.

We didn't know Ember was doing these hard drugs and nobody came forward to tell us. She started doing heroin and it stunned the hell out of me to know that she could hide it in a cigarette box. Everything she needed was in that cigarette box and she was packing it around in front of everybody. Nobody knew that she was an addict because she seemed so perfect.

She grew up in Kitsilano. Once we were in Kits at our local park and a man called the police on my daughter saying that he saw her shooting up in the washrooms. I'm sitting there having a visit with my daughter and I didn't even know the police had been called.

The police show up and they seem to know my daughter and they say that somebody's called them and they start handcuffing her. They said that she wasn't under arrest, but they had to take her somewhere else, so they asked her where she wanted to be relocated.

"Smudge Ceremony" by Joanne Moen, 2004. This is a photo of Wheels and Lawrence Desjardais. Smudging is an important First Nations' tradition used to purify the body, mind, and soul. Most often used during celebrations or in difficult times, it builds strength and unity and is used to show respect.

I said, "If you're going to take her somewhere, why don't you take her to the hospital?" They said, "There's nothing wrong with her," and I said, "There's something wrong with her, she's sick."

Ember said that she wanted to go to the park on Commercial Drive. They took her there to East Vancouver and eventually she made it to the Downtown Eastside because of the way the system channels the addicts. There are few resources anywhere else in the city.

Ember ended up in St. Paul's Hospital on September 19, two days after her twenty-ninth birthday. That's when I moved to the Downtown Eastside.

There's so much drug activity going on in that hospital. The girl in the bed next to her was a crack dealer and she took my daughter up to the roof and then my daughter ran from the hospital. She had double pneumonia.

I put missing posters up for her. I could've called the police, but I knew there was a chance she wasn't going to make it because she was so sick, and I didn't want to call the police to have her incarcerated. I was scared of her dying in jail, particularly since my own mother died in jail.

In February Ember ended up back in Vancouver General Hospital and on life support. Smudging is a ritual where you wash yourself with herbs—I used sage and sweet grass. I smudged three times when the doctors called to tell me that Ember was in the hospital because I knew this wasn't going to be a happy ending. I smudged once and that wasn't enough, so then I took off all my clothes and smudged naked before I went to see my daughter.

I had medicine stones with me. I met this lady from Eugene, Oregon who did healing circles with women. Her name was Eagle Stone Woman. One day she said she was going to do a ceremony to help me find a heart stone.

She sang and chanted over at Jericho Beach. She told me to walk around and look until I saw a stone that made me come to it. So we did that for quite a while and then this one stone just made me laugh. I looked at it and I started to laugh and then I picked it up and I knew that was the stone I was supposed to have.

I thought, I can't see why the Creator wouldn't let me share my stones, so I took them to my daughter in the hospital. She wound up with a staph infection called MRSA. It runs rampant in the hospitals and addicts are more susceptible because they have weakened immune systems.

The doctors gave us hope at first, but then she got the MRSA in the lungs. They couldn't take her off the life support to cut out the bacteria that was attacking her.

In the hospital, Ember was like the little girl she was before she used drugs. She didn't have anger in her face. She was beautiful—too skinny and worn out from drugs—but she didn't lose her spirit. That was the magic of this time. We got to see Ember again and not the addict. She had peace because the family that she wanted came to see her. There was a resolution and a reward of love and light for all of us.

We prayed for strength. We prayed for love and for forgiveness for everything we've done. We prayed for trust. In the end it's the Creator's way.

Everything's the Creator's way. I have to give up that idea of owning Ember as my daughter. She's a free spirit that came through me into the world to live her life.

I gave life to her and then I had to let go. Sometimes I feel like I'm crazy because I'm talking to my daughter, but I know that she's around. I brought home my medicine stones and dropped them in water and put them on the balcony. The next morning it was like the wind blowing through this part of my hair and her voice said, "It's better on the other side, Mom."

I entered the photography contest for Ember. I knew that there was going to be a whole bunch of people wanting to get a camera, so I stood in line from 8:30 in the morning and I was fifth in line. I told Ember, "I'm doing this for you."

My son came along and we were taking all these messy shots of graffiti, and then my son said, "Let's go to the park, maybe they want something different," and so it was his idea to lift his boy up to the sky and then magic happened (see page 44). You can see a happy face in the clouds behind my grandson.

My grandson Keona is the greatest thing in my life now. He's a gift from the gods. That's what his name means. My son swore he never wanted to have children and Keona's mother was told by doctors that she wouldn't have children. Keona's part of the connection to coming back to the First Nations community since he's a legal status Indian with my last name.

I'm a Bill C31—the bill that took away aboriginal women's rights when they married a non-Aboriginal—so I can't pass my status on, but my grandson has status through his mom's nation.

In September we held a ceremony for Ember and spread her ashes in the ocean because of a dream her brother Danaan had. He dreamed that three killer whales had beached and one of them had bumped her head and so the other two couldn't leave. This picture just seems to suggest that she's there in the spirit world.

Ember's spirit isn't dead and people have to know who she was. That she was alive. She touched a number of people. There are many people left for her to touch and if it's through me, then that's good because she passed through me. I've always told her that she saved my life.

When I see kids on the street, the lost kids on the street, they look like her. I look at them and then some of them give me negative energy. I just say, "Can I hug you?" and I hug them, because I know they need that and I need it too.

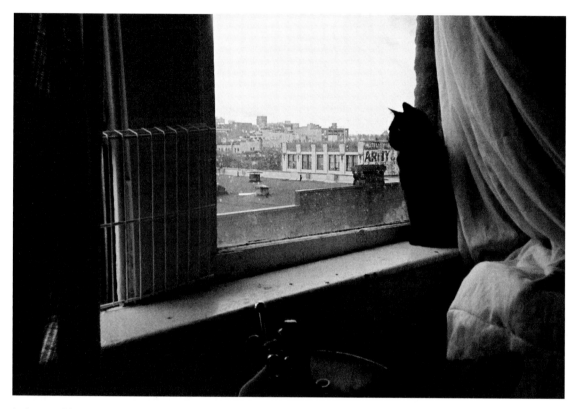

"Baby Peanut" by Edie Wild, 2007.

# EDIE WILD

born 1955

If you have a fly in your room, we don't take that as a sign of filthiness, but bed bugs? I liken them to lice or crabs. They're something that disgust me and are near impossible to get rid of. The place where I live won't do the professional spray, but they'll give you a couple cans of Raid. I went and pulled everything outside of my drawers, closet, piled it all up in the middle of my room. It's taken me two months to treat my whole room, constantly getting rid of those little bastards.

I was over at a friend's and we were watching a movie on his bed and out walks a bug and I said, that looks like a bedbug and he says, "Oh yeah, I know." When I went home I reached in and grabbed my housecoat, went to the bathroom, pulled all my clothes off, put them into a bag, and sealed it up. I would not take the chance of infesting it again.

It's not just down here; apparently some big hotels had them too. They live in seams so they'll usually infest your bed first. They'll go into dirty clothes. They'll go anywhere. If you see people down here with bites, then usually it's bedbugs. They're something I've never been around before. I've only been in the Downtown Eastside since March.

For most of my life I was working and living in nice apartments. Then I got cervical cancer and the whole rest of my world fell out. I was on unemployment insurance when they detected the cancer. I went into the hospital for surgery and unemployment insurance ran out. Then I went onto welfare

because I couldn't work. They classed me with people with multiple barriers which is really just a small step up from regular welfare benefits. I live on a little less than $300 a month after my rent is paid.

But I have what I need. I'm comfortable. I eat. I have a roof over my head, but I'm not used to living downtown. I don't like living in the drug scene. There's a stigma attached to living downtown because people assume you have a drug habit. There's a whole lot of people I haven't told that I live down here. It's just that some mornings I wake up and I say, how the hell did I end up getting down here?

First off, I didn't really plan for my retirement. I've always lived by myself. So I don't know if I'd want to get shared accommodation, plus I have two cats and I'm not giving them up. I've had the one cat for thirteen years.

I have cockroaches and the bedbugs. I have a sink in my room that they will not repair. My personal grooming is usually a private affair, but now I have to use a shared bathroom—anybody can walk in. It's a way of life that I'm not used to.

I've always been independent. I've always worked and I've always provided for myself. My trade is industrial plastics welding. We used to make the chemical processing boxes for MacMillan Bloedel and all the heavy-duty plastics that you see around. It's exactly like metal welding only it's forced-hot air instead of gases or heat. Good money in that.

I've been in the trades for thirty years. I actually liken myself to being ahead of my time because thirty years ago getting into the trades wasn't easy for women.

I got started at home with my dad. We'd tinker around the house and I'd follow him and watch him and then start giving him a hand with stuff and the next thing I know I'm helping him build a room down in the basement. I found that I loved the work. Throw a drill or a saw in my hand and give me the schematics and I can build anything. There's a knack to it. Not everybody wants to be a doctor or a nurse.

It's not about the conquest of going in and proving that I'm a woman and I'm gonna show you guys us women can do it too. It's the interest in the work. I never said, "I am woman, hear me roar." That's crap.

I'm not a woman here proving I can do a man's job. I've got the natural talent and instinct of most men. It's like men who are going into nursing—they're not considered fruity or gay anymore, but at that time the mentality was that men should do men's work and women should be at home. So it took longer to get respect, and for them to figure out that I wasn't there to get laid or look for a husband. I have steel-toed boots and a hard hat and work clothes. There's nothing tight-fitting or wiggling when I go to work.

You can do a man's job but still be womanly. Once I got myself established, then I could allow the woman to come out. Then I could flirt. Like they'd say, "Well, I'll show you a thing or two," and I'd say, "If I have to show you a thing or two I'll turn you into a man." So I guess I am the proverbial tomboy, but I can still be a woman.

I mean, I would go out on Friday night at the end of the work week for a beer with the guys and I'd buy the rounds just like they do. I don't sit there and think that because I'm the woman I don't have to pay for anything. You gotta

go the whole distance on this. I still won't go for drinks with a man unless I've got money in my pocket; I'll say I can't afford to go out. I'm still uncomfortable with somebody footing the bill. One of the downfalls of my beliefs is that I've had very few relationships and my independence is part of the reason.

Truth is, I don't really need a man for anything. The garbage is not his job. If you don't want to take the garbage out just say so—I'll take it out. If you don't want to build the shelves say so—I'll build them. I've got my own tools ready to go.

But what I find is that men fall in love with me for who I am, but then end up hating me for it later. If I'm working with men and I want to go for a beer on Friday after work I will go, but I will call my guy and say I'm going to be a little late getting home, I'm just going to stop in for a beer. If that man isn't secure in himself he's going to start thinking, oh she must be out screwing around or something. A lot of men can't get a handle on that.

I'm not in a relationship now. You see I had the surgery for cervical cancer, which is like a man losing his testicles. For the last couple of years I've felt unwomanly, but I'm starting to come around. It's been hard losing all my plumbing, plus it put me into menopause. Then I ended up downtown. It hasn't been a very good journey for the most part.

Like before I went for surgery, I phoned friends that I'd known for a while to tell them I was going in. A friend of mine was at my place and heard me making one of these calls and he says, "You know what, it almost sounds like you're telling these people goodbye," and I said, "Well, I am, because the surgery could go either way."

I got depressed because of the surgery and then having almost zero income. I'm not used to not having money. Now I've adjusted. At first I wondered where all my friends were. But then I realized I'd walk in somewhere and somebody would say, "Edie, you got a cigarette, money? Buy me a beer." All through the years, I am the one who has consistently worked. I got that from my dad.

Just not being able to work was itself enough to spiral me down into depression because that's what makes me who I am. I work at the bottle depot downtown. It's not the money I'm used to making, but I'm still going out there and working, and that feels good.

I also have Hep C so I get tired easily, and now with menopause I'm not kicking out the hormones. I don't have the apparatus to do that anymore. They're also still keeping an eye on the cancer because it may make a comeback.

One of the shifts at the bottle depot is four hours long, and after I am so tired I go home and sleep. But I still give her hell when I'm there. I need to work and I'm allowed to make five hundred extra dollars on my disability.

On cheque day I go out and buy all my cat food for the month. I buy my tobacco. I buy all my groceries. I buy everything I need to get me through the month, and I can make a meal out of a bone, so I can stretch my dollar.

Between you, me, and that bedbug, I'm gonna apply for disability; I think it's $1,100 a month. Then I'll be able to afford an apartment, nothing big, then still have five hundred dollars on top. I mean, you have to dot your i's and

cross your t's and brush your teeth as you are filling in these forms, but there is someone where I live that can help me get it done.

I make everything from scratch so that makes it cheaper. I can buy the basics and have a banquet. You have to learn to adjust. Maybe I'd be swinging from the rafters if I didn't know how to stretch a dollar, but I've always been good with money. I'm happy but I'm poor.

This photograph that I took of my cat Peanut—I mean, look at the state of my windowsill. They won't fix a thing. I've got bedbugs, cockroaches, and holes in the wall. These people can't even give me paint or fix my sink.

But look at the sheer I put up for a curtain. It's about twelve feet and it's beautiful. It's one of the few things that I kept, so I hung it up and it was pure elegance, and I've got this beautiful molding that goes around the room. They won't give me paint, so fuck 'em. I'll pick up paint myself. It's for me and the answer is simple: I can live in depression or I can change it.

"Potter's" by Gary, 2006.

# GARY

born 1948, Kihei, Hawaii

This is a picture of Potter's Place where they hand out free food. I never eat there. I have my own money. I took this photo because it looked like they open the door to people, but when people get there a minute late they won't even let them into the building. I never eat in the free places, but to me closing the door was wrong, so when I seen them with the door open I just snapped the picture.

Potter's seemed to be a place that people could reach out to, but they need to go further than just giving somebody a free meal and then saying goodbye. They need to actually work with these people, and if they were proper Christians they would do that instead of just saying goodbye to them after the altar service. They should be helping them in other ways, like with housing and not just giving them free food, because it lets them spend their money on drugs.

There has to be housing. I mean people have to have a place to live. You can't expect them to change their life and go out and get a job if they have no place to live. If they're sleeping in an alley or in a shelter and they can't shower or change their clothes, then nobody's going to hire them.

I always have money. I don't spend my money on drugs or booze. I don't drink. I have maybe two or three beer a year at Christmas time when I go for Christmas dinner with my friend so that my money can do other things.

I was in Florida a couple years ago. I've been around the world. I spent most of my life in the military. I was born in Kihei, Maui. My dad was in the US air force, and I didn't get along with him. Him and me didn't see eye-to-eye.

I joined the military when I was seventeen. I went to basic training at Camp Pendleton and then later went for specialized training. I was in the US Navy Seals. They're one of the elite forces along with the Marines.

When you join the military there's three things they promise you: one is you get an education; two, you have a steady job for as long as you want; and three, you get to see the world.

Germany was the first place I'd been. I went all over the world. The next place I was stationed was in Cypress. I was in the Philippines for a while and of course Vietnam and all through Cambodia and Laos. I was a POW from Hamburger Hill.

One tour is basically a year-and-a-half stint. I was there for two years, ten months, twenty-seven days. I was just seventeen when I went over. I was eighteen when I was captured.

People that I knew didn't come back from there. My best friend of all time that I grew up with didn't come back. I killed the sniper that killed him. He was a Native Hawaiian. He was in my classes right from grade school on up. His name was Taylor.

The first tour has bad memories for me. That's where I got this bayonet wound that went across my stomach, in the wrist, took two on that wrist. I got at least ten or twelve bullets in me. I got a fucked up leg because of it.

Every day whether I like it or not, I live Vietnam and Hamburger Hill. I live it over and over every day of my life. Especially at Carnegie because they all know I'm a Vietnam War vet and some of the staff always ask me about it and I have to go back and relive it. I have to go back and see my friends killed.

I don't know how you tell somebody that you watched your best friend die. How do you tell somebody that they sent you into a slaughterhouse? How do you chit-chat about that?

I can't say Vietnam was a positive experience because it shouldn't have happened—America shouldn't have even been there—but the most positive thing in my whole life has been helping little children in countries that are war-torn. You actually see the smiles on their faces and you know that what you're doing for them is making a difference—just being there, regardless of whether you want to be there because you could be killed any time.

There's some fun things too like when you're talking to the children and you give them something they rarely ever get, like a hug, just a little hug—just an "I love you." It goes so far, or maybe you have a candy bar for them or some kind of a toy. When you think about how we live and the way they live, they can be so overjoyed over a little stuffed animal. To me, that is the best part of soldiering.

I came out and I returned from the military. I got into things, but I was so fucked up I couldn't hold an eight-hour job. I couldn't work for a whole day because that's how fucked up I was. I had mental issues that had to get dealt with. I dealt with things as best I could and I got little jobs driving trucks.

The first time I came to Canada was in the 1970s. My mom and dad had property on Cortes Island and I came up here and I liked the fishing so I kept coming back. I came out of the force in '86; that's when I started coming up here again. I finally moved here around '90.

In March of 2006, I had open-heart surgery. I had five bypasses done. My life is luck, I guess. People that have had bypasses done before me died on the operating table. I happened to survive.

I go to hockey games, football games, lacrosse games. I go to a lot of concerts. I went to see The Police three times last week. That's my favourite band of all time. Sting is just an awesome musician.

I still scuba dive. I was scuba diving two months ago at Horseshoe Bay.

The heart specialist doesn't like me doing it. He says that you can get water on the lungs. I disagree with him because I haven't got any water on my lungs. He's got water in the head if he thinks I'm going to stop it.

Some people say, "Oh, you can't walk as far as you used to." Well, hell, I can walk quite a distance if I want. I don't puff and pant and that. I just walk normally.

I have a yearly bus pass too, but a lot of people don't have them. Transit is one thing that should be changed here in the Downtown Eastside. The bus drivers aren't letting people from the Downtown Eastside on the buses late at night. Sometimes they turn women down out there. For the last three nights, I've seen women turned down by the bus drivers and so they have to walk or else wait for another bus standing there by themselves. That means they're putting their lives in danger, at the mercy of another Willie Pickton. Pickton murdered my best friend Heather Chinnock. I was the one who reported her missing.

I met Heather back in '89 through a guy named Jim. I don't see him no more, but I met her through him and then she came to live at my place. A couple years later we were engaged for a little while.

Our engagement wasn't a positive experience because I didn't go through with it in the end. She demanded too much money for drugs and booze. But having said that, of course I don't think she deserved the fate she met at that pig farm. I don't think any of them deserved their fate out there. I don't think any human being deserves that fate.

Heather's murder was a turning point in my life, and I thought that I'd met my end. I thought that this was going to kill me, but about six years ago two positive people came into my life, Peggy and Sarah. They were just there for me all the time. Peggy works at the Carnegie Centre and Sarah helps out at the Women's Centre. Peggy was there for me when I actually got the news on October 4, that there could be no mistaking anymore, Heather was confirmed dead.

Peggy was running the music program. I was there and she got the call that I had to phone a reporter. I actually thought it was good news. I went to Carnegie and there was umpteen dozen messages on the wall for me, and they said, God you're a popular person—you've got all kinds of messages on the wall, reporters have been phoning you. I thought they must have found Heather alive.

When I phoned, they told me that they had found enough DNA evidence to pronounce her dead. I had the phone in my hand and it fell to the floor. It went straight down to the floor because once again another positive person in my life was lost. Even though she was a drug addict it brought back flashbacks of Vietnam, seeing people die in front of me.

I didn't see her die, but just the knowing that I'd never see her again—had Peggy not been there that day I probably would've died. Peggy was there for me that day and for at least two weeks after when I had this Japanese reporter following me around and wanting to do a story. Every day it was another flashback of Vietnam, of Hamburger Hill, of almost being killed there. Heather's death triggered flashbacks like you wouldn't believe.

Heather was just a person I really liked. Sometimes she was a real pain in the ass because all she wanted was money for drugs and booze. But sometimes she was a good pain in the ass. She got a raw deal out there. She was a lovely person. She liked to take off in my car, even though she didn't have a driver's licence. That didn't bother her. 'Cause if she got pulled over she could just charm the cops. She could turn on the charm when she wanted to. It's just that the addictions eventually outdid her charm.

Close to Christmas one year, I took her to Middlegate Mall, a Burnaby shopping centre. She wanted a Christmas present, so I was gonna buy her a Christmas present, and I said, I'm not going to the liquor store, though—you're not getting booze, but you can have an early Christmas present, so she picked out a little white kitten.

She had it for two days and the next day when I walked in there Heather was sobbing. She brought it to me in her arms. It had died. It ate some poison that had been put out for pests. She was so upset that it broke her heart. I had to go out and buy her another cat, so we went back to that store and they didn't have a white one, so I bought her a black one. Even so, I still always used to hear about the white cat—she always talked about that poor white kitten.

"Hug" by Bronwyn Elko, 2003. David Cunningham and Naomh Corvus. A co-founder of Vancouver's Anti-Poverty Committee, David has lived in the Downtown Eastside since 2000. Naomh has lived in Vancouver all her life.

# BRONWYN ELKO

born 1954, Racine, Wisconsin

I took this photo at about 9:30 in the morning. I was on the Carnegie Centre side of Hastings going down toward Carrall and these two were crossing the street. I was with another photographer in the contest, my neighbour in the same building, and I said to him, "That's a winning photo." I said, "Do you want to take it?" I was going to let him snap the picture on his camera, because he really needed the money more than I did.

The little girl had this mark on her forehead. You can't really see it here, but that's what caught my eye. You see that little "Zee?" I had some chocolate milk I just bought and I said, "Can I take your picture if I give you this chocolate milk?" and she said, "Yeah."

You don't see kids in the neighbourhood often. It is pretty horrendous to see people shooting up on the street and if you do have a child that is a toddler, in my opinion, I'd never let them walk down here unless I had a firm grip on their hand and they were wearing sandals. So you don't see many kids down here, especially on Hastings. You might see a couple babies on a summer day like this, but you're not going to see a lot of kids.

Someone called me and told me a few weeks later that I won. I was thrilled. It really cheered me up. I was in a pretty depressed state of mind when that whole thing was going on and it was actually quite a struggle to go out everyday and deal with asking people if you can photograph them because even sometimes asking them is enough to get them angry at you.

I came to this neighbourhood because it was the only place I could afford to live. I was terrified, to be honest. I'm not terrified anymore. I'm on disability. I have a really bad back and I've had other problems as well, so I just had no choice. It was the only apartment I could find where I could have my own bathroom and my own kitchen for $440.

The building, on my side, is right above the drug alley. We cringe before welfare day. I mean there's no less than fifteen people in that alley every hour. They go back there and shoot up and everything so when welfare day comes they either get really, really quiet, which is a blessing, or if they are doing meth then they get crazy.

Over half of the people in my building are recovered or never did drugs in their lives. They are just poor, that's all. We don't really complain that much unless someone starts dealing and they are going to be bringing violent people into the building with guns. We had a guy stabbed right below me. He was dealing heroin out of his apartment.

My landlady is in her mid-sixties and she's just exhausted. She has to rent to someone and she doesn't like to discriminate against people. It's not a matter of whether they use, but there is a difference between using and dealing, because if you are dealing you are bringing all kinds of problems into the environment.

We have a mother and child in our building. She is a hard-working single mother. She works her butt off. I don't know for how much. I assume not very much or she wouldn't be living down here. She is like a lioness with that kid. A lot of people when they are high will just reach up to grab your kid and if

"Friendship" by Bronwyn Elko, 2006. This is a photograph of Allen outside of United We Can where he works.

they have that staph infection, you don't want them touching your children.

Things aren't hidden behind nice appearances. Everything is completely out in the open, including the tremendous suffering that drug addiction brings you to. People who come in from other parts of the city and see it, I don't know what they think. There are fears about life down here and they are justified. I've seen things that I never believed I would ever see in a civilized country.

I mean I've seen mothers smoking crack right with their babies in a carriage in front of them and that really gets me upset. I report them to the agencies, and of course I don't know the names of these people. I just don't see any change. I really don't. I have been here three years and I don't really see much of a change that way.

There are people down here who have had money. There are people here who used to own homes and had good jobs. A lot of people forget that. That these people weren't born into this. Some of them were, some of them were raised in homes with that same kind of drug and alcohol environment, but a lot of them weren't. A lot of them slipped down the slippery slope and lost everything. They've lost their families. They've lost their children.

Go walk around here on Father's Day or Mother's Day and you'll hear a lot of mothers talking about their daughters and how they miss them, and how they want to call them but they don't have the money, or they are going to call them as soon as "I get my next hit" or whatever. People are estranged from their families—they are not only cut off from all of society, they are cut off from everybody that was near and dear to them.

I have seen the most horrific and vile narcissistic behaviour. Then, on the other hand, you'll see some guy who's got running sores all over him and he's got no money, no place to sleep, and yet somebody else would be crying in the gutter, "Oh, if I only had a cigarette, please," and he'll go over there and give the guy his last cigarette and that touches me.

It is very different when the rich give to the poor versus the poor giving to the poor. When the poor give to each other they are giving from their absolute rock-bottom nothingness. For them to break free for even a millisecond and be generous and self-sacrificing while in the grip of that addiction, I think that is a profound act of humanity.

That is why I was happy to capture this photo, because I thought it did express love and that's made me happy—to think that people are going to look at it and go, "This is the Downtown Eastside and by god there is love down there."

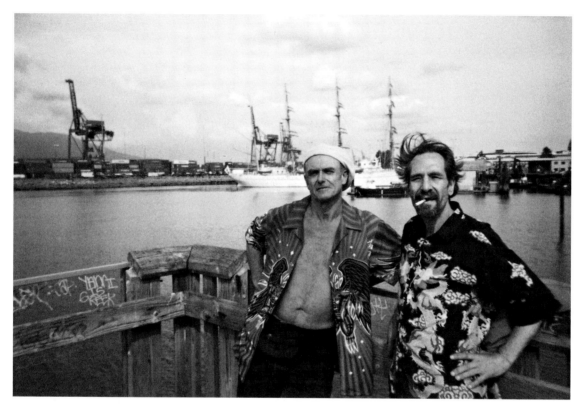

"Tom Quirk and Dennis Pegoraro," by Tom Quirk, 2004.

# TOM QUIRK

born 1949, Ottawa, ON

I'm a Marine worker. I have a three-thousand-ton coastal masters ticket and coastal towboat masters. I was a binge drug user so three years ago I gave up a place I had for eighteen years in Kitsilano to go into recovery.

I was born in Ottawa. Army family. Dad worked in Ottawa; we lived in Valle Tetreault, but he didn't want Quebec on the birth certificate. So I was born at the Ottawa Civic Hospital. I've been out west since 1965. I lived in the North Okanagan, and I spent over ten years on the water on the West Coast and the Arctic. I've been in the Downtown Eastside for twenty-seven months.

But I'm more interested in his life, the fellow standing in the picture with me. That's Dennis Pegoraro. I set the picture up carefully so that the ship would be over my shoulder. He was an old friend of mine and of the twenty-two pictures that I took, two of the people in the pictures were dead within three months. He was one of them.

I'd known him since 1967. He taught me to box. In fact I got three-and-a-half years for marijuana in '68 and I was in jail with him and he taught me to box and broke my nose. He was from quite a well-known family of street fighters in Vancouver at that time. Hector Pegoraro's still alive. He was famous in those days—people used to recall the flashy feet of Hector Pegoraro.

This goddamn photo haunts me. He was dead within three months. He had endocarditis, among other things, which is related to shrunken heart valves

from shooting cocaine decades ago. He should've been dead many years before for various reasons. No one knows exactly how he died, but he passed away in his sleep in the night by himself.

This picture keeps popping up. I won third prize for it. Gallery Gachet is right near my place and every time I walked by, it was hanging right there. And then two months later there was an event there, a presentation by some writers, and there it was hanging again.

I just came from acupuncture and energy work and I was working with a woman who had limited psychic ability and, not knowing about this picture, one day she said to me, "I see a ship with four masts."

Now I'll draw your attention to the picture. I had to come home and look at the picture myself. The ship is a Japanese training ship that I carefully placed so that it would show over my shoulder, but it does not have four masts, it has three. This is a crane at Centennial Pier, so she was reading an impression in my mind, not the picture.

Now here's the damn picture again. His wife died under my hand, too, about a year before this. He phoned me.

At the time I was studying for higher foreign-going certification. I had a three-thousand-ton coastal masters, now I have foreign-going certification that would let me get a white hard hat on the dock and not sail anymore. But the math is very difficult. I hated the math, spherical trig. I hated it, so I was using half a gram of heroin a day. But I was doing the work and in fact I passed those first exams.

The only thing I could pray for was for guidance, to be made useful. I thought, well, I wanna pass these exams, so I'll pray to be made useful. The next morning he phones me, he says, "My wife is dying, you know, Valerie." I had had an affair with her long after they had separated.

The last time I'd seen her was eighteen years before. I thought, he can't handle it; the son can't handle it. So myself and an old friend of mine and hers ended up visiting her every day. She was supposed to die within two days but took a week to die.

She had lung cancer, and now it was throughout her body. She could see and hear you clearly, but she couldn't speak. We ended up visiting her every day and it was one of the greatest experiences of my life. The son couldn't be there at the end, so the last words she heard were me telling her that her son loved her very much.

So then I get my final orals and this is where they really grind you. I go to the exam and the guy's got my record in front of him and he says, "You've been around, haven't you?" And I have. I started in 1966. He says, "Well, you're not gonna be in here very long today because I don't wanna hear any wrong answers from you."

I hit the pavement. I was pissed off. I figured I'd been ripped off because I'd done all this work, and then it occurred to me that I had prayed for aid to do this and what had happened? I had been made useful in another manner, through comforting this man's wife when she was dying.

He was one of my best friends. At the Sea Festival they used to have in Vancouver, there was a dance on the tennis courts at Kitsilano Beach. There hasn't been a dance on those tennis courts since 1965 because Dennis at the age of fifteen beat a sailor nearly to death and went to jail for it for three years.

It was very much circumstantial, but he was actually a nice fellow. When I went to jail he took care of me. I was nineteen. He'd already been in there a while.

I did a year on three-and-a-half. Marijuana, too much marijuana. They were putting you in jail for long hair in the '60s. They didn't know what was going on, you know, dope became so pervasive later that they basically gave up. Plus the hard drugs took over, in about 1970 or so.

I started when I was sixteen so it never helped my socialization. I never learned any financial responsibility. Even back then it was easy to borrow five hundred bucks from somebody. I mean, even today it's a little bit of money, but then everybody had money. There was work for everyone.

It was the Liberal government borrowing money from the future. Our wages went up ten percent a year every year for years and years. I remember we hit ten grand a year in '74 and that was big news 'cause for many years $350-$400 a month was a good wage. And still today our working hourly average wages are roughly geared to the cost of a case of beer.

I never used on the boats, that was never an issue. I grossed $44,000 in four-and-a-half months in '96 and I came down and was flat broke in ten weeks. I

did it all in a little studio suite not much bigger than this, barricaded in there. I just keep phoning the Viets, Vietnamese delivery people, shooting cocaine, you know, just keep phoning the Viets. So I would shuffle out to the bank machine in my bunny slippers every couple of days.

You can't survive that. You can't stay up non-stop 'cause you go psychotic. An eight-ball would last me eighteen or twenty-two hours and then I'd get about a four-hour break and then do it again.

Now that I'm clean I find that I can be useful just by being out there. I mean part of the idea is that we know the people in the area and you can tell when the sick are really sick. I distribute alcohol swabs. I have detox cards. In fact the last time I worked I got a chance to hand one out and say, "Hey, come on over. Get onto Safe Ride and get to the hospital."

The Psalm 23 is useful for this area. It says, "Yay though I walk through the valley of the shadow of death I will fear no evil." And the unit blocks of Hastings for an addict is that valley of the shadow of death.

I ask for guidance and if I pay attention throughout the day, I'm given it. Look at all this business with this goddamn photograph. I mean you can't explain that. I can't explain that. I mean it just makes you wonder, the synchronicity of it over and over. And his wife dying under my hand. I had said a few things jokingly to her in the hospital. One of them was, "People wonder what happens when you pass on and I'm a little bit envious because you're going to find out very soon."

The nurses laughed. When we had the memorial a week after she died I was dropped off on my mountain bike and I stopped at 7th and Vine, where those little benches are. I could feel her presence so strongly that I closed my eyes and called out her name several times. It was only recently, a few years later, that someone pointed out to me, "Well, you asked her what happens?" So I'm not saying that anything is there. I'm just saying, isn't life the perfect thing to pass the time away?

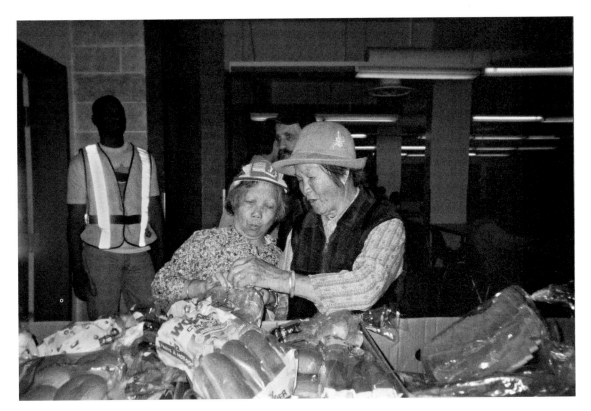

"Choosing Bread" by Aaron Bolderson, 2005.

# AARON BOLDERSON

born 1975, New Westminster, BC

I was in a treatment centre when I took that photograph. We gave out bread to the homeless people. At first those women annoyed me, but it was nice just to see them every day and they made me smile in a place where it's hard to smile sometimes.

I used to dance with them and I'd put their hats down over their eyes. That's a really good memory for me, that's why I took it.

We feed them and on their way out they can take a couple loaves of bread. There's a limit of two, and they'll sneak more if they can, but it's okay because it's going go to waste anyway. They come in big groups and sort through all the bread to get the stuff with the furthest expiry date. They just huddle there. If you don't shoo 'em out, they'll stay there forever.

The ladies coming and being all cute and stuff, it just makes it easier to be there. You start to look at your life and the decisions you've made and how you got there and ultimately it's your own fault. It's hard to acknowledge that and admit that okay, I've made some bad choices.

Feeding people is what got me through the first week in there. It made me see where I could end up if I didn't straighten out my life. It becomes a way to make you feel good about yourself, that you're doing something to help out. I almost left, but the food line, just doing the food line, is what kept me there.

I lived there for eight months and I would've been there longer but my counsellor said that I was ready to move out. I'm going to school now, and taking an addictions counselling course.

Being in recovery is an ongoing process, and giving back is one of the things that they suggest you do on a constant basis. I don't know why it means so much, but it's humbling. By staying humble you don't fall back into your old behaviours. You don't think you're better than anybody else.

I love those old ladies and I'm grateful for that place. I'll never forget what they did for me.

Being there also made me realize that I'm capable. So now I can be a brother. I can be a son. Before I wasn't being those things to my family, and I've finally made it to my niece's last two birthdays. I was crying my eyes out at the first one. In that moment everything came flying back, like how I'd manipulated my grandparents and everybody else in my life.

I was using cocaine—not crack. I was just snorting it. It started off really slow, like maybe once a year when I was about eighteen. Just like New Year's or something. We'd do it occasionally and then I don't know what happened. There were a lot of things in my life that I didn't deal with, like the separation of my parents when I was seventeen. I never really had a

"'Gypsy' Ross Brown" by Aaron Bolderson, 2005.

"Busking" by Aaron Bolderson, 2005. Richard "Slinky" Mahoney had been homeless and busking in Vancouver for two years.

relationship with my father. Those are the things that I thought about while being in the treatment centre.

I'd do about a half gram a day. Eventually my mom knew, but not for a long time. I would avoid my family. She knew something was wrong, but she just didn't know what to do and she enabled me for a long time. Then she changed the locks and I lost my family.

That was the worst. I'd lost my job and I was still into some bad stuff on the side and that was all coming to an end. I knew that I was losing everything. Then I started stealing when I couldn't afford it. I was stealing tools from my landlord. I mean I would break in to his place upstairs just to get beer out of his fridge.

He evicted me; I had two weeks and then I was gonna be homeless. I was sitting on my living room floor and it just all hit me at once. Everything hit me. My family's gone, girlfriend's gone, I'm gonna be on the street with nothing.

I started crying my eyes out. I had tried to get clean, but I was doing it for other people. I had some information and pamphlets. I called my mom and I was just bawling my eyes out and she said to me, "Well, why don't you use some of the information you have." She calmed me down and then I picked

up the phone and I made a phone call and I got on a waiting list to get into detox.

"Couple from Stairs" by Aaron Bolderson, 2005.

Then funny things started to happen after that. I got into detox. I was staying in the women's wing and you're not supposed to do that. When I was leaving this woman came up to me and asked me who my father was. I told her and turns out she grew up with him and there's not many of our last names in the phone book. She knew that I must've been related, so she snuck me in sooner than I should've been in there. If I wouldn't have got in there I would've been on the street and then I don't even know if I would've made it to detox.

I got cramps. You can't go to the bathroom and you sweat a lot. At night you have nightmares, you shake, you don't sleep. I don't remember doing a lot of thinking. I was just kind of recovering. And then when you start to feel better near the end of your stay you have a glimmer of hope. I was like, okay, I can do this.

So that Friday, I left detox and went straight to Harbour Light and right into the program. Then I started to notice that the more good things you do for yourself, the more good things happen.

When you have a house full of people that are all addicts, there's lots there who don't want to be there, so you don't learn much from those people, but

you learn that you're all the same, that nobody's better than anybody else. Knowing that everybody else was going through what I was going through made it safe to have feelings and express them, which is weird for a house full of guys.

I hugged everybody. They called me Huggy McHuggins there. I've always been more emotional than most of my guy friends, so being there kind of let me come out of that shell a bit. We as addicts run from ourselves. We don't feel comfortable in our own skin. I'm still new to sobriety, so I'm still learning how to be comfortable in my own skin.

My mom never really abandoned me. She just was using tough love, you know, and when I think about her hurting because of me, and her accepting me back into her life, it's amazing. Even my girlfriend stood by me the whole way through, which is shocking. I rarely ask her about it and if I do she just says, "It's because I love you."

"Piano Man" by Frank Thompson, 2004.

# FRANK THOMPSON

born 1971, Masset, BC

I'm from Haida Gwaii. The last time I actually went back to Masset in the Queen Charlotte Islands was 1999, for my mother's funeral. It's a culture shock now for me to go back to my own homeland. I'm addicted to the city. I'm so used to hearing the sirens and all the people and everything else that's involved. It would take me about three or four days just to calm myself down.

In the village it's totally different. You see the same people every day, and it gets tiring. I lived there for nineteen years—walking by the same houses every day and saying "good morning" to the same people over and over.

That was a long nineteen years. I knew as soon as I graduated in 1991 that I was definitely not sticking around. "Thank you so much for teaching me everything and I'll see you later." That's all I said at my podium at graduation. Said goodbye to everybody and they couldn't believe I was leaving.

When I got to the ferry landing, my mother was standing right there. I said, "Mom, you got to give this up. I'm leaving and I'm not coming back for awhile." But she came with me on the twelve-hour trip south to Vancouver, and then stayed with me for two months before she went back home. I've been here ten-and-a-half years.

I enjoy interacting with all the new people I see every day. The major thing keeping me here is the people and being able to meet somebody new every day.

That's what people say about the Downtown Eastside—it's one big community and everybody is always helping each other out. It's not like that anywhere else in Vancouver.

I enjoy going around the rest of the city for the scenery and sometimes to interact with the people, but it's totally different. The people in other parts of Vancouver are not as open and friendly as they are in the Downtown Eastside. Other parts of Vancouver are not a fun place to be when you are being looked down at. So I go for the scenery.

If there's work then it's easy to stay down here, but if you are on the street then it's a hard life. People don't believe me when I say, "You wanna job? It's not that hard, get up and go, knock on the door, somebody will answer it." That's what I love about this city, opportunity is everywhere. It's all in the way you talk to people if you want a job. Open. Honest. That's it. People see that and feel that right away.

The worst job I ever had was working at a chicken factory where I had to load up the trucks with live chickens. Eight hours of that and I said, "Nope, I'm not coming back here." Right now I move restaurant equipment and that's a good job.

I got my job through First United Church. I used to volunteer there and one day someone came and said, "Do you want to go to work?" and I said, "Sure." That was two years ago and I've been working ever since.

This picture of James was taken at First United (see page 88). He plays there every morning. There's probably close to two hundred people in there all the

"Frank Thompson" by Myra Williams, 2007.

time. James is one of the Downtown Eastside residents who's been down here for a long time and I've known him quite well. He's always trying to sell something. He goes binning to collect empties and he picks up all kinds of stuff—cups, work gear, pants, sunglasses. Anything he can get his hands on. He fixes it up and sells it. It's about all he does.

I don't buy from him. That's how close we are. If I wanted something he'd get it for me. He's a very good guy and musician. I would like to see him get his talents back and keep working at it. I enjoy listening to him.

He was excited about that picture. He sang me the whole song. I was just teasing him and said, "I'm going to take your picture and make you famous."

At First United, I serve coffee and soup. They provide showers and basic things that people need down here. That place has helped me out so much. I really appreciate it. It's one of the cornerstones down here. My addiction I guess brought me there.

People down there helped me get off the drugs and alcohol. There were three ladies there who have pretty much done everything they can to help me out—

dumping out my alcohol, taking my money so I don't spend it all, sobering me up, and kicking my ass.

People say I'm famous for being found on Main and Hastings. I've been there for three-and-a-half years now. It's the one place we sit everyday. My circle's just getting bigger and bigger.

We go on trips. Once we chartered a bus and went down to Splashdown Park in Tsawwassen. There were about twenty-nine of us and I knew everybody on the trip. Next we'll probably go do paintball.

"Friendship" Tina James and Bev Martel by Frank Thompson, 2005.

I try and keep myself positive by keeping my actions positive. It's hard to watch people around here killing themselves. They get so caught up in the drugs and alcohol. I've seen three of my friends pass away from them in the last three months. That made me decide that that's not the way I want to go out. That's not the way I want to die.

You see a lot of drug dealers beating up their customers because they owe them money. Nobody does anything about it and nobody really talks about the drug dealers. They are greedy. They'll do anything for money, including

feeding you a drug that will kill you right in front of their face. Somebody will be down on the ground, tweaking away, and they still say, "Sure, I'll take your money." It's ruthless. I wouldn't go home and have coffee with them.

There's a lot of fear down here, but I feel safe because I know that I'm not going to say something out of line. I'm not going to instigate a fight. I don't rip people off. I don't borrow money.

That's the way it has to be. I give out a lot of money. I never expect to get it back. It's not for me to ask for money back. If I give something away, it's not coming back to me. There's no point in giving anything away if you want it back.

Community is important down here and believe it or not people come here to feel safe. To fit in. That baffles me because it's the Downtown Eastside. Worst drug place in BC. But here you never pretend to be something you aren't and anyone can fit in.

A lot of people moved away from Masset because they can't handle all the politics that goes on there. It's garbage. There's a lot of urban Natives here. There's close to about 150 I believe from Masset alone. They come for work, their addiction, their family, or who knows. Maybe it's the same reason I'm here: just to know someone.

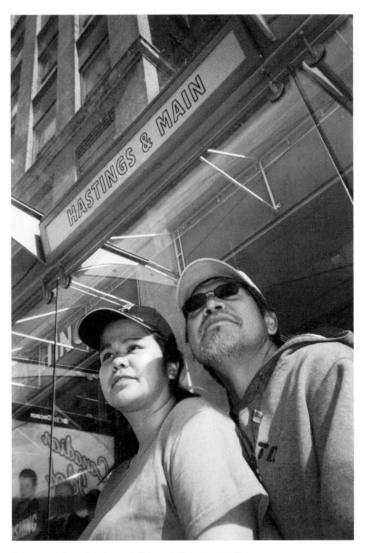

"Teresa Lincoln and Fred Lincoln" by Frank Thompson, 2007.

# TERESA CHENERY née LINCOLN

born 1974, Prince Rupert, BC

My mother Judy Lincoln is Tsimshian from Kitkatla village and my dad Johnny Lincoln is Nisga'a from Kinkolik. Chenery is my legal name. It was given to me by Sergeant John Wayne Chenery of the RCMP and his wife Louise. They adopted my brother Gerald and later adopted me. The Chenerys were living in McBride at the time. They had two children of their own living with them when they adopted Gerald. I was still living with my natural sisters Sylvia and Edith.

The three of us had been adopted by the F. family in Kelowna, who were Roman Catholic. I didn't wanna bow down to them; I had a breakdown with my relationship with them on account of the abuse I went through in that home. I didn't stop stealing and lying when I was living with the F. family so they made arrangements behind my back to send me to the Chenerys.

Gerald was taken away from our natural family when he was seven or eight and by the next time I saw him in McBride he was twelve and I was thirteen. When we pulled up to the RCMP detachment in McBride, he was there out front playing with two Belgian sheepdogs. I remember looking at him and recognizing his hair, his glasses, and his ring. He wore a puffy down-filled coat, jeans, and black shoes.

I ran to Gerald and couldn't wait for Sergeant Chenery to open the chain-link gate. I put my arms around Gerald but he didn't recognize me. My other sisters got out of the van and we played outside for a while. We thought we were

just having a visit. I didn't know I was going to be left there and separated from Sylvia and Edith. They didn't tell me until after supper. I remember Mr F. telling me to say goodbye to Sylvia and Edith and I wouldn't. That was the first time the four of us had been together since I could remember.

Sylvia and Edith were raised by the F. family. None of us are in contact with our adopted families anymore. There's no contact at all. In some ways moving in with the Chenerys was good because the sexual abuse that happened between me and Mr F. stopped and nothing like that ever happened between me and the Chenerys. With the Chenerys, it was abuse through discipline. If Gerald did something wrong, they would take a belt to him and beat him from head to toe.

I hated Sergeant Chenery. Not too long after I agreed to be adopted by them, in the summer of 1988 I first saw them lock Gerald up. They used to lock him in a cell and leave him there for hours and hours on end.

Eventually the Chenerys gave Gerald up. He became a ward of the court and, as far as I know, he was then raised in a group home in Kamloops. I stayed with the Chenerys and tried to make it work until I was seventeen.

The next time I'd heard about Gerald, I was living in Lillooet and pregnant with my third daughter. My husband at the time helped me look after my first two children and I got pregnant with him. We had a restraining order against each other for beating each other up. I'd actually miscarried because of him so I was ready to run. We went through all the court proceedings and I was ordered to go see a probation officer every week.

My probation officer at the time asked me if I knew the name Gerald and I said, "What, you know my brother?" And he said, "Yes, I know your brother. As a matter of fact, I'm his bail supervisor."

That was the first time I had even heard that Gerald was still alive. The probation officer said he couldn't give me my brother's phone number and address. I asked him to give Gerald my number, but he couldn't even tell me whether he did that or not. I started looking for him after that and we always just kept missing each other.

I can't remember how Gerald and I finally got hold of each other. Over the years I'd heard he'd had a girlfriend and daughter down here in the Downtown Eastside, but I had never met either one of them. I didn't see Gerald at all during his adult years. We managed phone conversations here and there. He told me that he was having troubles with his girlfriend and that she forced him to let her current boyfriend adopt their daughter. Not too long after the adoption, his daughter choked to death.

The next time I heard from Gerald, we were living in Kamloops. I was living with a guy named Daryl at the time and we had gotten into an argument and I was trying to kick him out. I didn't know that previous to staying with me, Daryl was living with another woman who was now at my front door and pounding on it, demanding to be let in. I didn't want her making a scene in front of my children, so I ended up calling the RCMP. They came to my door and I told them what was going on. I asked them to get Daryl to leave because my children were in bed and I didn't want the Ministry called.

I remember standing there giving my statement to the RCMP officer and he looked at me and he said, "Did you say your last name was Chenery?" I said, "Yes, it's my legal last name." He said, "We just picked up Gerald." I'm like, "What? Where is he? What's his address? I need to know. He's the only family I have."

This RCMP officer finally looked at me and said that Gerald didn't give them an address. But he could tell me that he had been in trouble and that he'd been in and out of jail, and that he had a drug habit that he had to support.

The next clear conversation I remember having with Gerald was when my mom had her aneurysm. That was August 2004. I didn't know this growing up, but my mom was a junkie and an alcoholic until the day she died and she was like that when she was pregnant with each of us. We didn't know that. That's what Gerald's learning disabilities were from.

I found that out that same month. I found our file from the Ministry of Children and Families in my mother's house. I don't know where it came from, but I read the whole thing. When we were young, my mom used to live with us right in the skids at the Balmoral Hotel. I was three at the time so Gerald would've been two and Sylvia would've been one and my mother would've been pregnant with our youngest sibling, Edith.

I grew up thinking I was the oldest of four. When I was eighteen years old, I found out that I'm the third youngest daughter of sixteen children. Sixteen. I don't even know all of my brothers and sisters.

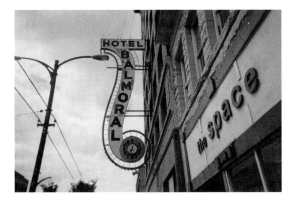

"Hotel Balmoral" by Leticia Whitehead, 2007.

I'm the only one that knew Gerald. I was the only one that had time with him. Things that happened to me, happened to him. We were both sexually abused in our natural home, before we were taken away by the Ministry of Children and Families. Our dad is a pedophile. He sexually abused each and every one of us. I was the only one to put him in jail, for raping me. He was sentenced to four years. I think he served just over three.

The day before my mom had her aneurysm, I blew up at her because I had found the file on us and I confronted her about it and told her that I was pressing charges against her for her involvement in the way that Dad treated us. I told her I remembered her selling me to Dad, letting him sexually abuse me, molest me and my sisters and my brother. He raped us and sodomized us so she could have her money to go to bingo.

I told her how much I hated her. I told her how much I hated Dad. I asked her why she could be with him because I found out how fucked up our family is. My dad used to baby-sit my mom and then she had kids with him. My mom was my dad's previous victim. I didn't know this until the day before she had her aneurysm.

I confronted her on everything. I remember standing there telling her she's not going to see my kids again. She's not going to see any of us. She's going to jail. Dad was sitting there and he tried to get up and con-

Unknown, Fred Lincoln, and Teresa Lincoln by Frank Thompson, 2007.

front me but I said, "You fat lazy fuck, do what you do best, lay on your back and blame everybody else for the things you've done."

Later, I ended up packing up the kids and going to a transition house because Mom came to my place and harassed me. She slapped my kids around and threatened me. Trying to make me feel small again. We ended up at the only women's shelter in Prince Rupert.

It was all over Prince Rupert that I'd had a nervous breakdown and made false accusations. After I had that big scene with my mom, she had her aneurysm. It was building up in her.

That day I was downtown shopping and when I went back to the shelter, the whole place was quiet. Everybody was looking at me. I had relatives there that I didn't even know were my relatives. They were coming up to me and putting their arms around me and crying. I didn't know what was going on. I got called into the office, and everything after that's kind of a blur.

When I got to the hospital, my mom was on life support. She was already dead though. Her spirit was gone. That was some kind of fucking hell, going

up to the hospital. My oldest sister was standing at the foot of the bed and my dad was sitting in the chair and my sister and my dad were groping each other at my mother's bedside while she was dying.

My sister is a previous victim of my dad's too, but the relationship never stopped after she grew up. It continued on even right at Mom's bedside, right there. She knew that I saw them doing that to each other while my mom was dying. She had me kicked out of the room so I went to the security and I told them who I was. I told them that's my mother who's laying there dying and that's my dad who's sitting there feeling up my sister. I told them about the relationship between the two. They brought me back into the emergency room. I was finally allowed to be alone with my mom.

I tried to apologize to her for everything I said. The last thing I said to my mom was that I hated her and that I didn't want her to be part of my life. Somehow I got hold of Gerald while he was in jail. My uncle had a son that was in jail and he and Gerald put it together that they were first cousins. He had given Gerald Dad's phone number so Gerald had called Dad from jail.

When he first got on the phone, I remember just enjoying hearing his voice and asking him how he was doing. Then he said, "What aren't you telling me?" I just started crying. He started crying on the phone too and said, "What is it?" and I said, "It's Mom, she's in the hospital and she's not going to make it."

I said, "You need to come home, boy." He just started crying. I said, "I don't know what you have to do or who I have to talk to, but put me in contact with somebody and I'll tell them what's going on. You need to be home because

she's going soon." He said, "You can't tell me that." I said, "It's true. Mom's leavin' us." I told him what it looked like when I saw Mom hooked up to life support.

We talked a lot about the things that he'd been through. I found out that he was in jail for beating up somebody who had raped his girlfriend. He beat the living hell right out of that guy, and he was also in jail for someone trying to rape him, trying to sodomize him. He beat the hell out of that guy too. Took a pipe to him. What people don't know is that Gerald and I were brutally beaten and raped and forced to do all kinds of things. If someone touches us in a way that we don't want to be touched, we tend to get a little crazy.

He told me about some of the other things that he did and he asked me if I could forgive him. I said, "It's not my forgiveness you need, Gerald, it's your own." I said, "Were you fighting for your life when this happened?" He said, "Yeah," and I said, "Well then, I have nothing to say, because I've done that too."

I don't know how long he'd been in jail by the time I contacted him about our mom. We spent our whole lives away from our parents—running away, trying to get home. It didn't matter about the hurt and the pain. They loved us. They really loved us. That was all we knew.

They let Gerald out on August 23, 2004. I was sitting in the funeral home just to be with my mom's body. I was ashamed because it was a fucking cardboard casket, particle board, painted blue. I was broke and had my five kids in tow with me in the funeral home in Prince Rupert.

My kids were sitting in front of me. My dad Johnny was sitting in the front, closest to my mom. Then all of a sudden I could feel this energy walk into the parlour. I turned around and looked. My brother was in shackles but holding his head up proud. I thought, that is one big boy. The last time I saw Gerald we were just kids, and here comes this big guy walking into that room. He's got his hands out and you can hear this clank, clank, clank.

Everybody looked up at him and were like, "Who the fuck is that?" I'm the only one who recognized him. As soon as I saw him, I got up. I actually pushed both my sisters and said, "Get out of the way. Move right fucking now." I was mad. I was angry. I was happy.

I remember looking at everybody and still nobody recognized him and that was my moment—seeing my brother, six-foot-two inches, two hundred and forty pounds. I had no idea that he was that tall or that big, nobody told me.

I remember seeing those chains, seeing him looking down at his chains, and he's got his arms outstretched, here I am, love me, love me, love me. Once Sylvia and Edith realized it was Gerald, they ran up. The four of us stood there with our arms around each other. Such sadness and such joy in the same terrible heartbeat.

He broke down when he saw Mom. He never got to talk to Mom as an adult. Mom was his whole world. For the longest time after we were taken away, Gerald was still with her. He broke down right there. I knew when he saw Mom something broke in him. That was all he ever wanted, to come home to his mom.

In one split second he was happy and then he was leaning over Mom. He just about fell in the coffin. When that happened, I knew he was a little boy again.

There were three security guards who were supposed to be beside him the whole day. They broke the rules for us all day long. They were trying to make things right. After the funeral service, we were standing outside the hall. Dad said he wanted a picture and we all stood outside the funeral home. I was standing beside Dad and Gerald was standing beside me.

We're all standing outside trying to get a whole family picture. I wanted my mom's family and my dad's family in the picture, but nobody would talk to Dad because his baby boy was standing there in shackles. We have one picture of all of us together and we were all standing there in black. I'm holding my mom's hospital bag in my right hand and it's got in it everything she had with her that day that she had her aneurysm.

We went to my dad's house. The security guards brought my brother in and they took the arm shackles off of him. We had a good visit there for a while. Dad was sitting in the kitchen with the two security guards who were supposed to be by Gerald's side. I gave them some of my eagle feathers to thank them.

The security guard was saying it was nearing the time for Gerald to go. Everybody started crying, even my kids. My middle daughter Chrissy took it the hardest. She bonded with him instantly. Gerald got up and righted himself and everyone started taking more pictures.

"Dinner Table" by David Brown, 2005

When the security guard finally put him in the back seat, we all stood at the door and I don't know how to explain it, but when a spirit leaves a house you can feel it leave and I felt that coldness. I looked at my sisters and I said, "I will never forgive you for not being here at Christmas." I have no idea why I said that to them, but at the time they just looked at me and cried.

I kept in contact with Gerald while he was still in jail. We tried getting approval for him to come to Prince Rupert because he had family there. I had a job. My dad had a home. We were stable, but for some reason they decided that Prince Rupert wasn't a safe place for him to be anymore because after the funeral and Gerald went back to jail, he kicked the shit out of somebody. They based their decision on how he responded to my mother's death.

When they released him from jail it was December 23. Gerald called us from Vancouver collect at my dad's. I told him I was willing to relocate with my children to be down here with him. I had just gotten out of a nasty relationship and Gerald wanted to help me with my kids because I was a single parent of five children. I had a sister who was staying with me and I also had a fourteen-year-old Caucasian boy who had been abused by his parents. So I had seven children living in the home with me at the time.

Gerald said he'd phone us later, but by Christmas Day we were worried because we hadn't heard from him for two days. Boxing Day came and we knew something was wrong. On December 27, I was cooking dinner at my place on McKay Street in Prince Rupert and there's a knock on my door and it was the same people who dropped off my fourteen-year-old foster son. I said, "Alright, what'd you do now?" I was trying to make light of the situation, and this cop and his stupid blonde sidekick pulled me outside and told me they need to talk to me. I said, "What about?" and they said, "Are you Teresa Chenery?" And I said, "Well, obviously, you know, you guys remember me, what's going on?" They said, "Are you next of kin to Gerald Chenery?" That's how they said it, "Next of kin."

I said, "Obviously you know that too, but what the hell is going on here?"

I'm standing there looking at these two and they're extremely rude. They were trying to imply what was going on but they weren't giving me any real information and it wasn't clicking with me. Finally she said, "He's been shot." I said, "What do you mean shot? Where?" I was trying to ask where on his body, but they didn't understand me. Inside I heard my kids crying.

She told me again, "He's been shot," and I said, "You said that already. Where is he? Tell me something." They said, "We can't disclose that information."

So I flipped on them. I remember one second I was standing there screaming at them and hollering and the next second I'm crumpled on the ground, curled up in a little ball looking up at the cops, and they wouldn't say for sure if he was dead.

All I was told was that it was in an alley in Vancouver and that it was between him and the police. I found out in the news that he was in the alley behind the Savoy Hotel, that he had knives on him and that in order to save an officer's life, they shot him twelve times. I remember a camera from Main Street looking at the alley and it was all taped up and there were lights everywhere. There was an ambulance and a fire truck and cruisers lined down the street. They said that he was gone. I knew then that it was Gerald.

Near the time I found out Gerald had been killed, victim support services came over promising they were going to help me. They even apologized for the way my brother died. The RCMP came to my house and said, "It was a tragedy what happened. We're sorry it happened this way. We'll help you out in any way we can. We'll make sure that his body's flown home, that he'll have a decent burial. You and the kids'll have counselling."

Then the Vancouver Police Department turned around and said that Gerald was at fault and that they didn't have to help me. I begged and begged for help. We didn't get any because everyone was telling me that he was at fault and that the police were justified.

They slaughtered him. What they did to him was pure torture. He was alive for most of it. I went to the inquiry so I know the details now. First time they told me he was shot between one and seven times. Some of the bullets entered him while he was on his knees.

They told me that one of the bullets entered Gerald's right wrist and went back out and hit the wall by the dumpster, and I was also told that he had his left hand up in a surrender position and that a bullet entered by his left wrist

here and lodged in his elbow. And I was told that while he was on his knees with his hands up, another bullet entered his lower leg and lodged up by his knee. There was another bullet that entered his right shoulder at a downward forty-five degree angle that went from the right side of his body to the left side, and that it was a fatal shot that possibly reached his heart. There was another shot from the front at a downward angle that went through his groin, exited, and lodged in his buttocks. I can't remember it all.

During the inquiry, they determined that if they let Gerald go with his family, he'd probably still be alive today. If they had done the things that we were requesting right from the start, Gerald would still be with us.

At his funeral, he wore the Salvation Army clothes that I had gotten for him that were donated. He was oozing on his right side. His whole stomach area was a big stain on the shirt from where they blew him apart and there was another one that was up by his heart.

He didn't die instantly. He felt all the shots. I had no roses there and I couldn't even buy him new clothes to bury him in. I had to go to the newspaper to talk to the reporters and tell them my brother was shot to death in Vancouver and that I needed to raise money for the body bag and plane ticket to bring his body home.

I started drinking. I started drugging. My brothers would come over and watch the kids. My kids ended up getting taken away from me because I was drunk when they came home from school and my brother was fifteen minutes late for babysitting. Welfare came in and scooped them. It took six cruisers to take my kids away from me. I screamed at them, "Do you know what I've just

been through? Do you know what just happened to me? Why don't you get someone in here to help me with them? Let me break down but don't take my kids." I still don't have them back.

They're living with my ex-husband. He's got custody of all five of them, even though only three of them are biologically his. I wasn't even served papers to have my rights taken away. I wasn't given anything. I went through hell after Gerald died. That was my first exposure to rock cocaine. After the kids were taken away, one of my friends came over, started cooking it up, and we smoked it out of a can. That's when I got started.

Eventually I came to Vancouver to fight the police. The officers who shot Gerald got paid leave immediately after they slaughtered my brother. To this day I still see one of the officers on the beat. She believes she was justified in killing Gerald. If she pulls up in the cruiser and I wave, she keeps driving. She didn't have to make a statement for months after the shooting. They took pictures of her the night that she killed my brother. She had a paper-like cut across her left hand and her hair was perfect.

I don't think I'll ever know the complete truth. Gerald and I had a hard life and a lot of our pain was a result of the system that raised us. Stuff like this is happening to other people in our situation and we can't get people to hear us. Gerald and I had been asking for counselling ever since we were kids. When they slaughtered him that way, they promised me counselling. I'm still waiting for that.

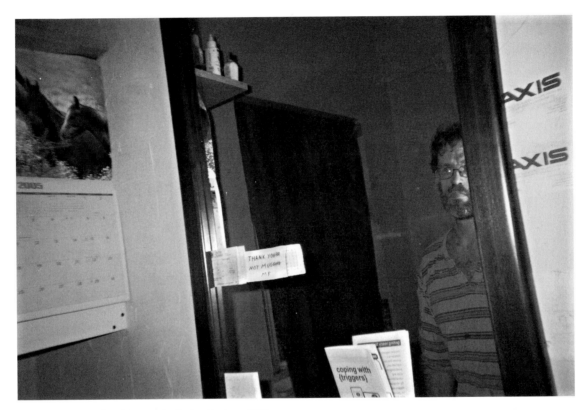

"Coping with Triggers," a self-portrait by Gordon Matthews, 2005.

# GORDON MATTHEWS

born 1955, Vancouver, BC

I was born here in Vancouver. My foster mother passed away about three years ago and my life went for a crap after that and I ended up living on the street, at the Lookout shelter over on Cambie. From there I heard about a vacant room at the Avalon Hotel and that's where I've been ever since.

I can't really tell you much about the photo. I was just hoping that I'd be able to capture some of my reflection in the mirror. I wasn't even sure if I was going to show up. I've always felt like I was observing my life instead of partaking in my life.

This sign on the mirror actually says, "Thank you for not mugging me." I made it up and wore it on my coat on various occasions as a conversation starter. Most people didn't take it seriously, they just laughed. But it worked, because I never got mugged while I was wearing it. I was mugged before that. Some girl was trying to get me to get money out of the bank machine and I didn't have my card. I was blocking her fists and some guy came up and slugged me from the side. I guess that was her partner or something. That was it.

I know there are a lot of worse places than the one I live. The hotel I live in has security cameras on each floor. I'm dealing with some depression issues. I'm taking anti-depressants and hopefully I'll overcome it and get back in the work force.

It'll probably be in construction or signage. I was in signage for five years before any of this happened. I was a foreman of a shop. You make good money, but I think I had about three or four days off a year so it wasn't much of a life.

I picked that calendar. It was all horses. That's why I picked it, because I love horses. I groomed race horses for seven years, from 1984 to '91. But then again I had to work 365 days a year. You can't just throw a horse on the shelf for a weekend and go away and come back. You had to be there seven days a week.

You never get a break. A lot of time, I was working at the PNE here in Vancouver. I've worked in race tracks all over the eastern United States—Florida, Atlantic Beach, Maryland, New York, and New Jersey. At the last place I worked, I ended up putting the wrong horse in a race and got suspended from working any race track in North America for two months. I never went back after that.

I have a doctor that I get along with well. I had a drug and alcohol counsellor, but she got transferred to a different department and I'm kind of starting with another one. And I think I'm going to be asking them to get me into a treatment centre. I'm going to end up with two options, either get busy living or get busy dying. That's what I'm going to be faced with.

Once I get my act together, I probably won't want to live right downtown. I'll probably want to go out to Burnaby or something—someplace away from this. If you live right in the heart of the Downtown Eastside, it's extremely difficult to get out of the whole drug scene. You can't walk down my street

without five people asking you if you want to buy something. Even if I was up as far as Broadway, that would be better. It's not nearly as bad up there as it is down here.

When I look at this photo now, I don't see too much of a difference. I just feel less motivated than I did then. The expression on my face actually tells quite a bit. Here I am looking at me again, the outer body experience just watching my life go by. That's what I think it says.

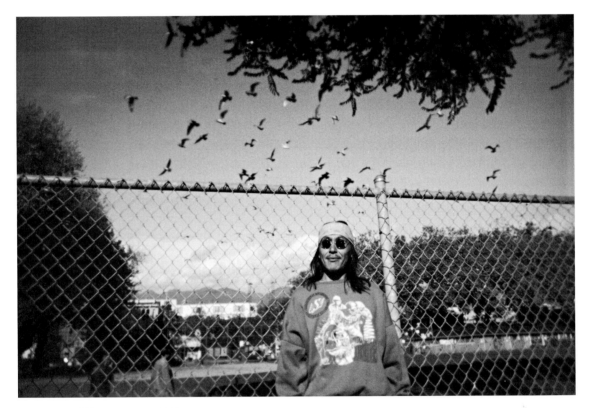

"Mitts with Birds" by Gregory Liang, 2003.

# GREGORY LIANG

born 1967, Vancouver, BC

That's a picture of Mitts. He's been down here for a long time. He was up at Oppenheimer Park and I said, "You know, Mitts, can I take your picture?" because he's got that unique kind of a look. I just had him stand there by the fence and the birds flying by were kind of an accident, but it actually turned out quite nice with the birds. They're not chained to this earth like us. They're free.

That's Oppenheimer Park right behind him. I wouldn't say I spend a lot of time there. I'm mostly downtown on the corner here. I wouldn't hang out there at night; during the day it's alright.

I volunteer at VANDU [Vancouver Area Network of Drug Users]. It's an organization that's made up of former and current drug users who work to improve the lives of people who use drugs, through peer support and education. I'm on their board right now. I help out with the programs or the workshops, whatever needs to get done. Giving back to the community gives people self-esteem. That's the main thing I find with volunteering. It empowers you in a way so that you know that you're not just a junkie.

There's a social aspect to doing drugs. It's a hell of a grind. You're always on the hunt to get money, look for drugs, or wait for the dealer. It's just a total grind all day long. The violence and people selling bunk—that's fake dope—it's not good.

It's happened to me in the past. By the time you give the person the money they're gone and they don't come out for a while because they know that you're looking for them. If it's cleaning fluid or something and you inject it, it's obviously not going to be very good for your body. It's pretty shitty when you're sick and all you got is ten bucks left, and you spend it on dope and it's garbage.

I use Insite, the supervised safe injection site, and it's saved my life. One time I got some really good heroin and if I would've done it at home alone I could've died, but at Insite I started to go down, and the nurses got me right away. With heroin, you kind of go to sleep. Then you stop breathing. So I was getting to the part where I was falling asleep and my breathing was getting really shallow. They gave me some oxygen and they kept me awake and kept telling me to breathe. I'm grateful for that.

I've only had a really good high a few times in my life, like two or three times where your whole body's warm. Have you seen that movie, *The Basketball Diaries* with Leonardo diCaprio, and he's a heroin addict? He's running through a field of tall grass with his shirt off and it's warm and he's just running and jumping without a care in the world. That's what it feels like. You don't have a care in the world. That's the high that you want, but basically now it's about maintaining and not getting sick.

I'm on Methadone, but I don't like it because I'm a slave to it. If I don't have it then I'm going to get sick and it's worse than heroin. I've been on it for eight years and I want to get off it—it's hell.

"Chinatown Pharmacy" by Gary Cormier, 2007. Francis fills prescriptions for methadone in the Downtown Eastside.

Methadone actually intensifies smoking rock, so that's why a lot of people on Methadone don't do heroin anymore, but they start smoking rock more than they used to. If you're on a large enough dose of Methadone it blocks out the drug high completely, but I'm on a lower dose so I get a little bit of a feeling when I inject heroin.

I'm Chinese. I got two brothers, but I'm the only one that does dope. In Asian families, there's a lot of shame toward people who do drugs. It shames the whole family. It was hard for a while, but I speak to my family now.

I was thirty pounds lighter when I was doing crime. I'd be up for days then I would go to my parents' place to crash for three days straight. Addicts can stay up for days, because you always have a need for more rock. Like with some of the working girls, they just have to go out on the corner and they just keep going for days and it keeps them up and eventually they'll come to a point where they get so tired that they have to crash, but that's when they fall asleep and they're in such a deep sleep that they can get robbed or raped and they won't even know about it because their body needs to shut down.

I ended up going out with a girl that was working the streets. I was doing B & Es at night so I'd have money in the daytime and she'd go out at night, and so we'd have dope day and night.

I've been in and out of jail so many times, I can't tell you how many. I've never done a lot of time because I've always pled down to a lesser charge. They charge you with everything and then you plead down to maybe two out of the five. So the most I've done is like thirty days out of forty-five.

I went to the New Haven Correctional Centre, which is now closed down. That was on Marine Drive. It's the farm. I didn't like the atmosphere. It was minimum security so a lot of the guys were there for petty crimes. It was like a kid jail. I asked to go to Fraser, which is a high security prison, but they wouldn't let me. I really didn't know anybody in minimum. It's better when you know more people in jail.

When you are in prison, you need to keep your mouth shut and find your niche. The "range" is a section where they hold thirty prisoners. They call it a "range" and the guards are known as "bulls." If you go on a range and you got a beef with somebody that's been in there for a while, then everybody is against you. Some guys would come on the range and they're beakin' off and I know they're scared or whatever, but those are the guys that usually get beat up. You have to have a little respect. So I did alright.

Doing a B & E is an adrenaline rush, but it's scary too because it's wrong. We were doing "smash and grabs" when computers first came out. We smashed into buildings, but I justified it by doing commercial businesses instead of residential houses. I know it's still wrong. I have a lot of regret.

Usually you're doing it with a stolen car, so your heart would be beating really fast. Sometimes the cops would be chasing you. It's scary. You could run

somebody over or wipe out a minivan full of a family and that would be it for your life.

I'm tired of going to jail. It's one of the reasons why I got into Methadone. I've been involved with drugs for eighteen or nineteen years now and it's getting to be way too long. I'm just slowly working my way out. I'm not lazy. I see a lot of laziness where addicts expect to get welfare and then they want more. Some of them just don't work for anything they get. It's like a hand-out that they come to expect. They don't understand that in some countries people are starving—they don't get nothing. People need to at least contribute to society.

*Greg's interview was among the first we conducted. We first talked with him in 2005. At the time of publication, Greg had recently finished treatment at a rehabilitation facility in Maple Ridge. He is presently drug-free and plans to go back to full-time work. Greg says that his participation in the photography contest was a factor in his recovery. He looks forward to getting off social assistance and freeing himself from methadone.*

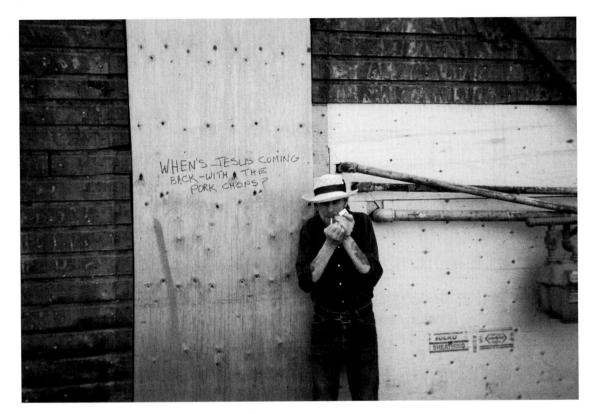

"When's Jesus Coming?" self portrait by James Cumming, 2006.

# JAMES CUMMING

born 1943, Vancouver, BC

In the 1950s, if you wanted to get along with the other little hoodlums at school and on the street, you smoked. When I'm talking to friends who know East Van from back then I just refer to it as the hoodlum circus. Basically it was fists, black leather jackets, night time, and theft. You're thirteen, so you had older friends who'd go to the liquor store with the money you'd be making from stealing. I made a lot better living when I was thirteen than I do now because I was a thief. We used to rob construction sites for materials and sell them to the scrap dealers.

My father had a job at Burrard Dry Dock in North Vancouver. My mother worked at Woodward's in the bakery. It was a different world—you'd have junkies but you wouldn't know it. They'd be in their rooms or the alleys or being hauled away in a cop car, but they weren't sitting on the street shooting up.

On the weekends, our parents would take us downtown. Mom would go to Army and Navy and Woodward's to do the shopping. To get rid of us she'd send us off to the Lux to see Roy Rogers or whatever was on. It was a decent enough neighbourhood at the time in the '50s. You could send the kids off to keep an eye on each other to see the movies for the afternoon. She'd meet us outside later and we'd help her home with the stuff on the streetcar up Hastings Street. I remember so clearly the *cling, cling*. My God, I loved those streetcars.

In the '50s it was all out warfare with the Italians. They had their area in East Van and you were stepping into some dangerous business if you went walking through their turf. They knew who you were. Same thing if they'd walk through our place, through our streets, the Scottish and Irish.

Chinatown was foreign and strange and we'd go there to peek at the Chinese, see what them guys was doing. But it really was like a different world. It still has that aspect. If you look at the people over on East Hastings and you move over to Pender Street, bammo, different world.

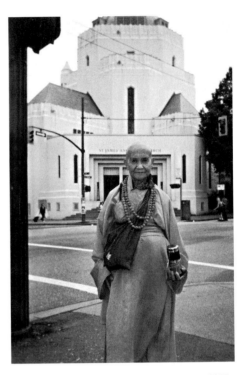

"Corner of Cordova and Gore" by James Cumming, 2005.

Vancouver has always been a port city, so there's always been heroin. I don't want to discuss my own dealings with it all that much. It was here. It was available, but as I say it was very low-profile because nobody wanted to go to prison. If they caught you with drugs, you were on your way to the hell hole of the BC Pen in New Westminster.

I was never incarcerated there. I spent some time in Oakalla in Burnaby. You were sent to Oakalla if you'd done something that got you less than two years.

You could do some time there without it being all that bad, but you better be tough enough to survive it.

When I was eighteen and coming off the hoodlum circus, I'd be sent to Oakalla and meet my friends there. We all did little stretches in there for something.

Oakalla is gone. It's townhouses now. They wiped it out and got rid of it. The BC Penitentiary doesn't exist anymore either. I know somebody who's got a condominium out on what used to be the grounds of the BC Penitentiary.

I know Native people now where I wouldn't have known them in the '50s. I just walked past them on the street at the time, but I know them now so we discuss what it was like in those days. One thing we agree on is that Vancouver was just an absolutely wonderful place to grow up and be a kid. It was an open world then. It wasn't all shut down with gates and security. We could go down to the docks and walk onto the ships and mix with the longshoremen.

I went to sea when I was fifteen years old. I went to sea because I was madly in love with ships and the ocean and the whole idea of sailing the hell outta here.

I sailed deep sea and I've sailed on the Great Lakes. I was out on the water from fifteen 'til about twenty-five, twenty-six. I shipped out of New York, on foreign ships, Norwegian, Swedish.

Those were slave ships. We weren't chained or shanghaied aboard, but on the deep sea ships, you'd work seven days a week under difficult conditions.

Living and working, being on the sea every day, is hard—you'd work all the time, except when you were tied up in port.

Then you'd have a bit of money so you'd go to the bars and pay the prostitutes and then you'd be broke and have to go back to the slave ship. Our reward was $25 a week, $100 a month. On Sundays we had our choice between an apple and an orange so that we wouldn't get sick. Which one do you want this week? Here's your $25.

I wouldn't care less 'cause I had $3,000 saved up from working Canadian ships, so when I got to places over there like Nagasaki or Red China, it was *hallelujah, baby*. When you got off of the ship in Yokohama in the '60s as a young sailor with a few bucks in your pocket and went past the docks, the prostitutes would fight for you.

Montreal was a hell of a place. There's a place in Montreal, it was called the Main. It was bars and brothels from one end to the other. That was my life. I've got a few tattoos for souvenirs, but that's all I've got left out of it.

I discovered art in New York City. I was nineteen and staying in Hell's Kitchen. I'd had enough of Manhattan and the Empire State Building, so one day I got all enterprising and took the subway uptown to Central Park. Somebody had told me that there's a big place up there showing pictures. I wandered around Central Park and found the Metropolitan Museum of Art.

Here I was wandering in—I'd been drawing little pictures, so I wanted to see bigger pictures. I'm walking around and it's huge. This wasn't my world. To tell you the truth, for me it was like Versailles.

"Kitchen" by James Cumming, 2005.

I had never been in art galleries. I didn't know anything. Believe me, in my parents' living room, we did not play Bach. We did not play Vivaldi. We'd be lucky if we got up to some jazz.

We did have prints—dogs playing poker. That's why it was amazing to me, and delightful, the first time I saw Rembrandt, Van Gogh, Gaugin, Monet, and Lautrec.

But I didn't go into the museum and see these big things then go, "Well, that's it mister, I'm inspired. I'm gonna be an artist." I walked out of the place feeling the shits. Who was I? Winslow Homer?

I had never even picked up a brush—hadn't got there yet. But I had a pen. I had a pencil and a piece of paper, or a little book.

When I walked out of the museum at nineteen, I knew one thing for sure. It was impossible. It was impossible for me to ever become an artist 'cause how the hell was I ever gonna do that?

I didn't know how to pick up a brush. I didn't know how to mix a colour. I didn't know how to stretch a canvas. I didn't know nothing, but I had seen

what the great artists had done and when I walked out the other end of the place I thought that I may as well go back to the bar.

Over the last few years, with the greatest difficulty, I've been painting. I've been buying paints and brushes with my food money. That means standing in the sisters' soup line in January holding tight because I'm so cold—slowly getting closer to my soup and sandwich. That's what being a bloody artist is, or is for me.

For the last few years I've been painting a 250-square-foot paint-

"Carver and Mask" by James Cumming, 2005.

ing that's a 100-year history of the Downtown Eastside. It's eventually going to be in the foyer of the Vancouver Public Library. Right now it's rolled up on someone's floor. I have no money, no strength. But I'm still painting.

As for the photograph, I was walking around the streets and saw this piece of plywood on the back of an old building. I read it and it says, "When's Jesus coming back with the pork chops?"

So I said to my friend Mark, grab the camera and get a picture. I'll stand here. I'll light a cigarette, make sure you get that in. Jesus is coming back when God's got the sense to get rid of us all.

I walked past a Christian a while back and he was in front of the bums telling them about the glory and the wonder. So I said, "Can I ask a question?" He says, "Sure." So I said to him, "Boy," I says, "did God create everything?" "Oh, you bet," he says. "Well then, tell me something, why did God create bedbugs? Why'd he inflict them on the poor?"

He had a little cap on his head with a patch that said, "I ❤ Jesus." He stood there with his mouth open looking at the ground for a moment, and said, "I'm gonna go home and look that up in the Bible tonight."

They don't like you asking questions 'cause now the other guys are jumping in. "Yeah, man, how come there's bedbugs? How come they're biting me? How come I'm poor?"

I don't mind being poor, but I hate all this thrown on me too. "Why does the whip hand come down again, why did God invent the whip hand, why's it have to smack down on me again?" That preacher doesn't know what it's like to have bedbugs on your back, that's the truth. He got back up on his damn soapbox, but by that time I was on my way because I'd had enough of the bastard.

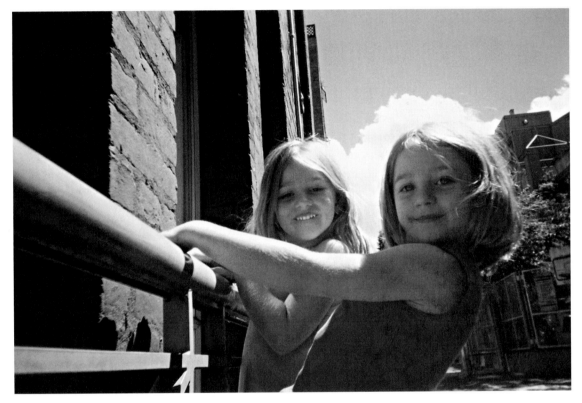

"Two Girls Playing" by Laurel Dykstra, 2006. Myriam and Harriet are four-year-old twins and daughters of Laurel Dykstra.

# LAUREL DYKSTRA

born 1967, Victoria, BC

I was born in Victoria in 1967, though I lived for about ten years in the United States in different communities before I came back to British Columbia. I've been in BC for three years now. I came to Vancouver because I wanted to be closer to family.

My stepfather was becoming progressively more ill and I wanted my kids to have the advantage of knowing him as much as possible while there was still time to do that. I was looking for any space in a housing co-op in a pretty big radius. Four Sisters, where I live, was the first place to have a vacancy. It's a housing co-op that has a fairly high turnover, in part because it's here in the neighbourhood and people don't always know what they're going to get when they get there. It's right at Main and Powell, behind the fire station.

That photograph is in the courtyard of Four Sisters. It just celebrated its twentieth anniversary. The girls are climbing on the balcony railing of one of the buildings. There are three big buildings. The interior courtyard is incredibly well-tended in terms of landscape and green, and there's trees that are twenty years old. If you climb up to the fourth floor, you can look down on this canopy that's right at eye level. Lots of birds are building nests right now, pretty amazing wildlife in this city for a hardcore urban centre.

My natural tendency is to be an introvert. I'm happy on a long-distance Greyhound ride to read my book and look out the window and not talk to anybody, but I think that that's not the healthiest way for me to live. To live in a

situation where I'm structurally dependent on other people and accountable to other people is really important to me. I think that a very nuclear family model of one family, one house, one car, one TV—or I don't know, three TVs—is not a really healthy model. It's really part of the sickness and isolation of our culture.

I've been in the neighbourhood for a couple of years. I work with the women's group at VANDU, so the people that I work with are folks who are experiencing and have experienced some of the worst of what our culture has to offer.

My twin daughters Harriet and Myriam and I have a unit in the co-op. My mom lives with us some of the time. Their dad, Bruce, who's my sperm donor, lives in the co-op in a unit across the courtyard. Their godmother, who's essentially a third parent, comes up and spends one or two weeks of the month with us, and then my girlfriend comes from Washington State to visit and spends about a similar amount of time. So they have parents and a lot of family members of all kinds who are involved in their lives.

Myriam and Harriet are five-and-three-quarters as they eagerly tell people right now. They are great, hilarious people. I think they really benefit from living in the co-op where there are kids younger than them and kids older than them. They have a relatively safe, very green, much bigger yard than they would have anywhere else in this city, unless we were living in a million-dollar home.

They're very shy. The whole transition to kindergarten has been a huge deal. They're very much attachment babies: they breast-fed for a long time. They grew up in a tight family in an extended community, and deciding to enroll

"Father and Daughter" by Myriam Dykstra, 2006. Four-year-old Myriam took this photo of her father Bruce Triggs and sister Harriet Dykstra.

them in public education rather than do some kind of alternative school or home-based learning was a big decision.

They go to Hastings Elementary in the French Immersion program. At the same time there's a whole lot to be said about five hours a day of state-sponsored childcare. There's a whole lot to be said against models of education which involve a lot of lining up and moving around as a group and stopping when the bell rings and learning good skills of conformity.

Because they're identical twins, they spend more time with one another. So doing things the same is a big deal for them and having everything be fair is a big deal for them. If one child is sick, is emotionally unable to walk a certain distance or whatever, then they both melt down, so it's always like double melt downs.

Myriam was feeling overwhelmed by school, not loving crowds of people and not liking when kids push in line and stuff. So she often has what I like to call a professional development day. She just stays home, but because I'm working part-time, we don't get to stay home, so she'll come with me to VANDU.

Recently she couldn't go to school because she had an earache, and so we went to VANDU and Myriam had this great day where she got to go to the bakery

and choose a cupcake to give to one of the women on the project as a birthday present. She got to meet someone she just considers the most glamourous person in the world who I don't think very many people would think is very glamorous.

Then as we walked through the alley to get from the office to the Chinatown bakery and back, Myriam says, "I see a syringe, you'd better pick it up." It's a great advantage to my kids to live where they do and to have the community that they have. All of those things, to be able to share a gift with somebody who doesn't often get a gift; to admire somebody who in lots of ways is really different from them; and to know about safety and harm reduction in the city, all of those things are relevant, valuable, and important. She learned in that day at least as much as what her twin did in kindergarten.

Mostly the kids are a source of endless renewal and joy for me. When I get angry at all of the suffering, I try to channel it into work for change. There's enough pain in this radius of blocks of the Downtown Eastside to eat up anybody, and so I think that family is a source of strength for me, as is being able to talk about the issues.

This neighbourhood gets pathologized a lot. It's like, "Ooh, it's the Downtown Eastside. Ooh, it's the poorest postal code in Canada. Ooh, it's the open air drug market of Vancouver." It's a vibrant community. People forget that children and families live here. There's a creepy thing that happens around drug use and addiction where people who often use drugs themselves and aren't also impoverished can look at an entire neighbourhood and somehow equate the use of drugs and poverty with blame. In a way that's really insidious, that people who are working on issues of housing justice in the neigh-

bourhood are adamant that not everybody down here is a drug user, as though being a drug user were somehow a reason for a person not to have rights to housing, nutrition, and decent health care.

I think that to be an Aboriginal sex worker who smokes crack and who has had her children apprehended is to be a person that everybody feels okay to hate. The measure of the city of Vancouver and the measure of the nation of Canada is how poorly those women are treated.

A model of justice is a model where each person is entitled to all of the goods of the kingdom. It's a model that looks not simply at the rich giving to the poor, but to the rich having less; it looks to a structural change; it looks to justice that's pervasive; it looks to changing tax structures; it looks to changing social structures; and it looks at the responsibility of the community as a whole.

Religion is a different experience in Canada than in the United States. In the United States, Christianity is much more overt: many more Americans identify as Christian than Canadians, so faith is much more contested there. For instance, the insidious organizing of the Christian right in the United States has forced the longer-standing Christian left to really articulate itself and its position within its work of justice.

The Downtown Eastside neighbourhood is saturated with faith-based organizations doing a variety of things, whether that's handing out candies to sex workers as a means of starting relationships, soup kitchens, or the St. James Society housing projects. The neighbourhood is saturated and yet people aren't really talking to one another.

My tendency is to lay low and get a feel for who's doing what. I think there's a real difference between a justice model and a charity model. I think that the neighbourhood is pretty saturated with the latter. And what charity does is

"Harriet Dykstra, Emile Wilson, and Daisy the Cat" by Laurel Dykstra, 2007.

make the provider feel good about exercising control over others. It's not a model of liberation, it's not a way of true justice.

The level of impoverishment and violence that pervades the Downtown Eastside means that there's just so much suffering going on that the organizations and individuals with excellent intentions and justice perspectives are caught in bureaucracy. I see a variety of theologies and practices in operation in the neighbourhood, some of which are more liberating, some of which are charity-based, and some more punitive.

A lot of women in the neighbourhood who are involved in sex work use drugs, and so all of a sudden there's all of these other harms that are much, much more pressing than whether or not you have a clean syringe or you don't use Brillo in your crack pipe. These things are much less pressing than whether, you know, the next guy who picks you up is Willie Pickton. And so people are negotiating and experiencing violence: women are experiencing violence from partners, from customers, from predators, from peers. So there's this whole area of harm that's not adequately addressed.

I certainly see women every day who come in to the VANDU office with signs of assault. If you live in the neighbourhood, if you work and walk around here, you can see guys dragging women into the alley all the time.

In those moments, it's hard to know what's strategic right then and what's strategic for the long term. Sometimes I stand around and look like I'm holding my cell phone and stare at the people involved. If I know any of them I try to distract them. I think that that's the most effective, non-violent technique: just offer something that's completely outside of the existing situation. So pretend like you missed the whole scenario but shout out, "Hey, I owe you a coffee date, so come with me." It's important to be completely public and random but not address the conflict head on to avoid entering into a further conflict.

There is overwhelming poverty here. My own experience with it happened when I first moved to Canada. When I was in Washington State I lived in a community where people would make donations to the needy. I had food, a little apartment, a monthly stipend to spend on books and beer, the clothing bank to draw from, so my basic needs were met. When I first came to Vancouver, I lived in a basement bedroom with some friends with no income and no community structure set up around my life.

During my first year in Canada, I hadn't lived here long enough to access some of the services. It was three months before my BC Med kicked in, and so all this money was going out to cover basic survival issues, and very little was coming in. I had a year of poverty that wasn't intentional in the way that some in my community experiences. I had to get food from a couple of different food banks and be incredibly strategic about what I could do with small

kids for very little money. So we would go to the park, the public library, and the swimming pool on the dollar admission day when my kids were young enough to get in for free.

During that year, eighteen months before I got the job that I have now, my stepfather died and there was a small inheritance that I was going to get—about a thousand dollars. I would fantasize about the ways that I would spend it—new underwear, a better toothbrush. I'd divvy it up all of these ways. I was dividing it out frugally. That kind of poverty takes a high toll. It was an emotionally difficult thing to go through and I was only doing it for a short time. That was my experience of suffering through poverty, and imagining going through that for a long time is daunting to me.

I have no desire for a fancy car. Just recently I've thought that it wouldn't be a bad thing to own a home one day, though I don't know that that's very realistic in Vancouver. The things that are appealing to me about the good life would be the opportunity to study and read and write without feeling like I was sort of stealing time from other things.

One of the aspects of the good life that I have had for almost all of my children's growing up is that I've been able to be really available and present to them, to be in a really intensive parenting relationship in a way that I think lots of my peers, in the scramble for the good life, haven't had, and really aren't any more financially ahead than I am.

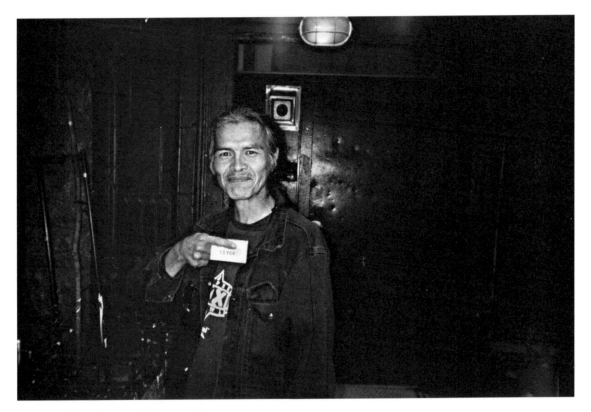

"Clyde Wright" by Rob Morgan, 2005.

# CLYDE WRIGHT

born 1963, Hazelton, BC

I'm originally from Hazelton. My nation is Gitxsan. I've been down here seven years now.

I was a ward of the Ministry until I became an adult, and since then I've gone through the prison system—first provincial, and then I graduated to federal.

Upon my release I was going to use the voucher for a bus ticket they give you, to go directly back home to Hazelton, but instead I got a ticket from Chilliwack to Vancouver.

I stayed here in the Downtown Eastside and got into drugs. I was injecting cocaine, heroin, morphine, percs, Demerol. I was doing whatever was available. I ended up flat-lining after an overdose. That was less than ten blocks from where we are now, towards the Native Friendship Centre. I was twenty-seven.

The number of times I overdosed scared me, but it was that last time that was the realization for me. I took my heroin and I flushed it. It was too pure.

In this photo I'm standing outside the Washington Hotel, where I volunteer and deliver food. It's a weekend gig. I'm standing there holding up my volunteer tag.

I'm doing better today than I was at the time of that photograph because I'm

helping more people now, and I get moody when I'm not being useful. I need to do a good deed every day so I feel good.

I've been involved with First United since I got down here. This is my second year as a board member of VANDU, and I'm the vice-president of the Western Aboriginal Harm Reduction Society. VANDU is made up of former and present users. I fall into both categories since I don't inject anymore but still use on occasion.

We help addicts. I myself prefer to call them hobbyists, because it's more discreet and less harsh a term. I've done most every drug that's available down here and my drug of choice presently is limited because I don't really get much from it anymore. I'm not helplessly or hopelessly addicted.

Functional hobbyist addicts are able to go to work, maintain their work, not do any of their drug of choice at work, and at the end of the day when they're not working they can indulge. They can control it. Should they want to quit, we can refer them to a detox or rehab centre.

A number of people down here confide in me because they know I'm honest and confidential in our conversations. Should we quarrel or argue, I don't bring up any of what they say to me. I'm not spiteful. I don't throw it back in their face. People have a lot of trust in me.

Being a VANDU executive this year is I guess somewhat of a promotion, because last year I was just a board member. The year before that I was just a member. I enjoy helping people because I've been through a lot in my life.

The government took me from my family when I was six years old. I was put in a residential school in Port Alberni. I was there four years and while I was there I was abused by the guardians of the residential school. The authorities at the time would not even listen to me, so I became somewhat disruptive.

I remember being forced on the bus—being literally dragged on board and sitting in the back. One father came on and actually took his son off the bus. I still know the son. Over the years I've had a great dislike for him and his father. He wasn't at the residential school and he tries to be part of the group when he's got no understanding of what residential school was like.

"I'm sorry, buddy, but you weren't there. It didn't happened to you. Your dad took you off the bus." He kinda sits there and doesn't say anything, which is good because I was forced to go. I had no choice. I said to him, "Your dad had knowledge about the school that if he took you off the bus, then you wouldn't have to go."

My parents on the other hand were told if we didn't go, they'd end up in jail—which wasn't the truth. But this guy's father knew that he could remove his son from the bus and he didn't let the other parents know. He didn't inform them about their rights. If he had, then no one from Hazelton would've gone to any residential school.

I was angry at my dad because he was never there while I was in Port Alberni. My mother had died and I was in trouble with the authorities, but they couldn't put me in jail because I was too young. I became a problem.

Authorities label me as a human time bomb on the grounds that I have an authority figure complex. This is the main effect that residential school had on me and still has. I have a high tolerance of pain. I've been maced and pepper-sprayed I don't know how many times. I've been tasered twice in a matter of minutes.

As soon as the police read my record, they step away from me. They'll be standing close to me, but as soon as they get that information about me over the radio, they step back two feet at least. It just makes me laugh.

I'm that dangerous? Okay, possibly, but they'd have to provoke me.

My oldest brother and sister were sent to residential school too. If they were abused, we didn't talk about it. We simply didn't talk about the school after we got home.

After residential school, I became a ward of the Ministry. They bounced me around foster homes throughout the province. I'd last maybe six months at any one place until one day they moved me to Victoria. I was more comfortable there and grew up there for I don't know how long.

The group home parents were elderly and I hurt one of them once. I felt real bad about that and still do. They were awesome parents. After I was released from jail, I went to Victoria to visit them; I knew where they lived and I knocked on their door, but there was no answer.

I'm not even sure if they're still alive. But I thought if their son or daughter were around then I could say, "I'm Clyde and your parents used to look after me."

I did leave a message. I wrote, "Clyde Wright, former resident of the group home on 1250 Balmoral Street, stopped by. You weren't home. I'm doing good." I put my age, my birth date, and I signed it, just to let them know.

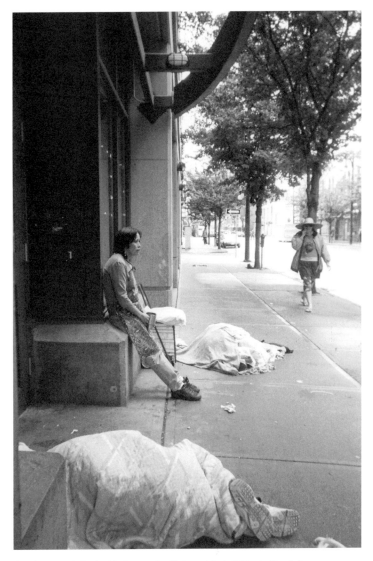

"Breaktime on Columbia" by Donna Gorrill. Laura Mitchell (Carrier Band), from Moricetown, BC, takes a break from volunteering in the kitchen at the Downtown Eastside Women's Centre.

# DONNA GORRILL

born 1956, Vancouver, BC

It took me almost fifty years to end up in the Downtown Eastside, so it's kind of a shock to end up here at this late stage of life after working since the age of sixteen. At the age of thirty-seven I had my first child, so I was kind of a feminist career woman up until then.

At the time I had my daughter, I was a facilitator in life skills at a local college. So to me it's fascinating that someone who teaches life skills and shows people how to create resumés and how to get jobs and cope with life ends up in the Downtown Eastside.

I went to university for the first time in my mid-forties. At that time, I learned that if you're from a family where neither one of your parents has gone to university, it's unlikely that you will get to go. In other words, I learned in sociology how to predict how my life would've been if I had come from a family of university graduates and had I myself been able to go to university as a teenager.

When I was a child our family lived in Vancouver's successful social housing development, the Little Mountain Housing Project, which is now being redeveloped. I was raised in a single parent family on welfare. Nowadays the sociological predictors for the success of a person like that are pretty low.

You're unlikely to go to university if your parents never did. You're more likely to perpetuate your social status. That's something I wish I'd had the

benefit of knowing when I was sixteen, not when I was forty-three. I might have made different decisions in my life.

In university I was able to look back on my life. Actually it was a blessing in the end because I could stop taking poverty so personally. I could see that the things that happened in my life were things social science experts could tell me were likely. No education, no good job, no good money, no good relationships. They could have told me, "Honey, you're going to end up dysfunctional."

I had my first child at thirty-seven, but still I wasn't prepared for motherhood. It was harder than I expected and not natural to me. There's this myth around motherhood that the baby pops out and you put it to your breast and you're one little happy unit for the next six months.

My baby didn't learn to latch on for four days and I worried that she'd starve to death. I had nurses tweaking on my nipples; nobody had ever touched my nipples unless I'd given them express permission to do so.

I don't know if I was raised in too much of a TV culture or what, but after I gave birth I was like, "Wow, this is what aging really looks like"—I didn't think it was going to happen to me, for some reason. So motherhood was a slap in the face—just learn to live without sleep and lose all your friends, because you're cranky all the time.

But here's something interesting I learned. Women take it on the chin for having the kids. If you're a single mother on welfare, people will say, "Tsk tsk tsk, you can't control your libido." But the thing is, if girls get their menses

at thirteen and they don't go away 'til they're fifty—that's a lot of years to try and not have a baby.

I mean, for women, it's pretty certain that some time in the next forty years you're going to get pregnant because that's the way women are built and that's the way relationships work. We really have to get off denigrating women for having babies for any reason.

As a single parent, I was on social assistance. I'd been out of the work force with my daughter for a year or two. I felt at the time I wouldn't get a good job because I was also in a new small town, so instead of getting a mediocre job and putting my infant in daycare, I went on welfare so I could actually be with her until she was in kindergarten. That's when I started university courses.

Education explained my life so that I knew that my poverty didn't happen in a vacuum. It happened in a greater context of things. Even still I don't think shame can be disassociated with poverty. I could understand poverty and I could be easier on myself about it, but shame still comes when you're standing outside for free food.

This photo sprouted naturally out of my daily routine of going for coffee in the morning. I was heading in there and I saw Laura. It was nice and quiet outside. Often there's lots of people, but she was on her own just taking a break. I decided that would make a good picture. I made a deliberate effort to get the people on the ground in the picture as well because I see people around there sleeping all the time and people that have slept there getting their blankets ripped off.

There are always people sleeping around the Women's Centre, but I've never seen any pictures of it. You wouldn't know that it happened that way without the photo. Bridge Housing is above the Women's Centre, so I think people feel safe to sleep there because there's an intercom and a camera in case of an emergency.

Laura is a volunteer in the kitchen. I got to know her at Mary's Place where women can go for coffee on Mondays and Fridays. I saw Laura there quite a bit.

I started living in my car on Homer Street because it broke down there. I don't know if you can imagine sleeping in your car on Homer Street as a single woman because you don't want to be visible.

One evening I came back and the windows were smashed out, so that was the end of the car and my living in the car. I called my brothers and they said that I should stay with them. Often family has good intentions, but what they offer you just won't work for you. I knew that I was going to have to do this on my own.

So my car's broken down on Homer Street and the police said, "You're coming with us." I'm told them, "Leave me the fuck alone." I think they called the nut van, thinking I was having a mental breakdown.

I was just stressed. I had no money and no roof over my head. I'd been living in my car. Life was going steadily down and I knew things weren't good.

So that's the thing about the Downtown Eastside. There's all the scary people and all the obvious drug use, but even more pressing is the sense that if you don't keep a damn good grip on yourself here, you can lose complete control of your life. They'll put you in the nut house because you can't deal with the stress anymore.

I'm not attached to a job so I can have any political opinions I want. I also have started learning how to paint in the Downtown Eastside, so that frees me. Freedom from a job means freedom to explore who you really are and perhaps things that you should have been doing all those years.

I came from a welfare family, and art wasn't a feasible consideration. Expanding your creative side enhances your critical thinking. They work together, not separately. I stopped making art in grade three and was lucky to find it again at forty-seven.

I fell in love with painting. It's the first time I've had a hobby in my life. I'm finding it hard to pursue because I can't afford supplies, but still I've discovered it and I know I'll pursue it.

I live at a city-owned building for hard-to-house women. Most of the people I live with are seriously addicted to heroin or other drugs and they are subsistence street workers. Now, I don't know if you understand what a street worker is. It's beyond prostitution. A street level worker is basically hooking to support their habit. They're doing it because they need the drugs.

I've smoked pot, but I don't do hard drugs. Now here I am living with hard drug users. I had issues at first. They were rude, loud, and noisy, and they still

are. I realized they're not going to change, so I had to change. I've come to have quite a bit of affection for almost all of them. Since I started working at sixteen I didn't have much time for friends and now I have never had so many friends—that was something lacking in my life.

I'm an independent, loner type of person, so it's not like, "Oh boo-hoo, I'm lonely." I never felt like that, but is it ever a wonderful feeling to go out in the neighbourhood and have people smile and say they are happy to see you. It doesn't have to be big heavy conversation, but it's nice to quickly check in with people.

The building where I live is friendly. I've lived in other apartment buildings where you hardly ever saw anyone else and you never said hi. In the Downtown Eastside there's more actual interaction between people than in most communities that I've been in. When you say, "How are you?" to people here, they will actually tell you.

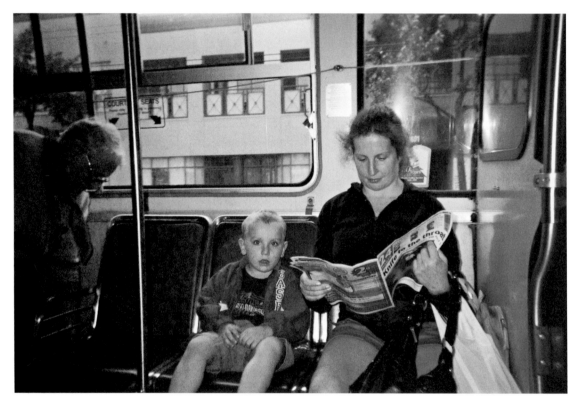

"Woman and Son" by Jo, 2005. Trina Prop and her son are riding an east-bound number 20 Victoria bus through the Downtown Eastside.

# JO

born 1962, Trinidad

I wish we would've kept track of this woman and her son, but I haven't seen them around the Downtown Eastside. To me she epitomizes what a mother should be like, because it was a hot day and she's coming home and her son is asking all these questions, and you'd expect maybe she'd be short with him, but she would turn to him, touch him, and answer very lovingly.

It was the number 20 bus running through the Downtown Eastside and she was getting off at the next stop, so I had to take the picture before she got off.

My husband and I have five grandchildren and five children. Our eldest is twenty-eight.

I've been married three times. My mother tried to marry me off when I was twelve. She said, "It's a good age," and the man she picked was twenty-eight years old. I sat there and I went, "What would we talk about?" The sex part didn't even occur to me. So my father said, "We're in Canada now. She's not getting married off at the age of twelve."

We come from Trinidad and Tobago. My mother's father was from Hong Kong and her mother was Caribbean-Chinese. My father is Trinidadian.

We left Trinidad when I was seven. We came over as political refugees because my father was in the government and they tried to have him assassinated. I've been in Canada for over thirty-three years now.

I live two blocks from Chinatown, which is where I want to live because I know all the foods and the markets and I cook Asian food. My neighbourhood has everything, but I am considering moving because the police have pushed everybody from Main and Hastings to Oppenheimer Park and they're trickling over to my apartment building. They mainline in my stairwell. I get those alcohol swabs and syringes that you can get free and just place some by them as I'm going down the stairs.

My husband Russ and I don't live together because I have a bipolar affective disorder. He's always kept a place of his own because when I get manic I would throw his stuff away. We're pretty much in each other's pockets, but for the first four years I got him kicked out of everywhere he lived when I had a manic episode. One time I sent the police after him because I told them he was a drug dealer. Another time I kept sending girls up to his room and they thought he was a pimp so they kicked him out. The poor guy.

Right now I work for Census Canada and I teach BRIDGES courses, which stands for Building Recovery of Individual Dreams and Goals through Education and Support. I'm in treatment and BRIDGES is peer taught, so I have to have a mental illness to be teaching it. I was trained and I've been doing it for two years. We have fifteen students and don't go any higher than that.

Most people do not believe that you can recover from a mental illness, but BRIDGES says you can. Most doctors just want to treat you with drugs, they treat you from the neck up. They don't believe you have a body, so if you have side effects they don't care about it.

"Bike Repair" by Jo, 2005. Local man James Parks fixes bikes up and sells them "really cheap" to people he likes.

I have diabetes from medication. I also had hypothyroid from medication, and tardive dyskinesia, which gave me uncontrollable spasms. I had to go and get three botulism toxin shots in my larynx just so I could eat, talk, and breathe. Then my eyes went. You could only see a quarter of an inch of the whites of my eyes. They were going to give me a white cane to walk around with because I was getting five botulism shots around each eye. Then I saw this doctor who said, "What's wrong with your eyes?" I said, "I have tardive dyskinesia" and he said, "Here, take this medication," and seventy percent of it was cleared up within a week. I'd suffered with it for five years. Doctors just don't seem to be able to get their act together.

I've been hospitalized for mania over thirty-five times—and I mean the real hospitalization where they put you in a straight-jacket and stick you with needles. The first time it happened to me, I kept saying, "I'm a Canadian citizen, can you do this to me?" They said, "Yes."

When I was young I used to love going to school, but one day when I was around twelve, I just couldn't go anymore. I was crying and my parents

couldn't get me out of bed and I didn't know why. I remember my mother said to my father, "Do you think she has it?" But I couldn't figure out what they meant.

When I was twenty-four my parents came to me and said, "You've got this and this and this," and I didn't believe them. I was in a jail cell when I had my first delusion. I had this hallucination that the police officers were cutting my relatives up into pieces, putting them in buckets and throwing them bucket by bucket into the cell. I tried to crawl to the bars of the cell and my hand pressed on something. I lifted it up and it was my daughter's eye. I spent the whole night trying to put her back together. I tried taking veins out of my arms so I could put them in her and build her back together.

The next day the prison matron who had talked to me when I first came in brought me breakfast. She had a breakfast cart between her and me. I lunged at her and tried to grab her because I wanted to rip her apart. I had assumed they were chopping up my relatives. The only thing that saved her was the cart between us.

When you're told that you're a monster like that, you have to believe in euthanasia. I keep telling my therapist I feel like I'm a weed and one day somebody's going to realize it and pluck me out of society, but now recovery is a possibility and I haven't had a manic episode for four years.

Sixteen years ago I left my home. I just totally left. We were living in Moose Jaw, Saskatchewan. My husband had the kids and they were visiting in Saskatoon. I just took off. I never left a note. I never did anything. I'd saved up

money. I took a bus to Vancouver. I'd never been here before. I arrived with two dollars and something cents on me. I came to Vancouver to die.

I lived in the Roosevelt Hotel, which is right behind the Carnegie Centre. I chose to live there because I was suicidal and I didn't care if I got killed. My room was clean because I knew the Chinese guys. They liked me. They gave me a hot plate and food and they would change my sheets. But the rest of the building wasn't kept up. You'd go into the bathroom and there would be rigs in the tub. So if I had to take a shower I would have to first clean out all these rigs in the tub.

Two weeks after the Olympics plebiscite was approved, people started getting notices from their landlords in the hotels saying they would have to vacate for renovations, and that when they come back the rent would be increased. I had another idea. How about, "You have to move for renovations, and when you come back it'll all be low income housing"?

You have these people living in these rat holes. They can't even get a drink of water if they even have a sink in their room because the building is so old. Who's going to drink water coming out of those pipes?

I've tried to kill myself nine times, but it doesn't work. I came up with a great plan: go to a gun range, say you want to practice with a gun, and then shoot yourself in the head. So I tried to do that in Saskatoon and just as I was putting the gun up to my head the instructor came back in, and because I knew what I was doing was wrong I put the gun down out of reflex. I put it down, but he stayed right next to me for the rest of my time and he said, "Don't come here anymore."

Thirteen years ago I was suicidal because I was told there's no cure and I thought that I'd still keep having all these episodes. One time I supposedly burned down my house. They can't figure out how it burned down, but they said I did it.

That night I had taken eighty sleeping pills and gone to a park to die. I passed out. I don't know how I could've gotten back to my house and burned it down. When I came out of the sleeping pills I was strapped down in a psych ward and there was this huge RCMP officer standing over me and he said, "Tell me, why did you burn down your house, assault one of my police officers, and trash a convenience store?"

I had no recollection of it at all. All I remember is taking the eighty sleeping pills and laying myself down in a park. In the movies, you take sleeping pills and you fall asleep. In real life, that's not true. My stomach felt like it was being torn apart. I couldn't breathe. I was like that for about half an hour to forty-five minutes before I actually passed out. That I remember.

The psych ward is inhumane, especially if they're going to be treating you with drugs and not addressing your body. A mental illness is a physiological disease, which means it affects your whole body. So why do they only deal with you from the neck up? A psychiatric nurse told me that within one week of staying in a psychiatric ward your muscles start to atrophy because either you're strapped in or you are catatonic.

My friend who had shock therapy sat in any position the nurses put her in and she was left there for hours. This other woman complained that her meds were so strong she couldn't get up in the middle of the night and find the

bathroom. The nurse said to her, "Why don't you wear one of our diapers, then?" She says, "I'm twenty-eight years old, I'm not going to wear a diaper to bed. I want you to adjust my meds."

I thought it was a reasonable request, at least in that ward. In another ward, a 300-pound orderly actually sat on my face until I passed out.

I'd like to think there is a community of mentally ill people in the Downtown Eastside because we have the Living Room, which is a drop-in centre for mentally ill people. They serve coffee, snacks, and meals, and they're free. They have Bingo and outings and stuff like that, so that's really good.

I live in a mental health building attached to Triage Emergency Services. We have staff during the day, and at night if you have a problem, the emergency centre can help you.

The police kept picking me up when I was manic. One time I thought there was a bomb on a Skytrain so I hopped down onto the tracks and I was walking along them looking for the bomb so I could defuse it. People were yelling at me, "Get off the tracks, we wanna go home."

A security guard came down on the tracks with me and she said, "What are you looking for?" I said, "There's a bomb here and I'm trying to defuse it." She talked to me and she said, "Well, don't step there," 'cause I was barefoot and we were coming up against some metal that has electricity. She got me up and the ambulance was already there. They strapped me in, but they were very nice about it, they said, "Do you mind if we strap you in 'cause it's easier to transport you?" And I told them to go ahead.

One time I hallucinated that the bus I was on was going to kill my children—I thought they were walking on the street, but my children are in Saskatoon. I forced the bus to stop and I was beating on it until an undercover policeman got me out, put me in a paddy wagon, and took me off to jail.

I prefer jail to the psych ward. I really do, because there they put you in four point restraints.

I've been in recovery for about four years. I haven't had a manic episode in that time. Before that I was put in the hospital two to three times a year.

Sometimes they say you can get better through age and therapy, but for me it was the therapy and finding out about BRIDGES that stopped me from being suicidal. They said, "You can recover," and I went, "What, I can recover?" I had never heard that before. I was stunned to know that you can recover.

My mind-set was that I came to Vancouver to die. My grandmother on my mother's side is a white witch and my grandmother on my father's side is an obay woman; obay means voodoo, same kind of voodoo you see in Jamaica. She used to do all these spells in front of me. I used to think, "Oh, this is cool," because my other grandmother showed me how to bake cakes and make food and pies and this one showed me how to pick a rooster and get the tail feathers. I was taught how to will myself to death and that's what I was doing when I was at Riverview Hospital.

I was in the quiet room where no visitors or unprofessional people are allowed. So Russ couldn't get in to see me, but one day they phoned him up and told him that all she does is sit in a corner. She won't eat anything. She just sits

"Chinatown" by Harry Jarvis, 2006. Photographer and addiction counsellor Harry Jarvis spent a lot of time in Chinatown during his own time of addiction. He learned basic Cantonese so that he could say hello to the Chinatown Merchants. The Chinatown Merchants Assocation has become a vocal supporter of North America's first safe injection site located nearby on Hastings street.

in a corner mumbling stuff and saying your name every five minutes. So Russ came in, took a look through the window at me, and said, "If you think I'm gonna do anything to help you guys keep her like this, you're crazy," and he walked out.

But they phoned him up again later when I had pneumonia; apparently they were sticking tubes in me to force-feed me. They told him they needed to do electro-shock therapy on me, but Russ said, "No, she doesn't want it and you don't have my permission." So they phoned my father in Saskatoon. They said your daughter's dying, we need to give her electro-shock therapy. Of course he said, "Do whatever you have to do to save my daughter." I got thirteen ECT treatments; every two days, they gave me one. The last two, they never put the anesthetic in properly and I started coming around. Boy did I feel that. Electro-shock therapy gives you a horrible burning sensation and tightness. It's painful to go through.

It's been terrible for Russ. He's lost a whole bunch of jobs because of me too, because when I got sick he insisted on taking time off to be with me in the hospital for all the visiting hours. After I'd had the shock therapy I didn't know who he was. He kept phoning me, and I said, "Please sir, could you stop phoning me? I don't know who you are."

So they wouldn't let him see me. He just came in anyway and four security guards were called and he looks at me and he says, "What do you mean, you don't know who I am?" And I looked at him and said, "Oh, Russ, yes I do know who you are," but the security guards threw him out anyway.

A couple of years later I mentioned Riverview to Russ and said, "That was the worst two weeks I ever spent in a hospital." Russ looked at me and said, "You were there for eight months."

I lost my math skills. I lost grammar skills and education. Until this day I can't even remember what island is next to Trinidad. I used to know all the islands and politics and things like that. I don't know it anymore. I've had to re-teach myself all of that. It never came back. And my memories of my kids are gone. They tell me about our life together, but it's just like a story they've told and not a memory.

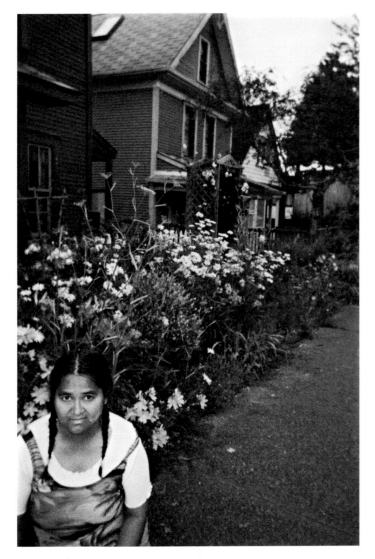

"The Garden" by Russ, 2005. This is a picture of Russ's partner Jo.

# RUSS

born 1960, Toronto, ON

I took this picture of Jo in Chinatown. We've been together for about twelve years. She's a wild one, man. She's bipolar, but she's a fighter.

I met Jo at Triage Shelter. I was there having breakfast. She just got out of the hospital after they had over-medicated her. At the shelter they gave her this big ass breakfast and she headed right for the garbage. I said, "Hey hey hey, I'll take that." She gave it to me and then she sat and talked to me. That's how we met. We've been together ever since.

Being with Jo has been a struggle at times, but we've had our good times too. Mental illness is such an awful thing. I've come to understand it. I even research her medication to see what's good and what's not good, what works and what doesn't. I've talked to doctors. I've talked to other people with mental illness. When I met her, I didn't know anything about it.

We'd sit down and I'd be eating some sandwiches and they'd bring in this little glass and say, "Here Jo, take these," and she dumps them out on the table—like fifteen different pills. "What the hell's that," I said, "a meal?" She said, "No, that's my medication. I gotta take it three times a day." I said, "What the hell's wrong with you?" She said she wanted to come out here and die. That's why she came out here. She left her family, her husband and kids, but she knew she had this problem and she didn't want to inflict it on them, so she came out here to die and that was it.

I had never met anybody who really wanted to die. I heard people say, "Yeah, I wanna die," but that was all bullshittin,' right? But Jo said, "I wanna die," and there she'd be standing in the middle of the goddamn road waiting for trucks to come by. I remember thinking, "Wow, this chick really wants to die, man." So I got to learn more about mental illness.

I'd say, "You're not the same person I met, who the hell are you? What's wrong with you?" She's swearing and she's throwing things. She's getting violent and shit like that. Her case worker where she lived told me that she's manic and she needs to be hospitalized. Then I understood her illness more and went gradually through a depression episode with her where she actually couldn't even get out of bed. She'd just lie in bed and I didn't know what was worse, the high period or the low. Since I've known her, she's been hospitalized maybe forty times. She's tried to kill me about five times.

One time I was sitting on the bed when she was manic and she thought there was somebody there impersonating me. So she ran in from the kitchen with a knife. I saw her reflection in the TV which wasn't on. I saw her coming right at me and I moved out of the way and took the knife from her.

I was getting her off the balcony once and she tried to kick me off and onto the road below, but I got her down and back into her house. Another time, she went into the ocean in the middle of February and was just floating there as her head was getting smashed against the rocks by waves. I got her out of there too.

She spent a lot of time in Riverview Hospital. When she first went there, she'd phone me and tell me that they stuck her in a body bag and took her down

the stairs by her heels as her head smashed on each step. I snuck a camera in to document the bruises because I believed her—this was in the early stages when I didn't understand that much. I had my camera and I got her in a private room and she disrobed, but there

"Playground" by Russ, 2005. Audrey McConnachie is photographed with her nanny, Iva Warden, in this shot taken at Lord Strathcona School.

wasn't a scratch, bruise, or anything. She was hallucinating. Later she'd be phoning me again and telling me all these weird things that were happening there. That was hard.

The doctor phoned me and says, "She's not eating. She's not sleeping. She's very sick. She sits in a chair all the time. We need to zap her memory out of it or she's going to die." I said, "I don't think so, man, she told me never to let you guys do that and I'm not going to let you do it." Then boom, they phoned her dad for permission and she gets electric shock.

I'm still with her. I don't know why. I don't know how. That's just the way it is. She has kids from a previous marriage and I have kids from a previous marriage, and together we have seven grandkids. She keeps me on my toes. She's not your normal person. She's a great humanitarian and she doesn't smoke, drink, or do drugs—never in her life has she ever done drugs. She's so clean she squeaks and I've never met anybody like that.

At first being with Jo was rough because I didn't understand mental illness. I'd say it took me a good five years before I fully understood what was happening. In the early stages I thought she could control it and that she was just going manic on purpose, and then I realized that it has nothing to do with her. It's not even her when she is manic. It's the illness taking over and it takes over everything. I told her, "There's nothing you can do. It's not you, it's your illness."

She'd throw away all her stuff—stuff that she loved so much. She wanted to wipe out all the memories of everything because she knew she was sick. The problem is that she's got no insight on her illness. She's apparently one out of ten thousand that when they get manic they're very violent and they have no insight.

She just spent another year in the hospital, from 2006 to near the end of 2007. She just got out of the hospital, like, three or four months ago. She was totally manic for over a year and nobody would do nothing but me. I had to call the cops at least five times, but the cops don't know anything about mental illness. They said, "What has she done?" I said, "Nothing harmful," and this guy comes out with a taser. I said, "Put that away. You're not going to need to taser her." "Well, is she going to come peacefully?" he said.

I said, "Why don't you just try being nice to her and talking to her?" But when they came in they were rude to her and so she fought them. She always fights when she's manic. She never goes peacefully and they hurt her.

So I told her, "When you get sick just listen to me and volunteer and go to the hospital. That way no cops, no pain, no bruises, nothing like that, right?"

She says, "No, I don't believe anybody should come in my house and take me away."

That's where she stands. She's not going to give an inch. But I'm not going to give an inch either. We clash when she's manic.

I've been in the Downtown Eastside long enough that I don't mind it. I've never been hassled because I'm not into drugs, so I'm away from that whole scene, but I need a change of scenery. I see people shooting up, crackin' up all the time. Everywhere I walk, every day, hundreds of people are doing the same thing.

My own daughter has been addicted to crack for three years. I've tried every goddamn thing to get her off and I can't. I actually kidnapped her once, stuck her in Jo's room, cleaned out all her pockets, threw her purse away, and stood by the door with a stick for three days.

She was crying. She was swearing. She was kicking things. I wouldn't let her out 'cause I had to keep her clean for three days to get her into a recovery house. The shit she went through was unreal, but I got her in that recovery house. Unfortunately she only stayed thirty days, but I got her in there and she was clean for thirty days. I hate that she's addicted to that shit. It's like everybody else around here.

I have a criminal record from twenty-five years ago. This is for things that I did as a kid, when I was eighteen or nineteen. I've lost so many good jobs because of it. I've been hired for a week and then they've come to me and said that my criminal record came back and they were going to have to let me go.

I'm tired of these goddamn under-the-table jobs, ten bucks an hour busting your ass. I go to this Cash Corner place. That's where I get most of my work. It's usually labour jobs, like unloading trucks or roofing in the summer, things like that. I'm in the process of getting a pardon.

You have to get fingerprinted, a criminal record check, you have to send documents to the Courts, to the jails. It's a long and tedious process. Fingerprints cost twenty-five bucks, fifty bucks for a criminal record check. Then there's all the charges you got against you and then they have to go to the Courts where you got sentenced and go to the jails where you spent time. It's a long process.

I need it though because I can't do heavy work. I was in a bad car accident when I was seventeen. I had five or six vertebrae all busted up. I was strapped to a piece of wood and in traction for six months.

Once I get my pardon, I'd like to be a driving instructor. I'll teach people how to drive. Or I can be a mental health worker. They already want me, but I got to get that record cleaned up.

I did that kind of work at Wind Chimes in Jo's building anyway. I was doling out meds and talking people down from their psychotic delusions. Wind Chimes is for mentally ill people and I was there for years. I was dealing with all these peoples' problems. They were knocking on her door to call me to do this or do that. I'd say, "Talk to the staff, I'm not staff." They'd say, "No, Russ, you come." I dealt with them like they weren't mentally ill, like they were just like me.

When I get my pardon and find good work I'll have some decent money and then I can get out of the Downtown Eastside. Eventually I'll get a place in another part of town and Jo can stay down here. I've lost four or five places because of her when she went

"East Hastings Street" by Fred Lincoln, 2007.

manic. I can't have her doing that no more. I tried staying at her place and not having my own, but when she goes manic she kicks me out and I have nowhere to go and so that was no good either.

She likes it here. All of her community and her doctors are right here. That's fine because she can visit me and I can visit her. We see each other every day. But I get a whole new life too. I get a new group of people and more activities and things to do.

I'd like to go to the West End and be around Stanley Park. I love Stanley Park. I'm out there at least once a week. I find a log or a rock and just relax with the nice breeze off the ocean, the mountains and the beach. It's my little paradise. I go there to just sit and clear my mind.

Jo was manic one day and we went down Hastings. She wanted me to buy her a gun so she could kill herself. She gave me two hundred bucks. I said, "Wait for me in the alley right behind the Roosevelt Hotel. I'll be back in ten minutes." So she's waiting in this little doorway for me to come back with a gun.

I bought a gun down the street. I took it back into the alley. I go, "Okay, you gotta be quiet. Anybody looking? I'm going to give you the gun, Jo. Are you going to do it now?" She says, "Yeah, I'm going to do it now, Russ. I'll give you a five-minute head start so when you hear the gunshot you'll be long gone." I said, "Okay, here's the gun," and I passed it to her all careful. She looks at it and she breaks out laughing. I bought her a cap gun from the dollar store. She laughed so hard that it brought her right down from her suicidal thoughts. We were there in the alley laughing. It was so funny. It was good.

"Outside Life Skills" by Kevin Sleziak, 2007. This is a photo of Verouz (left) and Roger Harris (right).

# KEVIN SLEZIAK

born 1966, Preeceville, SK

I've been living in the Downtown Eastside for ten years and before that I camped down on Wreck Beach at the old Musqueam Reserve for fifteen years. I used to sell beer and other things down on Wreck when I was a younger kid.

I was in my early teens, probably about nineteen when I first went down to Wreck. I grew up in Saskatchewan and then I went east to Toronto and tried to work out there. I stayed there two years. Then I heard about Wreck Beach. I was told that it was like Black's Beach down in California, where people would go and sell their wares.

I'd get up in the morning around six a.m. and make a little breakfast. There's not too much food there in the morning, so you get other people from other campsites looking to trade or buy food. Then I'd start to open up. I liked to make a little store along the logs. One year I sold handbags from Nepal.

It was a great life down there at the time except for the winter when it was wet. I had a tent, big tarps, and a Canadian Army sleeping bag. A few other friends camped around just to make sure it was secure, because it's pretty far out there. After midnight it gets a little hairy with people coming from out of town and other people from downtown coming down there. There's been a couple murders and a few assaults. You have to be really careful after dark.

After a while Wreck got territorial. A few people were selling sandwiches and there was another person two doors down who was doing almost the same thing, but the next morning their stand was burned down because somebody didn't want the competition. I find that stupid. It's a free beach and everybody should be able to make a little bit of money.

We used to see a half a dozen dealers at the bottom of the trail just sitting along a log. Once in a while if somebody was making too much of the money, they'd get into a fight or somebody would call the cops on their competition.

Wreck wasn't bad in that way until a few years ago, and after that I only went there on weekends. I've been assaulted a couple times down there in the past and it got to the point where I didn't feel secure and it wasn't as friendly as it once was, so I decided to quit for a while.

I volunteer at a couple of the churches, First Baptist Church on Burrard and Nelson and the Blue Bus from Aldergrove that usually comes here to the Gathering Place. They open up the bus to give out sandwiches, soups, and drinks. They offer clothing and a food hamper so you can get as much food as you want to take away. I do a lot of volunteer work because I hate standing in line waiting for the food, and you don't know how many hands have touched the food by time it gets there. Plus you can stay dry instead of sitting out in the cold rain waiting to get in.

They've got sweets and bread and pies coming out the ying-yang. There's just so much food out here, but also so much waste. There's too much bread and sweets out here. I think that's why there's a lot of diabetes in the Down-

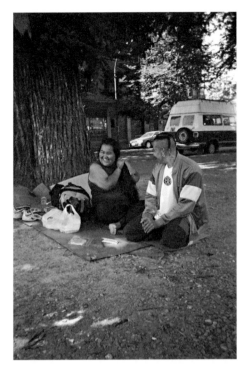

"In Love" by Kevin Sleziak, 2006. This is a photograph of Jodie from the Nuu-Chal-Nuth First Nation outside Tofino and Jose who is originally from El Salvador. "I took this photo," said Kevin, "because they are so much in love."

town Eastside. We need wholesome foods like fruits and vegetables, not all the sugared stuff.

I'm a rich man when it comes to my health. I see a lot of people down here catching colds, pneumonia, and even losing limbs because they're dumpster diving. People jump into dumpsters and get nicks and cuts and a lot of them don't wash properly, so infections are common.

It's a bit of a change coming downtown from Wreck. You need to find things to do—can't lie around the beach all day getting a suntan. I spend a lot of time volunteering at Life Skills, which is a community centre for people to hang out, do laundry, eat, and maybe get some drug and alcohol treatment. There's women's wellness, men's wellness, and a computer, and sometimes they can help us get into schools.

I took this photo outside of Life Skills (see page 170). I wanted to take a photo that was a rainbow collage since Life Skills is for everybody and not just white people or Natives. I met Verouz on Wreck Beach actually. He was

famous for making zombies. I see him around a lot and so we relax and smoke cigarettes.

When I took the photo, Verouz was telling a funny joke from back when he was in his native country. There was a lot of war happening, but a little bit of a light came on when his family found new homes through working with different associations. This other guy thought his joke was pretty funny too.

Verouz has been here twenty years. We ran together on the streets, collecting empties, and friendship mostly. We've sat in the park and enjoyed a few beers together. We even took a trip over to Victoria. Verouz had a station wagon. We went down the coast and had a good time. We keep busy around here.

The Day of the Dead is coming up, so we're going to be doing a little march. We go out to all the places where people have died. I know a lot of my friends over the last ten years have lost their lives over drugs. We remember the dead, that's what the Day of the Dead's all about. We got two or three people over at Oppenheimer Park who died and we like to remember them because they were so happy. We walk around, place flowers in the neighbourhood. We try to get the kids involved with piñatas and have a little party.

# VEROUZ

born 1956, Damascus, Syria

Kevin was asking me questions and I said, "To heck with that, take my picture anyway," (see page 170) you know, because when I came here I was doing good in Canada and then I start getting into drugs and my life started going down the drain. You can see the depression in my face. I was sweating and cursing at the time he took my picture here.

I came to Vancouver and I got the wrong friends and I end up using drugs. I want to be bully. I want to be the tough guy on the street and I end up being down and out in my life.

That's how I was thinking about this picture. I remember I was cursing. Actually I said the f-word. I said I wish I wasn't even existed. Kevin says, "Do you think this photo will win a prize?" and I said, "Of course I'm gonna win. Can't you see? All my life I'm a winner."

I'm born in Syria, Damascus. I'm born in 1956. But to come to North America, they have to change my date of birth because by a certain age boys can't leave the country because of military service. My father used to work for government so we had access to make my age two years younger on documents.

Now I'm able to come to this country because they put me born 1958, which made me a twin with my sister even though we're not twins. But to come we must be twins. That's how I was smuggled out of Syria.

We left because of war and because I'm Christian. I come from a Muslim country and Christian and Muslim are massacring each other. That's what's happening every day all over Middle East.

You're Christian then you are godless. It's a difficult life in Middle East for a Christian, especially Armenian. I'm Armenian. Armenians have a history with Turkey, a history of massacre. So it's very hard for Armenians to live in a Muslim country and we survive.

I come to this country and to me it was heaven. I was kissing ground when I got in Canada because I never smelled freedom until I came here. I never had a childhood until I came here. I didn't have a toy to play with or cartoons. We didn't have these things. Just war, war, war, war, war and politic. Everybody sit down and listen about politic. They didn't know about stories, fairy tale stories, anything like that.

At first when I was young, war was funny and happy, like a kid's cowboy movie, but as soon as you started getting older, like ten or eleven, you start understanding a little bit. Someone's father dies and you understand what it means. You start thinking like an adult even though you're a kid.

I mean for people who were born and grew up here to complain about life— they never seen nothing yet. They're in heaven here. This country's heaven. If you visited my country you will know what is hell like. You see a building and next day you don't see it. See your friend and next day you don't see him. Life is short where I came from. Here I have opportunity.

I watch TV when I want. I have a coffee for free. I have so much things, like

free clothing. I look at the people come from other countries. I look at their health. They got home. They got car. They got business. Where I'm from, in your home you didn't have nothing. Maybe you had a camel parked behind your tent.

I'm a welder and a printer so I make colours. I'm a master colour maker. I could put any colour together and bring any colour you want. I know what it's mixed with.

I move to Hastings and met a girl. She's working on the street girl and I got to like her, more close to love, and it started fading, my life. Though it was good people who tell me, "What're you doing? You're not the same anymore."

I thought they were jealous of me or something and I end up being a junkie for crack.

Sometime I have $500 and an hour later I'm broke and I'm wondering if I could buy ice cream cone. I put my hand in my pocket and I don't even have the change to buy ice cream cone. That's how bad it is for me.

I don't blame the government. Even though I'm drug addict, I think the government is doing a good job trying to clean up this district. Maybe by cleaning up this garbage, we'll be cleaned up too.

I want to get to recovery. I mean detox. I'm going to try it again. I can't lead this life. I may smile from outside but I get hurt from inside. When I meet someone and we both from the street, I don't want you to see I'm hurt. I don't

want you to feel my feeling. I don't want you to see weakness, but inside I'm weak. I'm really weak inside me.

You can't be a bum on the street, take your blanket from place to next place, not to get wet when it's wet. You're miserable. You can't sleep. It's cold. You can't wrap with a cold, wet blanket or you freeze more. I feel that pain inside me every day. Honestly there's no shame to tell you, I get tears in my eyes every day.

I'm sick and tired to be sick and tired. This crack is not right. One is too much and thousand is not enough. They say this and it is true. What the media do is true. You can't stop. Anytime you have two, three dollars instead of having a pizza slice you go for a hoot. That's what they call it, a hoot. A little tiny three-dollar piece and then after you finished doing it you become more stupid and you wanna get more money. That's not a life.

I'm sick of these drugs. Open the clinic and make it legal. Go in the clinic and buy it instead of buying from a drug dealer and he give you garbage to poison your body.

This doesn't work for me and it doesn't work for other people too. I seen girls come from other provinces and they come clean here. Two months later they're prostitutes on the street and doing things they never done and they cry. They tell me their story.

Here in Downtown Eastside, everybody have the similar story to each other. Where we come from and what we did and maybe you didn't come from a

war country, but you came from a broken family and that's the same thing as growing in war.

If I tell people I'm Armenian they say Iranian, but Iran and Armenia are two different words. I know a few guys from Iran. I know a guy from Afghanistan. I know guys who come from that side of countries. For them it's the same thing.

My mother, she's Lebanese, my father is Syrian. My mother, she was at age eleven and my father was I think twenty-four when they got married. My mother when she was with child she was almost twelve years old. She was almost twelve years when I'm born.

So my mother's older than me by almost twelve years. If I walk with her, they think I'm her brother. She's young when she got married, but that was in the old days.

I never heard of divorce, fight or nothing. I never seen this until I came to North America. This girl has no mother or his mother's going out with another guy and his father's going with her? I never seen that life before.

Death 'til you're apart, that's how it is. There's no such thing as divorce in our culture. You can't say, "I used to love him and now I don't love him." My culture doesn't work like that.

In our countries, we don't just go with any girl and have sex. Your family arrange a girl for you or you have a girlfriend and the only thing you have is a kiss. There's no sex involved until the day you get married. That's how it is in

our old countries. There is prostitutes but that is legal by government. You gotta go to a whore house, pay at the desk.

There's nothing like in our cities. Here we see things we never saw and then we lose it so fast because we never saw that freedom before, a lot of us who come from countries like that.

I could get anywhere a three dollar piece of crack. Only province in Canada where you can find a three dollar piece. Nowhere else you could do that. All my brothers and sisters down here are all suffering the same way as me.

They have different stories but it's same thing. We end up doing things we should never do, on ground tweaking, touching dirty things just to think it's crack cocaine.

You're taking a leak in the back alley and the guy next to you while you pee is on the ground picking up little stones and putting it in his pocket. I see that in front of my eyes every day. There's a pile of shit on the ground and the guy's tweaking right there. I want to say it's a beautiful country, beautiful province, but Vancouver has to change.

It's still behind from rest of Canada. Maybe looks like beautiful but as a law it's behind completely. I've never seen in Montreal anybody on the street walking with crack pipe, never in my life.

Here every alley you walk by there's a guy with crack pipe. Police walking in this way, the guy's walking out this way. He has a tube around his neck with a crack pipe this long hanging with resin on it and police doesn't say anything

unless you were smoking right in front him, but if you have the crack pipe around your neck he lets you pass. This is not a law.

If cops comes, everybody walk that way, cops comes, everybody walks this way. Spanish dealers go. Spanish dealers come. They make the money and the guys who are homeless have nothing. These drug dealers use us. They say, "Can you hold my dope? At the end of the night I'll give you half gram."

If you get busted you go to jail. He's not gonna go to jail. He has the money in his pocket already and it's, "Ciao, amigo." Then when you come out you have to pay him that dope money, even though you got busted for him.

These South American dealers got no friends, no amigos. You owe them a penny, you'll get slashed. You get beat up. You owe this guy five dollars and the Spanish guy says to another, "Take this, go smash him," so somebody else homeless is gonna go hit his brother on the street to get that extra five dollar piece.

I used to be a vendor at Wreck Beach. That's where I met Wreck Beach Kevin. I used to sell beer and zombie and souvlaki. I make the best souvlaki in BC and not only in the stores but in the whole BC. I make the real souvlaki.

Here they use tzatziki on it. All wrong. You don't use tzatziki with souvlaki— it's shish kabob. You don't use that for falafel either. You put tahini, lemon, olive oil, little bit garlic, and parsley. Put the chop parsley in it on the top of the falafel or hummus.

Tzatziki on falafel? That's garbage. See, if I give you shish kabob and I give you beef and I put the same dressing on it you think the same, tzatziki. The only taste is tzatziki. You don't taste nothing. Don't taste the chicken. Don't taste the beef. If I put tahini, it'll taste different.

If you taste good hummus, you don't wanna eat nothing other. This delicacy is not Greek and is not Turkish, is Middle Eastern, Mediterranean food. Falafel is number one in Syria. Falafel is Syrian food. Hummus, all this come from Syria. Tabouli is Lebanese. Babaganoush is Lebanese. You make the thin bread in a clay oven.

Zombies, souvlakis, and zombies. I used to make them with grenadine, vodka, and a little bit juice. I used to put one slice melon on the side. It used to be five dollars a shot. Kevin was my best customer actually.

People came from places in the States. They came straight to me. They said, "You're the zombie guy?" I say, "Yeah," and they know my name. Somebody tell them my name. I was famous. They all say, "Go down the beach. Go see Verouz."

"Lower Town Blues" by Marcin Kubat, 2006.

# MARCIN KUBAT

born 1983, Poland

I was about seven when we came to Canada. I lived in Poland until I was five, and then I moved to Austria for two years, then to Toronto, and Kitchener. My dad said he wanted to move to Canada to give me and my brothers and my sister a better life.

Poland's not doing so well right now. It's a struggle out there and out here it's easy. People take things for granted. I take things for granted.

We lived in a complex. They were rows of six houses and we lived at the very end. We had woods behind our backyard and there was a pond where we skated. My brother used to be a bike courier and he bought me a bike. We'd work on our bikes together and we'd go for rides with our mom.

My parents split up when I was a kid. It was shortly after my mom had my little brother. My counsellor tries to get me to talk about that, but I don't really think it's a big deal because my dad lived close by and I had a good relationship with him at the time.

I lived with my mom and she wasn't making a lot of money. At that time my brother and sister moved out. I'm not sure if they left to go to college or if they were finishing off high school, but they moved out.

It was messed up. I started doing drugs with a couple of friends. We were smoking pot and drinking, like everybody else was. At the time I was getting

a lot of crap at home. I had a group of friends that I was hanging out with and those people became more important to me than my family. I started to push my family away.

School was going badly. I was lazy. Then I got into ecstasy and then later into PCP and crystal meth. Ecstasy was always my favourite, but you can only do that for so long before it stops having a decent effect. Meth is a different thing. You can do as much as you want of that.

I eventually had psychosis—recurring thoughts that would embed themselves in my brain. It's like a daydream that runs continuously throughout your head and eventually it becomes an illusion. You don't know if it's a dream or reality.

I'd only go out during the night. I avoided people. I was all messed up because I'd been on it for so many days at a time. The most I ever stayed up was nine days. I woke up in the back of an ambulance. It's pretty fucked up.

In Vancouver, meth is readily available and it's dirt cheap. In Ottawa, you have to go to Montreal to get it. We used to go to Montreal to get meth and PCP to use and sell. That's how we got by.

I'd lived on the streets for two years in Ottawa. Ottawa's a clean city and homelessness is pushed out of sight. In Vancouver it's out in the open and people hate you for that.

Winters on the streets in Ottawa were cold. You gotta dress in lots of layers and there's always a place to go and do your laundry or take a shower. I used to stay in parkades and squat in abandoned buildings.

Before I left Ottawa, I got a job that I worked really hard to get. It was a pre-apprenticeship program for automotive mechanics, and the people there knew I was on the streets and they helped me out. We got to build a car out of scrap.

They taught me a lot and then I was going to be put in a work placement for six months. But they placed me at Canadian Tire and I was really pissed off about that because Canadian Tire sucks.

I wanted a small garage, somewhere where I could get my hands dirty. At Canadian Tire, I wound up running errands most of the time. After about six months, I was getting into my old ways again. On weekends, I was hanging out with street kids and all these people I used to know.

I wound up not showing up for work a lot. Then one day I went to work high and drove a car into a tire machine. I lost my job.

Instead of going to look for new work, I wound up partying. I owed three months' rent on my apartment and my place was trashed. I was pissed off and I realized I was going to wind up back on the streets in Ottawa. That's when I got an income tax return for $400 and I bought a bus ticket to Vancouver.

I was determined to not be back on the streets in Ottawa. Wherever you go, you'll run into street kids and all the street kids know all the street kids in all the cities. So I knew some people out here.

I wound up spending a year on the streets in Vancouver. I slept all over the place, often the art gallery—at the back where the water fountain is, that one area where it's gated off now, we hopped over there—five, six, seven, eight of us, slept in there.

I had a lot of insecurities and depression. You walk into a place, you get a job, you feel great for the first three days. Then people start asking you questions like where do you live? Either you lie or you tell them the truth and either way in the end you feel like an idiot.

I had this old girlfriend I used to live with in Ottawa. We only stayed together for a couple of months. I met her before she ever got into drugs. She was such a sweet girl with all these dreams and aspirations and she actually got me off the street in Ottawa. I ran into her out here in Vancouver and it was like, "How're you doin?'" but by then she was a serious drug user. I had my history too, so we just hooked up and started going crazy on drugs.

She's a heroin addict, but when we used together we always used crystal meth. It looks like glass that's been pounded into dust, like tiny little shards. You put them in a glass pipe and heat it up. It's almost the same thing as a crack pipe, but it's got a bubble on the end of it with a hole in the top of the bubble. The crystal meth sits in the bubble and when you heat the glass, the glass heats the crystal meth, the meth vaporizes, and you inhale the vapors.

It's a rush. Your body temperature rises. Your heart rate rises. Your senses get more aware. You feel like Superman. I don't remember all the dumb shit I used to do. You don't need to sleep, you don't need to eat, you don't feel pain.

Eventually you start getting weird in your head, man. You start seeing things. You're just so stimulated, the mind's running at a million miles a second. I didn't hallucinate, but I used to get reoccurring thoughts. Everybody has a different psychosis.

"Feeling Blue" by Donny Melanson, 2006. This is a photo of Marcin Kubat in an alley between Homer and Richards.

I'd have a conversation with someone and when he said something back to me I'd doubt if what I was hearing was what he was saying. I'd think, is he saying this or am I just thinking about this, or what the fuck's going on?

It got pretty bad and I got really weird. I tried to clean up a few times, but I was so dependent that I couldn't get out of bed without it. I used to get sores on my legs, chest, and arms, but never on my face. Crystal meth is water soluble, but it's corrosive to your skin. You sweat it out, and when your sweat settles, it sits on your skin and eats it.

My girlfriend wound up leaving town. She's a heroin addict. I was a crystal meth addict. We didn't get along.

After twenty days at Harbour Light I didn't really want to leave, so I just kept staying. I finished a three-month program. I did another six weeks learning life skills. I finished that and now I'm at the halfway point to moving out.

"View from Window" by Marcin Kubat, 2005.

That's a photo from my room at Harbour Light. This is the back alley and they feed the community in a food line and everybody comes out the back door. Then they walk up this alley. So I was just sitting in my room and I had the camera and I looked out my window and I took a photograph. I've never been to a city that had so many alleys before.

I feel more comfortable walking down a back alley than I do walking down Robson Street. That's a culture shock to me—everybody's all prim and proper. Vancouver is full of social expectations that seem obscure to me. I came out to Vancouver because I thought I could start again. Vancouver amazed me. I remember when I first got here I just sat out on the waterfront watching the sunset in the harbour and all the boats.

"Alley" by Olga Afonina, 2006.

# OLGA AFONINA

born 1960, Moscow, Russia

My story is like this. I'm landed immigrant from Russia. I came to Canada in 2004 with my two sons. We choose Canada because here it is more liberal, more interesting, and I want for my sons a better life and we choose that one. My one son went to college here called Langara, and everything was good. Then I go to different country, to Sri Lanka, and after some time I miss contact with him and I found that he's in trouble. He has problems and I come back to Canada.

I found out he gave up school and went missing. I couldn't find him. I start my search and with supportive people I found him in Downtown Eastside. He didn't want me to see him because he thought I will scold, I will cry, I will push him back, I will try to dictate to him—how to live his life because, you understand, that's not normal.

Then one day I met him in the Carnegie Centre. I thought I would get heart attack. I was crying and asking, "Why are you doing this? Why such troubles? Why such problems?" But I was happy like never in my life. I was so happy to find him.

He was poor-looking, homeless, but he was healthy. He tried to explain me that he needs to learn from traveling—from life, to start from zero. For him it was a spiritual journey. He wants to learn from the street, from such an environment like this, and he found great friends here.

He told me about street philosophers and poets and musicians and people like that, how much real wisdom they teach him. He wasn't drug addict, I really worry about this. He said he had spiritual experience from smoking cannabis. It stops him from using hard drugs.

It was strange to see how much he changed. His eyes were shining and he was so different, different, different. He talked about the Downtown Eastside— how he met with people, like hippie community here, excellent boys and girls and they're very artistic. They live marginal, in their own life.

They all like him and he joined them and was happy. That is how I came here.

To find him I was not in downtown but living in suburb—a good one with good reputation. But it was so difficult there. I was under such pressure. I had all these worries about my son, with my movement from one country to another, settling to a different culture and climate. This suburb was so bad— people were pretentious. In my case it was that my roommates were working, working, working, watching TV, go to bed and then next day for job. Friday they will drink to that and then more pretentiousness. They always try to show that they are success and all of them on anti-depressants.

My roommates in this suburb tried to violate my privacy. I was insulted, abused in this house, and one day I just called a taxi and took my bags and came to Downtown Eastside. I rent room there in hotel and I stayed there for maybe six months like this. After all these things it was a quiet safe place for me. Nobody tried to position me.

"Carnegie Community Centre" by John Dawson, 2007.

I don't have many illusions now. I just do a little bit more art. I was doing a mural. I paint on yoga studio. I paint on bathroom. I have two degrees. I'm artist. I am also yoga teacher. I have some private classes. It's bringing little money and that's it.

I like Canada. I can be individual here and walk free and change things because here people are making beautiful country. I am not sentimental about the Downtown Eastside, the poorest, poorest area. Everybody knows that it's deadliest place. I read statistic about people missing here, mostly prostitutes, drug addicts. These are unlucky people.

They don't have good families and education and jobs and they become like this. The poorest area is really here, but I don't see, for example, only crackheads. I see young friends of my son, smart and creative young people. Their thinking is open.

There's so many kids from dysfunctional families also and this is of course big problem. They just run away from home and they try to find a different home, happy family, big family, but the problems come—they're homeless, no real home. They're abused and some take alcohol, sometimes heroin or crack. I know so many families that are affected by this.

I think every mother loves their son, but they not speak with their kids after they come here? That is sad. I think because they're not educated, because they didn't learn how to manage this, maybe they just don't know, and it's a hidden subject. Nobody teaches us, nobody show us.

My life? Already my dream becomes true. My son is okay. He's wise, strong, supportive, and gentle. Everybody likes him. I hear so many good words about him. He's living his own life now.

I was growing in a country where our church is orthodox and conservative. I don't like any orthodox conservative things. Then I found yoga. I found Tao. I met a great teacher in Sri Lanka. He was a Taoist and he taught me a lot. Spirituality is different for everybody. It's a long path—a long time it takes just to see light like in that photo. It's my spirituality. We all have shadow in our heart, but we can also bring light to the world.

Education is everything. Parents need to be educated and prepared better to support their kids, to show them light. They need to know how society and psychology works, not live in their fears.

When I took this photo it was not much about portraits—just about light coming through shadows. I got my son back. He said to be homeless there on the street, after some time you become like animal—like it doesn't matter how intelligent you are or how educated. Anybody can become like that if they don't have a home.

Then a few days later I was going past this area. It was late evening and I saw the lines across the sky. I saw such a beautiful light—just like a church.

The flies were shining in the sunlight. There were two girls in the alley and one girl says to another, "We build such a beautiful house in back alley, from garbage." Of course, they were in it. That's the back alley and that godly light shining everywhere.

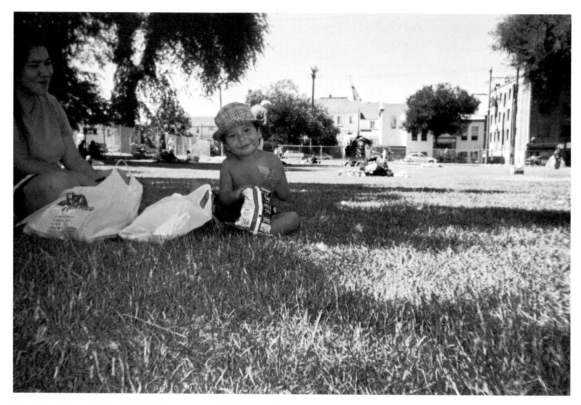

"Picnic" by Marlene Thistle, 2006. This is a photograph of Danita and her son Nathan.

# MARLENE THISTLE

born 1963, Terrace, BC

This picture is of Nathan in Oppenheimer Park. I wanted to focus on the beauty of the people in East Vancouver, instead of the way the news dwells on the negativity about the drugs, alcohol abuse, and prostitutes. All they ever talk about is the negative aspects of the Downtown Eastside. They don't see the people who are here to help others.

We do a lot of activities in Oppenheimer. My partner and I go with the people who we know are in a healthy state. We'll get them playing bocce ball, baseball, soccer, or volleyball. If it's raining we have the Oppenheimer Park staff put a video on, so the people can come in, watch a video, have coffee or play cribbage.

In the picture, Nathan is only about three years old. When we knew he was here, my partner and I, without saying anything, went around, picked up the needles, and got rid of all the garbage. We do that for any of the kids.

On any given day, there's maybe about only six or seven kids in Oppenheimer Park because of the large amount of alcohol and drugs. It's a major struggle because the ones that are using don't care. They've thrown their lives away and they don't care anymore and it's really hard to see.

I have eight sisters and three brothers. We were separated and only came together later in our life. My grandmother had me and three other siblings and

my uncles and aunts had three or four siblings per group, because my mother had polio and they weren't able to care for us all at one time.

I was raised by my grandparents and my uncles and aunts. My grandparents were leaders in our community in Kitwanga, which is outside of Hazelton, BC. We're Gitxsan. For the first six years of my life, I thought my uncles and aunts were my brothers and sisters. I even got to the point where I thought my mom was my sister, until my oldest brothers drilled it into me that she was my mom.

Both my grandparents were chiefs, so the chieftainship falls down to my mom, and then from my mom to one of us girls. When my elders see me as responsible enough, they'll bring me home and make me become more aware of our cultures, regulations of our house clan system, and start grooming me to be a chief.

Three years before she passed, my grandmother had shown the other chiefs in the surrounding communities of our village that she had chosen me to learn our Native language, because I'm the only one out of my eight sisters and three brothers who goes home to visit.

I understand the language. I could speak it, but I have a difficult time speaking it in a non-Native environment. When I'm back in my culture I can understand it. When my grandmother had passed away they were talking only in Native tongue, and my sisters are like, "What are they saying, what are they saying?" and I was translating it and my mom sat there and she just looked at me and she cried. I'm like, "What's wrong, Mom?" she goes, "You understand

what they're saying." I said, "Well what do you think, Mom, I've been here. I come and go and I understand." She was happy for that.

When the head of the feast called my mom, he said, "Molly, would you introduce your daughters and your sons and your son-in-laws and daughter-in-laws?" and my mom said, "No." She handed me the mike and asked me to introduce them all. So I sat there and rambled off all my sisters, my sister-in-laws, my brothers, my brother-in-laws, and all their kids. Everybody in the community just applauded. They were amazed at how many kids my mom really had. They thought she only had, like, three of us.

In our reserve none of us, my mom included, has a home. We don't have a home on our reserve so we're still fighting for that, but I'm the first one that has a lot. I've put money down to have a house built, but to this day it has not been done.

My mom raised us in Prince Rupert because she had to be in the hospital there all the time. She was in a wheelchair for over fifteen years and then out of it for seven years, but now she's back in it. So we moved to where she was so we could be together. But I went back to the reserve every summer and every holiday you could think of.

I learned at a really early age how to cut moose and prepare the fish, whether it's smoke dried or half dried. We weren't allowed to go hunting for moose. The men did that at that time, but things have changed and I have a hunting licence now.

We use everything on the moose except the bones. My family didn't deal with the skins. The skins were brought to an elderly lady in the community who used them for whatever crafts that she had done. When they go catch moose or deer, they don't get to keep the first five or six. They bring it out and make sure all the elders in our communities, or the ladies that don't have partners, are fed first. After everybody is served, then they provide for their own families.

"Elder" by Marlene Thistle, 2006. This is a photograph of Michael, a Carnegie Elder.

We were fed fish all the time when growing up. I love fish, but right now I only get to eat it maybe once every six years, so that's really difficult. Fish to us is a natural right.

I miss the fresh air, the peacefulness, and the networking with the elders and the youth. We all work together so that each of us learns from each other. Like when a youth is in trouble with the law and is having difficulties with school or parenting in the home, that youth is sent off to an aunt and that aunt will actually work with that child if she's got difficulties. We help them get back on the proper road to be respectable and responsible for their actions.

No one cares what the kids do here. Nobody is really watching what's going on with them. They don't take responsibility for the kids doing wrong. A week and a half ago, we saw two kids on top of the building across the street from us throwing rocks down on traffic coming down Hastings, literally hitting the vehicles and breaking the windshields. Nobody did anything, though. We told security in the building, but they didn't deal with it.

That's the difference right there for our culture. We deal with it right on the spot. That kid would be dealt with. He may not be our blood child, but that saying, "It takes a community to raise a child," is an Aboriginal saying because the Aboriginal people do that.

There's no work on our reserves, and no housing available for anybody like myself, who wants to come home—we can't do that as easily because there are no homes for us to go home to.

I'm educated and I'm not able to go back to the reserve and work. I find it really hard because the Native people are lacking in resources such as social housing, education about violence, domestic abuse, and drugs. Right now the drugs are a big thing in that area. I haven't heard so much about it being in the community at the village, but in the surrounding towns like Terrace and Hazelton there is an epidemic of crack cocaine and heroin. Our youth are going gung-ho on it because they think it's a new fad. But more than anything, they need to be educated by our own people.

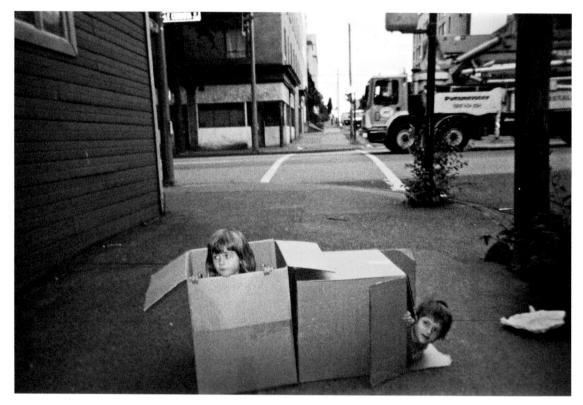

"Box Houses" by Elisha-May Walker. Chloe (age four, left) and Sage (age six, right).

# ELISHA-MAY WALKER

born 1994, Vancouver, BC

I'm turning twelve this month. I go to Strathcona Elementary just up the block. It's my favourite school, even though it's the only one I've been to. Sometimes I home school and I see other schools and this is a good school, but through the years it's been getting worse with the kids a little bit, like more hardcore verbally.

I don't swear. I'm against it because I think it's laziness and you can say better things than just saying one word that's rude.

I started hanging out with this group and they all swear. So then I was like getting into it and then I was like, okay this is bad, so I told my mom and then she helped me work on not swearing.

I'm lucky 'cause my mom talks to me about these sorts of things so I know about swearing and about hurting and about gossip and how to deal with it. Just say, "I don't want to talk about gossip."

I have this one personal friend and I go over to their house and their family's good. Their family cares, but in some families the kids are just not close to their parents.

We like to hang out at Oppenheimer Park, the one across the street. We know all the Oppenheimer Park staff and they play with us, and I like to play in the basketball court 'cause I get to get some practise in. The people there are nice

and they say hi to you when you're there. If you come to the park everyone says, "Kids in the park, put away your things," and everyone does that.

If they ever give my mom trouble, my dad comes out and then they say, "Okay, we're backing off, backing off." They're scared of living a real life, not doing drugs. They think that this is the only thing that they're appreciated for, that they make money off of. They think they're only good at dealing drugs.

If anybody tried to do something to me, there would be someone there that would not let them. The women in the park that are drug users, they're hard-core. They're really nice. I talk to the women. There's this one girl and she has a dog and I play with her and her dog. You can walk down the street here and people will say, "Hi, hello, how're you doing?" A woman will come up to me and give me five stuffy bears and say, "Tell your mom I gave you this." You go over to the rich parts of Vancouver and no one will talk to you.

One time this guy was pretending to hug a woman and he was grabbing her wallet and my mom saw him out of the car and he's like, "Shh." She's like "no" and she honked the horn. That's the only incident where I've seen anyone steal stuff from someone like that. Of course, there's probably stealing happening in the park, but it doesn't happen to us.

I'm helping people and it makes me feel good. On Christmas and Easter we bring stuff to the women's shelter, 'cause it's what Jesus would do. Like in the Bible he didn't go to a rich neighbourhood. He became a poor carpenter, someone that was with the poor.

"Chloe, Sage, and Mercy," by Elisha-May Walker, 2006.

I really like the people because they're friendly and they won't only be talking about drugs. They'll talk to you about you. They'll be saying, "Don't do drugs" and stuff. When I'm older if someone offers me drugs I'll know to say no.

I want to do a detox group at our house, but it won't work because it's right across the street from all the drug dealing. If they did a detox with kids around, they would really cheer everyone up.

Sometimes people will freak out right when I'm there and they'll throw a table, and sometimes there are racists. I saw this one guy and he was swearing at a Chinese guy. He's like, "I was in effin' China for like this many effin' years" and stuff.

I waited because he was going into the gate with the Chinese guy and I waited for him to go because we know the Chinese guy. If anyone ever hurt him I would be able to scream and someone would come to help.

I know someone named Catherine. She's an older woman. She's been here forever, but she doesn't do drugs. She's in a wheelchair and everyone knows her. All the people are friends with her. She'll buy us popsicles and stuff and she always bought these guys smokes and they knew she had money. They mugged her and slit her. Then she had to go to the hospital. But the thing is,

when that happened everyone knew those people were gonna get it big time, because everyone knows her and everyone was mad when that happened. She's a good friend of ours.

I stayed in West Vancouver for two months up in the British Properties with this friend. I just don't like it there. I don't feel comfortable. I like the Downtown Eastside much better.

Here, we invite people into our home to eat with us. It's like a community dinner. We have it almost every day and it's just, that's what we do for dinner, and then there's so many people that come in and we know them all, and then new people come and we just meet them for the first time.

You don't have to be quiet and you can sit anywhere. I know it's not what other people do, but it seems normal to me. Those are the people that come for dinner and they're our friends and neighbours.

Every year we do this "Jesus Christ Superstar" thing and we all dress up, watch the movie, and sing the songs. We do that and we invite people in. If I could tell people about the Downtown Eastside, I would tell them about the "Jesus Christ Superstar Party" and the birthday parties we have because we always have theme birthday parties. I would tell them about the people there and what we do, like secret Santa stuff and the good things that happen.

The photograph I took was half set-up, half not. I saw these boxes. The kids were playing with them. We were thinking of making a fort out of them and I just had this idea to put them in the boxes and we wanted a big truck to come

by, to show this is what it's like. These big rigs come down this road fast, and I was lucky I got that truck.

The theme of the contest was "Hope in Shadows." What the photo is supposed to mean to me is that the boxes make the shadow, like the Downtown Eastside, the homelessness, and then the kids are the hope. There's still hope. That's what made me take the picture.

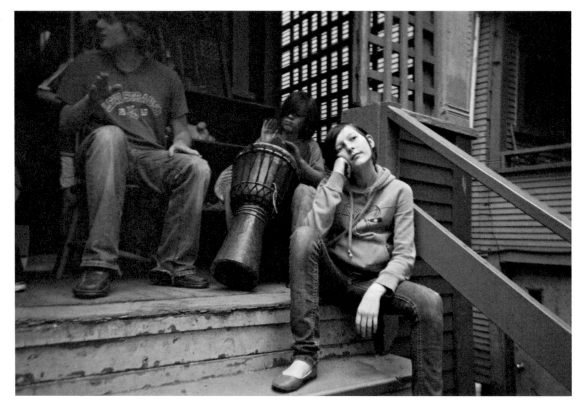

"Drumming on Steps" by Rosalynn Humberstone, 2007. Elisha-May Walker (right) listens as Tim Vincent gives his son Kael (eleven) a drumming lesson on a Djembe.

# ROSALYNN HUMBERSTONE

born 1968, Langley, BC

Sixteen years ago, I was in jail on a thirty-day sentence for working the street. A woman named Jen was there too, for protesting an abortion clinic. She got six months. I was having a problem with somebody in the jail because I got charged with an armed robbery that I didn't do. They dropped the charges but somebody said that I ratted on them, so I had a really bad name in jail. Jen actually was told to stay away from me or she was going to have a real hard time during her six months.

Instead of listening to them she became my best friend, even though I was only in there for another two weeks. I went to visit Jen after she got out of jail. She was living with a community of Christians and that's when I met the Walkers and the Vincents and Hannah, the oldest Walker child. She was six months old then and she just turned sixteen a couple of weeks ago.

Me and Hannah became good friends. We used to have the same interest in books and movies. Hannah and I get along good because I'm still a kid. I like cartoons and everything. I never had a chance to grow up so I'm doing it now.

There are four houses on Jackson Street that those families manage, and this photo was taken at the red house where we were having a community dinner. I had my camera with me so I decided to take a picture. Tim was teaching his son Kael how to drum a proper beat and Elisha was just looking out into space.

They've helped me a lot. I'm a manic depressive and sometimes I need somebody to talk to. I lived with them for a while when I was trying to stay clean. I'm probably moving back in with them after I go to treatment. I was turned down for treatment because they don't have the right doctors there and I have to try and apply for another one.

It's a better situation for me in that community. I can't live in an institution because I have problems with institutions from when I was a kid. They bother me. I lived in group homes and foster homes and in treatment centres when I was young.

I started working on the street when I was twelve, so I've been working in Vancouver for many years. I ran away from my group home and I had to look after myself. That's how I started on the street. Me and two other girls decided to start working on the same day. I was living at the Maples; that's a treatment centre that is no more. It's part of Willingdon now.

Working the street in the Downtown Eastside has changed a lot since I first started. It's getting a lot worse for the girls. They're ripping people off and it's causing problems for other girls. People used to work together to help everybody years ago. It's not like that anymore. You can't trust hardly anybody. The dope changed everybody.

I was an emotionally disturbed adolescent. I had bad behaviour problems. I hated myself. That's why the Walkers are important to me. They think that I'm worth more. They helped me care about myself so I haven't seriously hurt myself in a long time.

The last bad date I had busted my left knee. And I got a scar across my hand here 'cause a guy pulled a knife and he put it against my throat. I grabbed it but he pulled it out of my hand so I jumped out of the vehicle. That guy got six girls. He didn't kill them, but he seriously hurt them all, stabbed one girl a whole bunch of times in the stomach. He sliced one girl's face up—fuckin' broke a bottle inside another girl. He got fifteen years when they finally caught him. Then a guy tried to shoot me and he got sentenced to life. He killed my street father, Ken Davies.

It was a Thanksgiving morning in 1987 on Broadway. I was working with my boyfriend who was the father of my first two kids. We partnered up with an older couple and got a place so we'd have somewhere to take customers. I was working on the street. Ken was the older gentleman, my street father, and he used to sell drugs to make money to help us out. That's how the four of us survived.

We didn't rip anybody off. That day the two guys had gone out shopping to buy stuff from the grocery store. I came back to the house with a bad date. He raped me and beat me up. You couldn't even recognize my face, I was beat up so bad. The guys came home and threw him out of the house and smashed a bottle on his car.

But he came back and tried to shoot me. Kenny pushed me under the car and I heard pop, pop, and then he fell in my arms. He died right there as I held him. I was eighteen years old.

I have four kids. My first two were adopted by the same family. When I got pregnant with my first one, they took him away from me. He was born just

before the shooting. I had my baby in September and the shooting happened in October.

I got pregnant with my second one and then the foster family who was looking af-

"Three girls" by Mercy Walker, 2007. From left to right, Deiree (four), Chloe (six) and Imagen (three).

ter my first one decided to adopt him. I knew who they were because I visited my son when he was there.

I phoned them and asked them if they would take Joseph's brother or sister too and they said they would. They would've taken the third one too, but I was in a coma right after she came out. I got myself so run down doing dope on the street and didn't take care of myself, so I ended up in a coma. They told my mom after twenty-seven days, "You might as well unplug her—she's not going to make it," and my mom said, "I'm going to give her one more week, my daughter's a fighter."

I woke up five days later. I had to learn how to walk all over again. I had to learn how to talk again.

Every two months, we go to retreats on the Sunshine Coast at a place called Linwood House. It's for street girls from the Downtown Eastside to get out of here for a break. It's right out in the middle of nowhere. It's a beautiful house and on the first day we have movies and stuff. We get huge beds to sleep in with down pillows, and the bathtubs are huge.

We get treated like queens. The meals there are just awesome. They have a hot chocolate machine. I get to have hot chocolate with steamed milk whenever I want.

There was one time when we went horseback riding. One time we just went down to the beach and it was summertime.

They even get a stylist that comes in for beauty day. We get our hair cut, our nails done, our feet done, massages, and makeup sessions. It's like a spa. They give you a journal to write in as soon as we get there.

They have a whole bunch of old-fashioned clothes and costumes, and there's one night when everybody gets to dress up for dinner in all these old clothes. They got different hats too.

Someone who works for the Salvation Army does this and they have a really good family that likes to help with the Downtown Eastside.

I don't know if you know about the Crosswalk. It's a building right across from where Woodward's used to be. On the second floor is the Great Room, where women can go there between ten a.m. and two p.m. Every day there's someone there. Upstairs they have the War Room. The whole building is run by the Salvation Army. Some of the people who work at the Great Room for the girls are the people that take us over to the retreat.

My boyfriend doesn't want me working the street. That's why I don't. He's the first person I've ever been with who loved me enough to not want me to work, so I haven't been working the last four months, not at all. It's hard when

you know that when you're broke that all you have to do is go outside for an hour and you've got money in your pocket. That's what I'm used to and now it's just hard because I'm trying to get used to the fact that I don't have any money.

But these days some girls are doing it for ten dollars so they can get their rock or pay for their down. Before, there used to be a set price and nobody undercut or they couldn't work around certain areas.

The whole scene has become more dangerous. Every time I've gone against my gut feeling, I've had a problem. Every time I've gone with my gut, everything's gone fine. Don't rip people off. When girls rip people off, some of the johns don't look for the girl that did it. They say, "They're hookers. They're all the same." So they'll take it out on anyone.

Sometimes girls get killed. I've lost a lot of my girlfriends on the street. My best friend, my soul mate, my lover, got killed. I found out she was dead because I read the front page of the *Province* newspaper and a picture of her was on the front page because her family's important. She was like the black sheep of the family.

I've known almost all of the ones that were done by Willie Pickton. The pig farm. I've known almost every one of them.

There's a newsletter called the bad date sheet that was given out once a month. Now they're published once every three or four months because there's not enough people reporting bad dates. The girls are being stupid. Why not try

"Hannah and Dominic" by Rosalynn Humberstone, 2007.

and help somebody else next time by giving the name and licence plate of a bad date?

If I see young girls on the street, I encourage them to not work. Some guys on the street will probably say, "You can be my friend," and end up wanting to pimp her so they can get even more money for dope.

If they do work, I tell them to make sure they follow their gut instinct and make sure they have someone to spot for them—to take down the licence plate numbers. When they get into a car, you just write down the licence plate of the car they got into. Unfortunately it doesn't help the girl if there's violence, but it'll help to catch the person later.

"Kiss on the Steps" by Hannah Walker, 2006. Dessiree, Evan, and Samjam the cat.

# HANNAH WALKER

born 1991, Vancouver, BC

I'm sixteen years old. I live on the corner of Jackson and Cordova in the Downtown Eastside, right across from Oppenheimer Park. I live with my family and a handful of other people who have come here to live as a Christian community.

This is a photo of Dessiree and Evan, the two youngest children out of the eighteen who live here in these houses. I knew that I wanted to take a picture of the kids because children remind people of a lot of good things in life. I had been walking home for dinner and I had the two kids with me and I saw this porch on the blue house with a cat on the steps. I sent them up the steps and said, "Dessiree, why don't you just give Evan a kiss, isn't he your best friend?" She said, "Okay," grabbed his forehead, and gave him a smooch.

When we first moved here, I was about two. We used to have this big chain-link fence in front of our house and I guess that was all part of the previous tenant's fear of the neighbourhood. At first we had to leave the fence there because the landlords wanted it up, but I think after a while we convinced them to let us take it down because it was so unwelcoming and ugly. After a while, we tore that fence down and put up a little wood fence.

I helped my dad build the fence, the wooden one in the front. We built it by hand with little pieces of wood and nailed it all up and set it up in front of the four houses here. Think of your typical little house with a picket fence and a

little garden. That is what we were going for because people don't really get to experience that down here.

I think we started letting people into our house for meals after two or three years of living here. Now we have an open-door policy. People come and knock and we open the door. They sit down with us at a table and we serve them a meal. Meals are made by everyone in the community. We put people in partners and those two people are assigned a night so one person will cook and one person will clean, or they divide the work.

Everyone pools their money together to buy the groceries, and we buy a lot of bulk food like rice and noodles that are relatively cheap, then we make a lot of curries and pastas and things that taste good. On an average night we usually feed anywhere from twenty-five to forty people.

With grant money from City Hall we started a Co-op and bought the four houses on this block this year. We have been renovating them so that we can use the rooms for social housing. Because of the Olympics crisis, there are a lot of people who are going to be without homes, and that's why we decided this would be a great project to undertake. When we do offer these rooms, people will have a really nice place to live for a normal price within welfare or whatever people can afford.

I've recently been more involved with the Olympics issue around social housing. I'm trying to advocate for social housing in the neighbourhood. I remember when they first shut Woodward's down. They had nailed up a bunch of planks over the windows and you couldn't get in. There were a lot of protests around there. People were sleeping outside and I think we did our own

"Rebuilding Woodward's" by Curtis Traverse, 2007.

action there to protest the shutting down of such a big neighbourhood institution. They'd promised to set it up for social housing and that never really came through.

We spray-painted the boards that had been put up on Woodward's to say *Homes Now* and *Homes for the Poor*. I spray-painted a flower. I would've been probably about five or six years old.

I am also active in antiwar protests. On Valentine's Day when I was in grade six we picketed the US Consulate. We shouted, "USA, have a heart, get out of Iraq," and we handed out boxes of heart-shaped Valentine's candies. My mom and I went to that action together. We didn't believe that it was okay to kill people in Iraq and someone needed to stand up and say, "No."

We also protested at the US border. My mom and a bunch of people from the community went down to the border and my mom and Irene sat down in front of the rigs that were transporting American goods into Canada. One of the priests from our parish came with us. We held signs as my mom and the other women blocked the incoming traffic.

Living in the Downtown Eastside has taught me so much. I've learned about the effects of drugs on people, which is useful in high school. In my first couple months of high school, a friend of mine overdosed on ecstasy at the school dance.

In high school, there's a lot of peer pressure about who's cool and who parties and who does drugs, but that doesn't interest me. My Christian lifestyle encourages me to stand out and be different, so my faith and community have gotten me

"Maya on her Bike" by Karah Walker, 2006. Maya, Hannah, and Kara are sisters.

through high school without feeling like I need drugs.

The hardest thing about living in the Downtown Eastside is watching your neighbourhood friends go through self-inflicted abuse. Experiencing violence is another drawback, but often there is redemption. Four years ago I was in the park when a man got shot in the leg. I was ten or fifteen metres away when he got shot.

He was a local drug dealer. There was a policeman in the park at the time of the shooting but he didn't do anything. An ambulance came, but the man refused to go to the hospital.

My dad went out to help the guy who'd been shot. We were tired of the violence. He told the man about the kids who lived here and how scared we were of the violence and how all this had to stop. The man said he wasn't going to retaliate. He apologized profusely and said, "I will help you. I don't like this violence either. This has to stop."

That's when we began holding meetings in the park and invited people to come and give input as to how we could stop the violence. As a result, the gun violence stopped completely and the violence in general decreased.

I've grown up here in this neighbourhood. I have made friends with all sorts of people, all ethnic backgrounds, all areas of the world, all life experiences. Probably the closest friend to me has been Rosalynn Humberstone.

I've known Rosalynn since before I can remember. She's always been a friend of mine. I'd say when I was younger in elementary school she was my best friend. She lived here in the house with us for a while and I used to play cards with her every night. Ros was always like a kid. She liked to watch *Scooby Doo* with me and we used to go out and buy stuffed animals at the second-hand store together.

Growing up over the years, we've maintained a good friendship. Ros never really talked about very heavy things with me. She just realized that I was still young. I do remember one time coming upstairs into the living room and she was sitting there crying so I went over to her and gave her a big hug and asked her what was wrong.

She told me that she felt like her family didn't need her anymore and that they

"Man Behind Fence" by Karah Walker. This is a photo of Anthony "Tom" Simpson at Oppenheimer Park.

were ashamed of her and her life. That was such a foreign experience for me because I've always grown up with a caring family.

I explained to her that we were her family and we loved her and cared about her. She talked to me about how she'd wound up on the street at a young age. As I've gotten older we've talked a little bit more about it and she's told me a bit more about her life, but for most of our friendship we've related on a kid-to-kid level.

Humans are important, whether they're humans who are poor or humans who are wealthy or humans who are addicted to drugs. I believe that all people are equal and so when I protest against war or poverty, I do it because I want everyone to hear what I'm trying to say.

I believe that I am lucky to have been able to grow up in this neighbourhood, and I believe that not many children ever get to experience the kind of life lessons and community that I have experienced. When people question how my parents have raised me, I always tell them exactly what I think—I have learned what community means because I have learned how to respect people.

"Remembrance" by Aurora Johnson, 2004. The inscription on the rock reads: The Heart has its Own Memory / In honor of the spirit of the people / Murdered in the Downtown Eastside / Many were women and many were native / Aboriginal women. Many of these cases / Remain unsolved. All my relations. Dedicated July 29, 1997

# AURORA JOHNSON

born 1993, Vancouver, BC

I live with the kids in this photo. I'm in grade eight. Sometimes I play with kids at school and sometimes I just hang out with the kids here in the community. We are all friends and we have parties and community dinners five times a week. We live in a bunch of houses by Oppenheimer Park. I lived in the red house when I was a baby and I also lived in the yellow house, green house, blue house, and the coach house. I grew up in these houses.

Before the community got this house, the person who lived here was my friend and we always came here. We had secret stashes of pennies because there's always so many pennies here. We hid them and then one day the guy who used to own this house said, "I have a stash." I'm like, "Okay," but his stash was made of marbles. He said that I could have them, but we all shared them.

I don't know how to explain it—he was mental. I talked to him from my house. Once my cat went to his house and he gave it away. He's like, "My friend has it now," and I'm like, "Oh, okay," and then I cried.

When I was younger we played house in the fort, or in the clubhouse. We would play restaurant and the older kids made little kids food and we'd sell things like for fake, like rocks and stuff.

We play dress-up like olden days. But it's sort of embarrassing because I don't play that stuff anymore. Unless we're really bored. We do spas on little kids.

We have mud masks like St. Ives or something from the Body Shop. Sometimes we dress the boys up as girls. There's one boy named Sage and when you put pigtails and make-up on him he looks just like a girl. We're like, "We don't know if you should go to Crab Park like that," and he's like, "Please, please, please, I want to." 'Cause he's a little kid, right?

Playing in Oppenheimer Park is good because whenever you walk by, all the people who do drugs always say, "Kids in the park," and then hide their drugs so we don't see them doing that. All the people are nice.

These days, I play basketball. We play "Bump It," which is a basketball game I learned at Oppenheimer Park. I play with Jamie, this guy who lives in the green house, and all the older kids. Sometimes little kids want to play basketball with us 'cause it's fun, but we make them lose so it's kinda mean, but not really, since we always give them second chances.

We used to get on our bikes and play town and city. We also played motorcycle people and cops. It's embarrassing now. We would pretend we're boys and girls and we'd say, "Wanna go on a ride?" Or, "The Hell's Angels are coming!" We always catch the bad guys.

But I don't like being a cop. I like being a robber.

Policemen are mean. They say, "Let's have no fighting," and then they fight. I don't know how to explain it. They have guns.

Once they were in the park trying to get people down because one person had pepper spray and she was spraying it all over and it tasted like tobacco.

We were in a tunnel in the playground. The police said, "Put your hands up in the air," or "Put your hands behind your back," or "Freeze." I don't know. I don't listen to them.

"Contemplation" by Aurora Johnson, 2004. Aurora's mother.

I listen to myself and my dog Zelda. I talk to my dog. She's my age. She's a German Siberian Shepherd. She looks like Wile E. Coyote 'cause her ears go this way and they don't go straight up. She's so cute, but she has a lot of grey hairs.

There's a lot of cats around. I like cats, but my one cat is named Dorky 'cause we name our cats dumb names sometimes. We also have Samjam, Rica, and Puss, but Puss isn't mine and Rica I gave to my dad, but I don't know if he wants her 'cause he's allergic. But he pets them all anyway.

I like to pick cats up from the wild, but sometimes people just give them to us because they don't want them. Once my mom was throwing water at a cat on the street, because if you throw water at the cat on the street it thinks water's gonna fall on it every time it goes to the street so it doesn't go on the street anymore and a lot of cats get hit by cars. So this guy, my friend, tells my mom to stop throwing water at the cat and she says, "Don't tell me what to do because I know what to do with cats." He got so mad and he made my mom stop. The next week the cat died on the road. He says, "I'm so sorry, I should've listened to you." Then he gave us two kittens.

"Sitting on the Steps" by Aurora Johnson, 2006. Aurora's father is seated in front, Jean is on the left and the man behind agreed to be photographed when Aurora suggested that he scratch his head so that he wouldn't be recognized.

Elisha-May's mom Kathy gave me the idea for this photo. We were playing at Crab Beach and she said, "Why don't you take all the girls around the rock?" It's a memorial rock for the women that got killed in the Downtown Eastside. They got killed and they were people like prostitutes and drug users. Some people say they died on a pig farm.

I was just like, "But what about the lighting?" and Kathy said, "Oh well, don't worry," because first it was sunny, then it went cloudy. Then I just took the photo.

There's something mysterious about this photo (see page 223) that nobody knows except me. Since it's the Women's Memorial, we didn't want any boys in the picture because they're not the people who got killed. But all the boys wanted to be in it so we let them sit on the ground and that's the top of their heads at the bottom. Those are boy heads.

Standing at the rock is Mercy, my friend Jasmine, and her sister Dominica. They're my fake cousins. And that's Cara, Elisha, and Hannah. That rock is a nice place because people always put flowers and knick-knacks there, but it's a sad photo because it's all these girls looking down like they're sad about the killing and they really wish the women hadn't been killed. That's sad for all the families—the girls looking down at that rock.

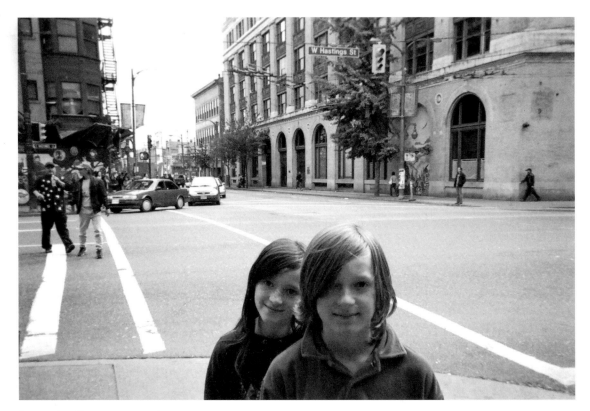
"Maya and Kael" by Graeme Bottomley, 2007.

# KATHY WALKER

born 1965, Vancouver, BC

Being concerned about poverty goes hand in hand with being Christian. If you are to be a Christian, you need to be in close relationship with the poor, struggling alongside them and working towards making life better. That is how we understand our faith and that is why we purposely moved to the Downtown Eastside to live and raise our children.

We are approaching our fifteenth year living here in the Downtown Eastside. When we first arrived I didn't have great concerns about the children and their safety. Back then I only had two young children and they were constantly with me. I was worried about being overwhelmed by the crises that people were having in the neighbourhood and I was wondering what these crises would do in terms of changing my life.

We have made a commitment to intervene in violent conflicts in the neighbourhood and because of that we have been in the midst of fights with knives, pipes, chains, and people just freaking out. I don't remember feeling terribly afraid. Dealing with fear was harder for some of the men. If you go to intervene in a fight someone is more likely to punch you out if you're a man than if you're a woman.

We've developed a discipline around our approach to violence and our own willingness to risk being hurt. We believe that we need to risk harm and that we need to be vulnerable. If you go into a situation aware of that vulnerability, to a certain degree you're disarmed and that is the first step in helping to

disarm the situation. For instance, we rarely call the police because we find that the police escalate violence for us. I mean they come with a weapon. They come forcibly. They don't want to talk.

We have done our best to humanize one another in the situation and look people in the face and say, "What can we do? Are you okay? I'm just a neighbour who's worried that someone's going to get hurt and the kids are looking out the window and they're scared and can you guys just stop." We have found, amazingly, that they will stop. I cannot tell you how many times this approach has completely de-escalated violent situations.

Once my friend Jen was in the middle of a fight where a man was being beaten with a pipe by four other men and she stood in front and said, "Please don't do this." They could have smashed her in the head, but she was prepared for that risk, and a commitment to non-violence means that you accept that risk. Thankfully they dropped the pipe and walked away.

I have definitely been scared at times. I had an unpleasant drug dealer threatening me over the course of one summer. He warned me that if I wanted to see my kids grow up, I shouldn't interfere with his business, and for him interfering with his business was me telling him that my kids were going to ride their bikes in the park and could he please make space for them.

I had to be persistent with him and insist that he needed to leave the park and that the way he was speaking was inappropriate. I was aware that I was dealing with somebody who was dangerous, so it was hard. I don't know how I got through that summer.

There was a woman macheted in the park in broad daylight. People were out and about, and one of my neighbours was a witness to it and was the only one who would actually talk to the police about what happened. People were too afraid to say anything. So we have had times when we have felt vulnerable, but we feel so much at home here that the vulnerability doesn't take over.

We insist on not giving in to violence. We will not be afraid to walk into a public park across from our homes. This might sound like bravado, but really it's not easy to do, and I've felt afraid at different times, particularly when I see other people close to me engaging in a violent situation. But if you believe in what you believe in, then you find ways of dealing with that fear.

We've raised the kids to have courage, and I think if the kids do not see their parents and other adults in their life acting in a way that demonstrates courage, they will not have a reservoir of that to build from in their own lives. I have to say I am constantly amazed at the goodness that is in people. When you deal with people on a human level and tap into their kindness in the middle of a violent conflict, they tend to come out of the violence and walk away as better people.

One time this man had a woman cowering in the corner of the park and he was abusing her, and my husband went right up to him and said, "Don't ever let me see you treat a woman like that in front of us ever, ever again."

The next day this same man starts heading over to the car my husband's sitting in. We both thought, okay, here we go, he is going to attack us. My husband rolled down the window and the man said, "I'm really sorry about what happened yesterday."

I have met and experienced some of the most genuinely good people down here who are doing a lot of bad stuff, but there is still a basic core of humanity in people. When we tap into that, people will say, "You're right, this isn't good." Their lives are hell and they actually have the decency to say, "I'm sorry." You don't get that in a grocery store. You don't get that on the highway when someone cuts you off.

There are a lot of radical activists who are only on about what they're tearing down, but they're not building anything. It is not healthy to just be against things. You must be for something, and for us that is community and giving people a sense of belonging so that they will feel better about their lives.

The Christian right is limited, much like the Christian left or the left in general. The left can preach a lot about peace except when it comes to, say, an elderly sick person. They might believe that it's okay to nudge them along towards euthanasia because it is faster and cheaper. Or a pregnant fourteen-year-old, who wants to deal with that? Or a woman who's drug sick and pregnant. I say take her in and help her with her kid. We don't want to bear those burdens. It is much cheaper to kill people.

I do not support the legalization of prostitution. To me there is no woman whose place it is to service men in that way and to be violated in that way. Women aren't for sale, to me this is basic feminist thinking. I know there's wealthier women downtown who are making money doing this and prostituting themselves, that's a whole other issue. I understand that people are trying to reduce harm to women, but I think it can be done without ever legitimizing this kind of survival sex.

People often assume that because we take our Christian faith seriously that we support acts of violence like the war in Iraq. We have to fight hard to be clear about our faith and how we embrace non-violence around Jesus's principles and not the violence that is often sanctioned by the Christian right.

I certainly don't identify with the Christian right, although I share concerns about similar issues. For instance, our community has a value that we call "consistent life ethic," and that is where we believe that fundamentally the taking of human life is something we ought not to do and that we should first make a commitment to not killing one another. Through this we embrace six issues: war and the arms race, poverty, abortion, racism, capital punishment, and euthanasia.

We try to work together in the spirit of peace and reconciliation to get people to see that there's a thread between these issues. If you take life on one issue you've devalued it in general. We hold to that consistent life ethic, so we end up working more with the Catholic left in terms of our way of thinking, but the consistent life ethic is embraced by Buddhists, Hindus, and Muslims.

We have also had refugees living with us. One fellow in particular was a Kurd from Baghdad, and through our relationship with him we became concerned about the sanctions on Iraq. The children and the adults worked together on a multimedia presentation to try and communicate what was happening under sanctions and what happened in the first Gulf War with depleted uranium.

Through education and finding out what was going on, two women in our community, Jen and Irene, made a decision to go to Iraq on a peace mission with a group called Voices in the Wilderness. They went to Baghdad and

spent time with the Iraqi people and visited hospitals and went to Basra where there were constant no-fly zone bombings.

Jen and Irene were in Iraq for Christmas and they went to Mass with people

"Community meal" by Elisha-May Walker, 2007.

in Baghdad and said it was one of the most beautiful things they've experienced. They had brought strings and different supplies for the orchestra, so they were invited to hear the orchestra who were sitting on plastic seats. Fantastic musicians in Baghdad performed on plastic patio chairs and could not fix their instruments because of the sanctions. Children in hospitals had no medication or pain relief from these sanctions.

We felt that it was important for Christian people to go there and say, "We are followers of Christ and we have no interest in harming you. Please understand that this is not the way all Christians feel."

When we were seeing them off, we knew we might never see them again. Their parents were there crying and it was traumatic, but people get hurt changing the world. People get hurt going to war, and if you're not willing to risk getting hurt for the sake of peace, then you might as well just go back in your house and lock your door.

People question our decision to raise our kids here, but most people need to be more profoundly aware of the numbing effect that privilege has on the souls

of children. Being separated from the suffering of the world is dehumanizing, and children who are isolated grow up to be adults that don't deeply understand people and don't have a deep sense of compassion.

I'm not scandalized by the fact that people use drugs. People are addicted to all sorts of things in this world, and it's too easy to look at people on the street using street drugs and focus all our moral outrage on them. Let's talk about alcohol. Let's talk about cigarettes. Let's talk about shopping. Let's talk about cable TV. I don't see drug addiction much differently.

I have exposed my children to suffering, but it has been mediated by a celebration of community and friendship and all the fun and beauty we've had in our lives. Without this it would perhaps just be a harsh reality, but with it we are exposing them to shared suffering that is rooted in compassion. Without prejudice, we are building family, which we understand as the kingdom of God.

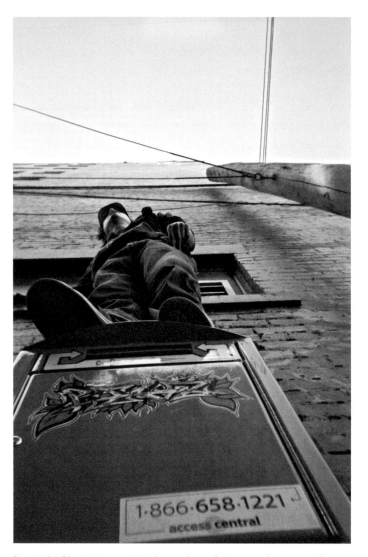

"From Below" by Tristan Vox, 2006. This is a photo of Tristan standing on a needle drop-off box.

# TRISTAN VOX

born 1985 in Sudbury, ON

I spent last summer just sleeping on beaches and doing various artistic things. I came to British Columbia when I was thirteen to live with my biological father. I lived with him until I was about sixteen. Then I moved in with my girlfriend and lived with her and her family until I was nineteen. In between those two periods, I was in a group home for about six months.

Last December I had a place for like three or four months. One night I smoked a joint and passed out listening to really spacey rock. I had left my sink running and I flooded my apartment and damaged the office buildings below where I lived. So I got kicked out.

I was working at Café Crepe, the largest one on Granville. I was working about sixty hours a week, so I started using Ritalin and crystal meth to be able to work such long hours. I'd used Ritalin for most of my life.

The meth quickly spiraled out of control. Eventually it doesn't hit you the same way, and you're tired and you start feeling like crap. Then I started using it intravenously. Probably about three months ago, I kind of hit a wall. I think I had like a heart attack and ended up being taken out of my friend's apartment by the paramedics.

I've just started living on the streets again like around December. I lived up on Black Mountain. We set up a camp under an old bridge. I bought a two-zone bus pass and would come into the city to work. I've been working for

a small independent video production company downtown as a junior editor and I worked the World Urban Forum doing videography.

A program called Projections was hugely instrumental to me getting off drugs and staying clean for the last three months now. It's funny how many times I got in fights due to drug anger or I was late repeatedly or didn't show up for a week. They kept giving me chances, but eventually I just got my act cleaned up. With their help I'll probably be going to a film school on Galiano Island.

I still live outside. I crash underneath Science World every couple of days. There's a giant fence so no one can get underneath there. You have to go over the edge and there's these poles that come down. There's a piece of metal that lines it and you can go on the metal about ten feet over the water. It's pretty safe because no one else is willing to try it.

I've seen three friends try and they've had to wade through chest-deep Science World water. I've never fallen in so I'm pretty happy. I can leave stuff down there, like my backpack. I've hung photographs down there and no one ever bothers me.

I'm really not so worried about other homeless people. They're generally pretty afraid of other people and they're fairly anti-social. There's a couple of violent people, but the majority just want to be left alone and avoid even being seen.

I'm more worried about jocks and yuppie types. They're more likely to try and pick a fight with you or jump you with a couple of people. I'm no lon-

ger an intravenous user, but I still carry a syringe in my pocket because I've been jumped three or four times last year. Twice in Stanley Park by a group of about seven or eight people who were with their girlfriends and the girlfriends were cheering them on and throwing rocks and big pieces of wood at me. Five or six of them were chasing me through the trails. I also got jumped at the one of the fireworks shows in English Bay. A lot of my homeless friends get beat up for stupid shit. Like sitting on Granville Street on Friday night, you're likely to get kicked.

I avoid the whole scene. Or I pull out a syringe and threaten people because they're afraid of it. That's the main thing, avoiding the so-called socialized middle class types of the city. I don't feel unsafe with other homeless people. I feel very uncomfortable around teenagers who are likely to be violent.

I sleep where it is hidden. I'm less likely to get poked by a dirty rig because they get left everywhere. Probably nine or ten months ago I was stabbed with a dirty rig while sleeping in Stanley Park. I just went to lie down on this kind of wood-chip area by a tree and I leaned up against the rig and caught one in the back.

I worked the World Urban Forum at the opening event with Stephen Harper there. I'm sitting up in the front photographers' booth and the person is asking me, "So how did you get here?" I was like, "Oh, it is my first assignment." I got to do that and then I'd get on a bus and I would go sleep under the old abandoned bridge near the Eagle Ridge Bluffs near Black Mountain.

This photo (see page 236) was taken about four minutes after I had the camera in my hands. I snapped my entire roll in about twenty minutes. I nearly

sprinted out and I saw a needle drop box and I thought it would be a nice angle so I jumped up on top of the box. I had my friend Graham hold the camera for me and take the shot.

Crystal meth is fairly addictive when you are doing a gram a day intravenously. That drug is not real—red phosphorus and battery acid—and you're asking someone to shove it into their arms. I'm pretty lucky I got out of shooting up with little more than a scar where I once missed my dope and burnt my skin.

I wanted to show that it's possible to rise above these things. It represented for me the street culture, that tagging on the box, and someone standing above it.

I don't like the other parts of the city. I don't like Downtown. I don't like Granville and I don't like any of the surrounding areas, especially around Robson. There you are more likely to get comments. One day I was walking on my way to work and a guy walked past me and he's like, "No one is going to miss you," and I was like, "Wow, I don't know who the fuck you are." He was standing around doing something and I just asked him, "When was the last time *you* had an art gallery exhibit?"

I got my job because I panned for ten dollars and I went and bought an instant camera. I ran around and showed some photos to my friends and they said you should pursue this, this is really cool, so I applied to Projections and I got in. It's like six months later and I'm not doing drugs anymore.

My parents didn't actually know I was homeless for the majority of the time I was on the street because it is not that hard to get a shower at a pool, buy

"Triston Vox" by Anon, 2006.

some clothes and get dressed up, cut my hair and go out to see them. It's really not that hard to clean yourself up in half an afternoon and look like you're not living under a bridge. I had to do it for work every day.

I'm actually really wealthy when I'm down here because I have a lot. At the World Urban Forum, I saw kids who can't get access to clean drinking water. Even if I'm poor as hell, I can still demand water on every single block and get it if I'm willing to make a huge stink about it. When it's cold people will give me a place to sleep, not that I need it anymore because I can take care of myself—that's not a problem. I have enough camping gear on the mountain that I can survive for months.

I feel really privileged. I live in the First World. I live in the place where people want to come to on their vacation. I can see pristine beautiful mountains in a half an hour bus ride. And I only have to have two dollars and fifty cents to get there, which you can make by picking up a couple of bottles.

I slept in a cardboard bin, but I went to work every single day. That's living on the streets. I see kids come out here from the suburbs because they are pissed off at their parents and they smoke a joint and suddenly they are fucking Sid and Nancy.

A lot of people want to get their own pair of dirty wings and do some falling. If you go to *flickr.com* and type in "homeless" there are thousands of pictures of homeless people. They are really popular. People who have nice cameras are taking pictures of homeless people. Someone had an art exhibit of homeless peoples' hands and feet while they were sleeping.

On the way here, I watched a cameraman with a Betacam filming a homeless guy who was sleeping. And the guy was asking, "What are you doing? Why are you filming me?" And he wouldn't say anything. Then he goes, "We're done. It's okay." It was like he was talking to a child. Then he took off with his camera.

"Al T." by Wilda, 2007.

# WILDA

born 1954 in Calgary, AB

I have built my own little world in my hotel room much like you'd see someone build their own little world on one of those home renovating shows. I don't have their budget, but I keep certain items that are in good condition because I feel special. I have Chinese umbrellas, stereo, TV, the whole nine yards. I even have a vanity where I can sit and look in the mirror and I have another bigger mirror on a door so I can do aerobics. People are impressed and they say you can't even tell you're living on Hastings.

I have this picture behind the TV and I put this lamp behind it without a shade, but because of the TV, you can't see the lamp, but it illuminates the picture. It's supposed to be a picture of Calgary.

I was born in Calgary. We moved only once, from the southeast to the southwest part of the city. I went to four different schools and graduated. I lived the good life. My mom says we didn't always have everything we wanted, but we always had food in our stomachs and we always went on holidays.

I have a nineteen-year-old son, Josh, and he lives one floor below me here in the Downtown Eastside. His father got psychosis in the last few years because of meth. I'm not saying I didn't do that too, but I didn't develop psychosis, thank God.

We were living in an apartment in New West when we got into speed. At the time I was living common-law with his dad, Claude. One night Josh came

home with a friend who was an older guy. I mean, he looked our age. Josh would have been about twelve or thirteen. So Josh came home with this older friend and he always had a lot of friends, so we get to talking with this guy and we were all babbling about this speed stuff. I couldn't have cared less. I didn't want to hear about it.

Anyway, the guy had some crystal meth and Josh and his dad and this guy did some. I guess I must've snorted some too. Then I was just scared of it. Then they kept saying, "It's up there if you want some."

The cops told me that they'd known Josh since he was nine, so he might have been doing drugs since then. I don't know how he got it. Then I stopped that stuff because it was stupid.

Then Claude started changing and all these people would be in and out of our place. I didn't know half of them. Then this pathetic thing happened when this guy came over about three or four days later—I went in and got started on it. The only people I really knew were my son's friends and they were like surrogate nieces and nephews. If it hadn't been for them I don't know how I would've got through this because they protected me.

Then Claude started bringing in dirt and bricks and stacking them in our apartment. The place looked like that movie with aliens and that mountain thing made out of piles of dirt and bushes. He brought in bricks and dirt and he said it had something to do with the microwave.

I have depression and I'm still having an up and down thing with crystal meth. Of course, Josh is too. I'm seeing a psychiatrist again. I would like to

go into recovery, but I don't want to lose my tenancy in this place. I've worked hard to make this place special. Just recently my shrink has prescribed Ritalin to curb my meth habit.

My happiest memory? I would say having Josh. When I got pregnant, I really wanted a kid. It didn't happen until I was thirty-four and I thought that was so good after what I seen my sisters go through. They were both pregnant as teenagers and had to give up their babies. Dad would act like he didn't know, but they were both still living at home and their bellies were getting big. I loved being pregnant. Claude treated me so well. Once he got all these nickels together and bought a carton of ice cream.

I love Josh so much. He's very smart. When he puts his mind to something, he can do it. Even with this crystal meth, I know we're smarter than that and we can get away from it.

I just have to give myself a little boost. Lately I've been putting my money more towards real things because meth is not a real thing. It's like a cigarette. It's a luxury item.

I'm not working right now because I broke my foot at Western Waffles and didn't attend to it on time. I worked at Western Waffles on Annacis Island. I was a production worker.

That was about three, four years ago, and Claude was pushing me to get to work. I was working through Labour Ready at first, and then finally they hired me on. Then I broke my foot at the back of a tunnel freezer, but I didn't get a cast on until a month after because Claude would force me to go to work.

It burned like hell and sure enough two months later, I was on a broken foot and a cast, but it didn't set properly since I didn't take care of it right away.

I didn't mind the oven work. I worked on the sorting line. I worked on packing. When the Belgian waffles come down you pack them. I worked in the oven room, flipping the Belgian waffles. I think I worked in every section except for the freezers and women don't work in the freezers.

It was a hard job because it was multicultural. I was one of the few white people to be hired because they had to hire so many white people and I just happened to be one of them.

Claude was pushing me to go to work, but Josh said, "Enjoy the ride." I'm like, "What the hell's that supposed to mean?" He meant meth. Well, that was stupid. I tried it, but the sorting belt was going so slow. I says, "Jesus, turn this belt up."

I'll never do that again. That was just plain stupid. If there is one thing that I regret as a mother, it's that I ever tried that stupid crap.

# AL T.

born 1957, Vancouver, BC

I was born in Vancouver in 1957 at the Grace Hospital and my first home was at the Vogue Hotel down on Granville Street. So really I've lived in Vancouver all my life. The Vogue is still there today, but it was different back then. They provided a highchair and a crib for me, or so I've heard.

As a boy our family shopped at Army and Navy, Fields and, of course, Woodward's. My mom was a waitress at the coffee shop in Woolworth's when she met my dad.

We did a lot of shopping and spent much of our time downtown. My dad used to take me to the Lux for the double feature. I got my first pair of Western boots at a place called Gabor's Shoe Repair next to the Seven Little Tailors that was right on Carrall. There was a pair of suede cowboy boots in the window and I really wanted them. I said, "Come on, Dad, there's a pair of boots." He got me those and a biker leather jacket from Hershons Men's Wear which was beside Army and Navy.

Then we moved to the North Shore just east of Lonsdale, next to the Baptist Church. I would walk down to the Dairy Queen with my dog and pay a quarter for an ice cream cone. I always remember that. My dog was a Maltese terrier right out of *Please Don't Eat the Daisies* with Doris Day and David Niven.

So I'd take Skipper down there with me and my buddy Davy, who lived next

door. With Davy and I and a dog like that, people would offer to buy us an ice cream cone.

Then when I was seven we moved to East Van. My parents bought the house because back then you could buy a house. It was 1964 and they paid eight or ten thousand dollars for that house. Now you couldn't even dream of using that to make a down payment on a cheap condo.

Pigeon Park used to be a lot different. There simply wasn't a drug scene like there is these days. The park might have a few drunks and rubbies, but that was about it. It was old guys with their cheap wine, although you might see the odd one drinking a bottle of Aqua Velva or Williams Lectric Shave. Nowadays you can see groups of them passing around a litre bottle of Listerine mouthwash and they're smoking crack at the same time.

God, I don't know how anyone could drink that stuff. It's horrible on your system, but apparently it's quite popular. It's over twenty some percent alcohol, so I guess that's what the attraction is.

It used to be that a family could go shopping in the area, or just sit there on a bench. These days it's more hardcore. That alleyway between Carnegie and the Health Contact Centre can get quite violent. It's right across the alleyway at the Roosevelt Hotel. I work in the needle exchange there. It's run by VANDU, which I've been a member of for many years. My last shift at the needle exchange was pleasant, though I had to rearrange everything there because some people don't keep things organized as I like.

"Fresh Rigs" a photo of Damian Ackles by Harry Jarvis, 2006.

When people come in, there's a place for them to drop their needles into a bio-hazard bucket. It's stainless steel and we just pull it back and drop the rigs in there and close it up. We hand out fresh rigs in singles; we have five and ten packs which are bundled with an elastic band around them.

We've also got boxes of a hundred and occasionally we give those out, depending on the person and how far they're coming from. Some people have good control over their habits and they'll come and get a box or two of rigs and come back every month or two. If you give them the chance, they'll take good care of themselves.

Right now I have no fixed address. My last address was over at Triumph and Nanaimo. Before that I was in Richmond. I also used to have a house in Surrey. Now I stay with friends or at shelters.

After the last shift I did the other night at the Health Contact Centre I wound up staying at the Recovery Club over on Twelfth and Kingsway. I was sitting there all night watching movies.

Sometimes I take a few rigs with me and that because people are always asking for them. I want to start stocking multivitamins because that big rush just takes a hell of a lot out and depletes your system. We'll carry condoms and

ties, all the different stuff that's needed. We also give out mouth pieces for crack pipes, which is really good because Hepatitis C's so rampant.

I don't think you can get Hep C simply from saliva, but it's easy to pass if you got a cut lip. So it's best to have a mouth piece and then change it since a lot of people have sores in the mouth or maybe they have burnt their lips on a crack pipe.

We give out all the accessories for shooting up and some of the stuff for smoking crack. We have a nursing station and we do foot soaks, which can be quite good for people when they're stuck doing a lot of walking or have poor footwear. You can get what we call "street feet" which is when your feet become cracked, swollen, and sore. Peoples' shoes start leaking and so they need help with foot fungus.

Our philosophy is to try and make it a lot safer for people. There's so much corruption and a lack of standards that goes on with prohibition. People need someone to talk to and they need help with basic things. When bad heroin comes out we put out warnings and we always encourage people to test their dope.

Bad heroin can simply be too strong or it could be cut with something bad. A lot of the time, heroin and cocaine are cut with baby laxative. Sometimes the worst is when it's cut with crystal meth. The government banned the necessary chemicals for meth from the market—different things you used to be able to buy over the counter at hardware stores and drug stores.

Rather than putting a stop to meth, it's just made producers use more danger-ous chemicals. Now it's not methamphetamine and not even pharmaceutical by any stretch of the imagination. Who knows what's liable to be in there since they're making it on some bathroom counter? There could be anything in there—hair spray, grease, or anything.

We need to get rid of prohibition and regulate drugs properly. We need to get it out of the hands of the criminal element to reduce the violence. I mean, how often do you see somebody coming from a liquor store with a six pack of beer and a bottle and they're challenged to fight? All kinds of weird things are going on.

Lately there's been this dope going around which they call Fish Dope. It's crack cocaine, but I'm not sure what else is in it. Maybe it's from freighters with some kind of fish. It's really bad and it smells like a can of rotten sar-dines.

When it comes to drugs, there are a lot of people who are complacent and brainwashed by the media. It's quite the propaganda machine in Canada. I'm an outreach worker. Now come down here and tell me about the benefits of prohibition. Then explain to me the ingredients of meth and how we can let that onto the street unregulated. Explain to me all the overdoses on China White. Explain to me Fish Dope.

"Helen 'Mom' Hill" by Skyla, 2007.

# SKYLA

born 1981, Abbotsford, BC

I moved to the Portland Hotel last year, but I've been eating downstairs at the Potluck Café for almost three years now. I used to live at the Balmoral and if I had dirty clothes there'd be restaurants that'd say, "Get outta here, you stink." Helen would say, "Come in and get your lunch."

As residents of the Portland Hotel, we get to go there for a free meal. Helen works at the Potluck Café and everybody down there knows her as Mom because we all look up to her as a mom. It's a great atmosphere because everybody respects everybody. What goes on outside of the restaurant stays outside the restaurant. I've never seen Mom lose her cool with anybody.

I took this photo on the spur of the moment. Mom was just standing out there in the morning having a cigarette and reading the paper. I'd never used a camera before in my life. It was something me and my husband thought we could do together as a couple. I said to my husband, "Watch, it's gonna be a waste of my time," but once we finished I wanted to do the photo shoot again. Taking this photo makes me think I accomplished something in life.

I spent most of my life in Dawson Creek, but I'm a product of the government. I spent three or four years with my dad before they found out I was getting molested as a child. I went to foster care after that and then at the age of seven I went to live with my mom in Dawson Creek. At the age of ten I moved back to foster care. I became a permanent ward of the province at the age of twelve.

They had put me in a group home for women sex offenders even though I'd never touched a kid in my life. They were trying to prevent me from becoming a sex offender because I guess statistics say that kids who were abused will re-abuse.

I was sneaking out of the house at night and started working. I was working from the age of fourteen up, in Dawson Creek and Fort St. John. Up north, you can get a thousand bucks for a blow job if you're under nineteen.

After I hit nineteen, I became a severe alcoholic and drug addict and went from there to street life. I went to jail for robbery. I robbed a store in Dawson Creek with a syringe. I got away with it at first. I ran from the cops and got my dope, but later I ended up getting arrested.

They dropped an attempted murder charge because I'm not HIV-positive, but when I was robbing them I told them I was. I pleaded out on armed robbery and got nine months instead of eighteen.

When I was in jail, I met a friend of mine. After I got out, I was sent to a recovery house but then got kicked out, and she had given me her address in case I ever needed a place to stay. That's how I ended up in the Downtown Eastside.

I've been off the street almost two years now. My husband gave me an ultimatum and I chose him. I miss the money. But I don't miss getting hurt. I don't miss being held hostage.

Once I got picked up by a guy who picked up another female friend of his and she told him that I took her for forty bucks. So he robbed me of $280. I had my knee busted and she hit me in the head with a pair of scissors.

They held me hostage for three-and-a-half hours. They covered my mouth and I couldn't breathe. I was about to pass out. Afterwards they're like, "You want a toke?"

I told them to fuck off and I walked from St. Catherine's Street to the Petro Can gas station on Broadway with a busted knee. After that I kinda worked, but it was too iffy to go out steadily again.

I didn't report that incident because the girl still lives in the East End. To this day I still get threatened by her. I guess you can't be friends with everybody. She wants to rumble, I'll rumble. I may be in a wheelchair, but I'll rumble. My arms work fine. That's the way I look at it.

To be only twenty-six-years old and have your life almost taken twice, it's too much. I'm also a survivor of the pig farm. I'm one of the lucky ones who wasn't killed.

But I refuse to go to Court on that. I've given them my taped statement, but I'm not going. I gave my statement to the lawyer and he'll read it out for me. I don't want to be there because I'll jump over the barrier and I'll kill him myself.

I never really had a childhood and I've done stuff that there's no way a twenty-six-year-old should've done. I'm now just trying to play with dolls. I have

colouring books. Since I've been here three years, I've seen twelve people I know die. At least four of them were from the Portland. I'm not gonna let this place kill me down here. I didn't let Pickton, I'm sure not gonna let the Downtown Eastside. I'm lucky to be alive.

A year and a half ago, I was thrown down the escalator at the Granville Sky-train station and I shattered my spine on the escalator steps. I have a hundred screws in both my legs from my knee down to my ankle. I'll probably never fully walk again.

I have one biological son and through my husband I have a stepson who's the same age as my boy. They were born the same day, same year, same hour, just two different towns.

My biological son is in Dawson Creek with my mom. She has full custody and guardianship of him. I did that just in case I relapsed. When I found out I was pregnant, I was a severe drug addict in Edmonton. It was skid row. I was picking rigs off the ground. When I found out I was pregnant, I quit cold turkey, but when he was six weeks old, I ended up relapsing.

I don't know who my son's dad is. I had a condom break from a trick. I got a cute little Asian baby. You could say he was my saviour. I still use to this day, but I cut down quite a bit. I'm off the heroin now and I'm on the methadone. I'm more of a crack-head now, but I'm not proud to say that.

He started kindergarten in September and he's all hyped on it. He's my mir-acle baby. When I was pregnant with him at five months, I was having Braxton-Hicks already and his heart had stopped for five minutes. He had no vital

signs and just as soon as the doctor said you miscarried, his heartbeat started up again.

He's five and he's overcome cancer already. He had three cancerous spots on the side of his face when he was two, but now there's no signs of cancer anymore. He's my miracle. I love my boy. I have women out here harassing me because I gave him to my mom, but I did the best for my boy. I'm starting to see him a little bit, but I don't wish to really see him because it's just too hard to hand him back over.

I'm a lot like my mom. When I was growing up as a kid, my mom was a prostitute as well. At night she would tell me, "These guys are your uncle, your uncle, your uncle."

She scolded me for being a prostitute at one time and I said, "Mom, where did I learn it from?" From the age of five to when I got taken out of the house, she had a new guy every night. She's changed now with my boy. She doesn't drink no more. She doesn't use. She's working in a restaurant and has her own little trailer. She's doing a lot more for him than she did for us and I respect my mom for that.

I have a biological brother. He's thirteen months older than me. He is in Dawson Creek right now. He's out there with his wife and his three stepchildren. He's a rigger. He chooses not to speak with me much because of our previous childhood experiences. We were both molested as children and because of that we did act sexually to each other, so now we kind of resent each other.

I have a half-sister that I don't talk to anymore. She refuses to say she has a sister now because she caught me out on the street. She lived a secluded life. She didn't live the life I lived. She lived in a normal home where her real mom and dad are together.

There are no signs of abuse in her life so she hasn't seen the other side of the world. She'll come down to Hastings and throw pennies at the working girls. That's the type of person she is. She's out in Chilliwack, but she'll come here at least once a year to do that, or she'll be one of the people that'll go and kick a panhandler in the head.

I haven't even met my two-year-old niece. My half-sister won't even let me meet her. I've come to the family and said if she won't let me see my niece, then I don't want her seeing her nephew anymore. And that's what I've done.

During the day, we're usually up around the liquor store. You have some nice people and you have some jackasses—all they do is put you down.

You can meet interesting people panhandling. I've met Robin Williams. I've met Dan Aykroyd and Al Pacino. These are people that everyday people wouldn't get a chance to meet.

We pan at the Dunsmuir and Seymour 7-11. We have different spots for hockey games and football games. Because of my addiction, I sometimes go up Granville Street on weekends, but otherwise I stay away from there.

I've had people come out of bars fighting and land on me. I've been punched at the Roxy. I've been spit on. I've had toonies chucked at my head. I've even been thrown out of my wheelchair by drunks.

I look at it as a learning experience. My life could have happened to anybody. I don't look at somebody with a million dollars and think their problems are any worse than mine. They could be at the bottom of their life, but I'm at a different level than they are. My bottom's a little lower.

For the longest time, I believed that it was the government and my mom's fault that I became an addict and a sex trade worker. It's not their fault and I know that.

Perhaps they pushed me to that point by not showing me love and compassion when I was growing up, but they didn't force me onto that corner. They didn't force that first rig in my arm. They didn't force a crack pipe in my mouth. I did that to hide my pain from society.

# HELEN HILL

born 1947, Kimberley, BC

When I started working here at the Potluck Café, people yelled at me. I was too old and slow and some of the residents were angry that I was there and not the girl before. Then one day I came in and thought, Oh, there's flowers here, I'm going to wear them. I asked my boss Johnny if I could wear flowers over my ears, he said sure, so I started wearing them to cut the ice. They'd say, "I like your flowers." I'd say, "I'm wearing them for you."

A guy swore at me one day and I says, "Look, can't you see I'm wearing flowers, they're for you, now don't swear at me anymore." To this day, I don't think he ever has.

I don't like the "c-word" or the "b-word." Some guys will call you that and I says, "Oh, don't call me that." I says, "I've been through hell already and I was called that, so you've got nothing left for me. Call me honey."

Now people here call me Mom because they need someone to be affectionate with and it lets them know I'm like home—like I should be baking bread every day and pumpkin pies on Sunday. We feed the residents upstairs from the Portland Hotel. They can come down and have a meal every day and we pay for it. We also have the café open to the public.

I grew up in Cranbrook and Kimberley in eastern British Columbia, then in Burnaby. I have dyslexia. I say I have it, but I've learned to live with it. I

couldn't write until I was thirteen and I couldn't read until I was forty. Everyone always says if you write you can read, but that's not true.

I'm self-taught in almost everything I do. Every day I'm learning something. I finally learned how to add and you don't die when you learn how to add. I swear. It's such a tortured trip that you think you're going to die, but you don't.

Pardon me for swearing, but I came from a shitty life. Half of my life was shit. My father and mother hated me. The only two people that love me in my life are my boys, my two sons, but they have to love me because they're my kids.

My mother told me to my face when I was older that she hated me and that I never had value to her. She said this in front of my youngest son. It upset him so bad that he said, "Well, if she doesn't like you, I'm half of you, what does she think of the half that's you in me?"

It took me fifty years to finally understand that she hated me because your mind says, "Don't think that way, sure your parents love you, they have to love you, you're their child." She should've told me she hated me years before, because I think I would be a different person. I wouldn't be a stick in the mud, being criticized all the time.

My father missed the best of me. He missed not knowing me as a person. He saw me as some crappy piece of lump on the floor that knew nothing.

School was a nightmare. I went to elementary school in Cranbrook. I'm going to say my piece because I'm sixty now. The teachers would beat me up. I got

beat up by the teachers so many times for not knowing one and one or three and three or the like.

One teacher said, "I'll show you stars," and she punched me in the head. I had a headache for five days, but she said if you tell your mom I'll do it again. I always remembered that. So you never told that you were beaten up at school by a teacher, but teachers were always beating me up and saying I was stupid.

The only thing I could do was play baseball. I was a hero because we had a dress code and we had to wear skirts and one day I slid into second base and I think the second base umpire saw my panties and I thought, *no more*—I was going to hit a home run from then on because I didn't want anybody to see my panties. I always made a home run, I swear. If the bases were loaded and I was up they were always happy because I'd bring everybody in.

I learned to write when I was thirteen. I had a teacher who was so beautiful. She played Chopin on the record player all the time in her class. When the record ran out the person closest flipped to the other side and then you went on with your work. What I remember is how she went up to the blackboard and wrote her name, *Mrs Powell*. There was nothing in my brain that told me to write until I saw "Mrs Powell" and her handwriting. I went. "My God, I can do that." And do you know what? I wrote like Mrs Powell, right there just like that. The three of us were in that room, Chopin, Mrs Powell, and me.

At seventeen I wanted to run away to Paris to live with Coco Chanel. She was a designer I admired. I should've just run off, but my dad said, "No, you can't go, you've only got seven dollars in the bank." I said, "Yeah, but that

seven dollars is going to get me to Paris and I'm going to go knock on Coco Chanel's door."

I should've pursued that. I was selling clothes at that time in a clothing store and if I'd talked to the right people they'd have gotten me to Paris. I found out years later I should've made every effort because Coco Chanel was an insomniac. I was an insomniac too and we both liked fashion. We both had black hair and were short and skinny. We looked alike. I wore big glasses, so what the heck? We could've been up all night drawing and sleeping during the day. The things you pass up. That's one of my regrets, not trying harder to connect with Coco Chanel. But I always bought her perfume.

When I came to Vancouver in 1972, I worked at the fisheries when it was the hopping place to be. I rented an apartment over on Triumph. Then I got married, but I've always been in the eastside. I've been here since 1972, which was a good year for everything, particularly the arts. There was a man named David Y.H. Lui and he brought everybody into town. Harry Belafonte I saw twice because I just loved him, and I saw Liberace in one of his last performances in Canada. I've seen Maria Callas. She was a noted opera singer. For ten years I seized on everything I could with the arts.

Back then they were affordable—for a hundred dollars I could buy a new gown, shoes, purse, my ticket, and have a meal afterwards. I can't afford to go now because you pretty well need a suitable outfit to go. It's like, "Don't ask me to go out because I don't have the clothes."

In '72, you didn't stay downtown after the stores closed because of the people on the streets who at the time were called winos. Thursday and Friday you

could shop until nine p.m., but you pretty well were out of the neighbourhood and home on the nine p.m. bus.

The streets changed when Woodward's closed up and things got bad when the drug use came. In 1984, my son went to pick up a dandelion one day and I says wait, I think I see a needle. There was a needle beside the dandelion he wanted me to have.

I learned to read when I was forty at my son's daycare. Like I said most people think that if you can write you can read, but that's not true. I faked it for all those years. I'd hear stories on the news and I'd say, did you read about this in the paper? Or I'd have somebody read it to me, someone who I could trust not to tell people that I couldn't read.

I was at the daycare once and a little girl hurt herself and the daycare teacher asked me to watch the kids for an hour while they went to the hospital. I said sure. So I've got these seven little kids and I said, "What do you want to do?" I was hoping in my head they wanted to play with their playdough, but they wanted me to read to them. I didn't want to tell them I couldn't read, so I took my time.

I said, "Okay, I need a good comfy chair." Then two kids sit here on my lap, two kids here, and now I've got to make six kids fit. One leaned over and says, "Where am I going to sit?" I says, "Well, sit on my head and put your feet on my shoulders."

So he gets up there and I'm helping him and he sits on the top of my head. I asked him if he was comfy because I've never had anybody sit on my head

before. Then I opened the book which was *The Cat in the Hat* and just like that I was able to read. I said, "I can read," and they says, "Yeah, I know." I learned how to read by all these kids sitting around me and one on my head.

And when I did read, I didn't die. It was a fantastic read. I went home and I cried my eyes out because I could read. I bought a newspaper that very day and I've read one every day since.

Learning to read was a new life for me. I had a bad marriage. I was not happy for a long time. I'll tell you this. My divorce arrived in the post. It was printed on such beautiful paper and do you know what I did? I proceeded to tear it to bits. I said to myself, "Oh, let's have a marriage burning." Then I realized I didn't read the date so I didn't know what day I got divorced. I started to put it back together, but there were seven pages and I said, oh forget it. I still don't know the day I got divorced, but I was very happy.

A while later somebody said that they wanted to take me out. I said, "No, I'm too fat," and he says, "You made yourself fat but your eyes are beautiful, I've always loved your eyes." I says, "Too bad, I can't go out with you because I'm fat." You see, I'm half of my former self as I am sitting here today. I was 316 pounds. I ate everything because I didn't want a man to see me, but I didn't count on my eyes—somebody loving me for my eyes. That's almost like loving you for your heart. But I can't take that leap of faith.

I struggled with my weight so I decided to eat sensibly. I dropped to 287 pounds and I stayed there for about ten years. Then I went to UBC and I met men there who really thought I had a brain. I enrolled in the Humanities 101 program and they liked my ideas and I liked theirs.

During the week of graduation we were in the gym and my friend says to me, "I can't get this scale to work," and I says, "I can get it to work because my weight hasn't changed in ten years. It's 287." So I locked the steel on 287 and it went *click* down like that.

It didn't balance, so I says well, let's move it this way, because I thought I'd gained weight. So when it still didn't move I said I have to go this way. It kept sliding across. I lost eighty-seven pounds during the six months that I went to school. I had to eat right because they give you a meal ticket and God forbid you don't want to waste a meal ticket. So I would eat at a regular time and then I'd have to walk to class.

Going to Humanities 101 meant a lot to me. I told my sons I have to go there and what I do there will help me prosper and they said, "Go, Mom, go." So I went two nights a week for a year.

I made people cry at my graduation speech, because I always say it took me a million miles to get here and half the time I was doing it in high heels marching backwards through fear and with two babies on my hips.

The first time I was on campus getting my meal, I ordered a salmon and spinach wrap. I put my order in, gave them my meal ticket, went to sit outside, and the next thing I hear is "Helen." This was on the UBC campus. I hear my name on the campus and I think, "My God, I'm supposed to be here."

I put that in my speech and all these people are crying and I'm crying. Afterwards one professor comes up to me and says, "Humanities 101 is for people like you—you should've had a chance the first time and we can only give you

a little bit, but we're here for you." Then I cried because it was like having my dream fulfilled at things I could do while not worrying about someone calling me stupid.

When I was young, I would hear about how I was stupid and how I was going to hell and then I'd go, "Sure I'm going to hell. My first name starts with Hel and then if you take my last name and make the "i" an "e" you get Hel Hell."

So one day after my divorce I'm sitting and thinking, oh my God, what's going to happen if I go to hell because nobody loves me? So I made a wish. I said please let me be somewhere where a hundred people will say I love you. And it was here.

Everyday somebody says I love you or people on the street blow me kisses or touch their heart, you know, from across the street, and these are signs that mean I love you. I don't know what I did to my parents for them to hate me, but let me tell you this: being here, around people that love me, is everything. I'm probably going to die alone, but I know that one hundred men and women love me for me. I tell you, this is the place I got my wish.

# ACKNOWLEDGMENTS

Hendrik Beune and Helen Hill's stories were first published in *Geist* magazine. *Geist*'s support of this project from the early stages has been essential. We'd particularly like to thank Stephen Osborne and Mary Schendlinger for much advice and counsel along the way. Special thanks also to Patty Osborne.

Thank you to Edith Leung and her family, Kelly Kramer, David Epp, all at Nootka Elementary and to the Garden Drive neighbours for keeping our children occupied while we worked on the book. Thanks to Rory Sarah and Micah-Sophia who waited patiently.

At Pivot, we'd like to thank John Richardson for joining us in this project. Paul Ryan's contribution was immense and quite simply made the project possible. We thank him dearly. Tina Tomashiro handled the contributor sign-off process with the utmost professionalism. Thanks also to Pivot business and development manager Peter Wrinch. Thanks to Pivot interns Tebasum Durani and Steve Parr who conducted pre-interviews with Donna Gorrill, Dolores Dallas, Skyla, and Edie Wild. Thanks to all the volunteers at Pivot who helped along the way.

Thank you to Kevin Paetkau, and to Walter and Mable Paetkau. We gratefully acknowledge the Abbotsford Mennonite Fellowship for their generous support of this project.

Thank you to Libby Davies for her fine foreword. Her commitment to the Downtown Eastside is enlivening and we are thrilled her astute words open the book.

Thank you also to Linda Cran for her generous support, Mandelbrot, Art Perry, Anne Grant, Chris Cameron, Rosamond Norbury, Michelle LaFlamme, Ryan Knighton, Colleen Kerr, John Jerome, Patricia Brady, Lori Baxter and all at ArtsNow, and Daphne Marlatt, who gave us kind and pragmatic advice at the start of this project.

Thank you to Kyle Greenwood and The Writers Trust of Canada for their invaluable support through the Woodcock Fund.

It is a great honour to work with Arsenal Pulp Press. Thanks to Shyla Seller, Linda Field, Janice Beley, Bethanne Grabham, Brian Lam, and Robert Ballantyne for all their hard work, editorial support, and professionalism.

Finally, we'd like to thank Erin Knighton, our transcriber, who felt like a third partner in this project. She spent many hours with the voices in this book and her fine and fast work was essential to its completion.

—Brad Cran and Gillian Jerome